PRINTMAKING TECHNIQUES

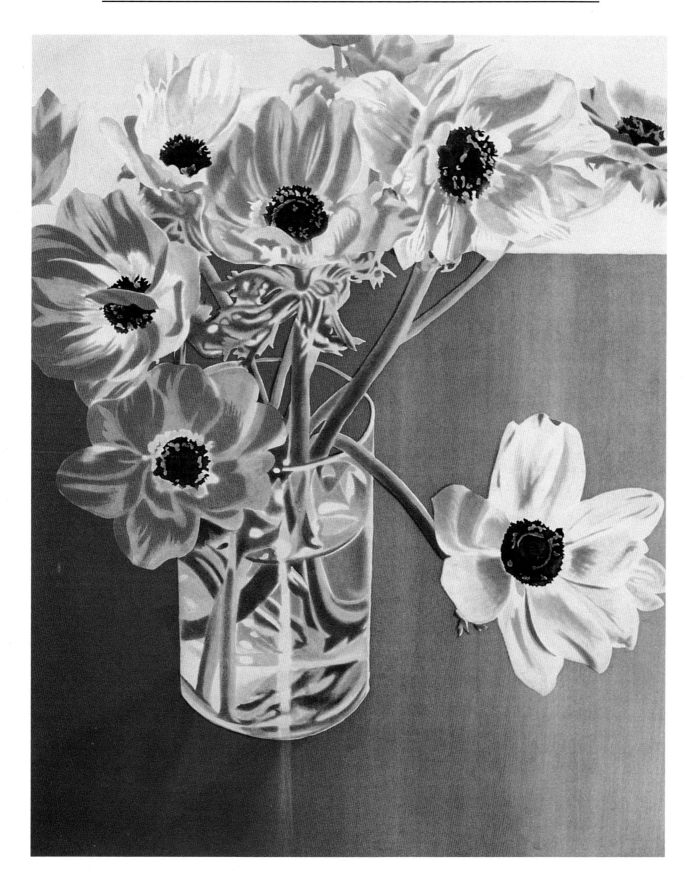

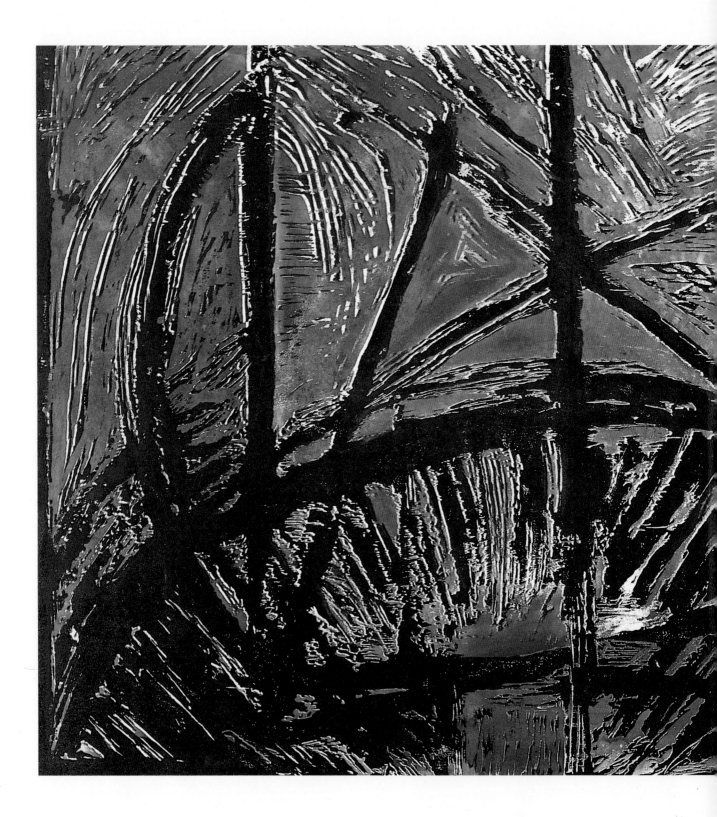

PRINTMAKING
TECHNIQUES

JULIA AYRES

WATSON-GUPTILL PUBLICATIONS/NEW YORK

Art on first page:
Carolyn Brady, *Anemones on Red Table.* Aquatint etching with spit bite,
35 $^1/_2$ × 29 $^3/_4$" (90 × 76 cm), 1981. Courtesy of Nancy Hoffman Gallery.

Art on title spread:
Mary Dryburgh, *Time/Space.* Woodcut, variable edition, 22 × 31" (56 × 79 cm),
1991. Printed at University of Tulsa Print Studio.

Art on dedication page:
Maggie Kendis, *Rosie.* Four-plate intaglio etching with sugar-lift and aquatint
techniques, 10 × 8" (25 × 20 cm).

Copyright © 1993 Julia Ayres

First published in 1993 in the United States by Watson-Guptill Publications,
a division of BPI Communications, Inc.,
1515 Broadway, New York, N.Y. 10036.

Library of Congress Cataloging-in-Publication Data

Ayres, Julia.
 Printmaking techniques / Julia Ayres.
 p. cm.
 Includes index.
 ISBN 0-8230-4399-1
 1. Prints—Technique. I. Title.
 NE850.A87 1993
 760'.28—dc20 92-43352
 CIP

Distributed in Europe, the Far East, Southeast and Central Asia, and South
America by RotoVision S.A., 9 Route Suisse, CH-1295 Mies, Switzerland.

Distributed in the United Kingdom by Phaidon Press Ltd., 140 Kensington
Church Street, London W8 4BN.

Manufactured in Hong Kong

First printing, 1993

1 2 3 4 5 6 7 8 9 10 / 97 96 95 94 93

David Ayres joins me in dedicating this book to our children:

Robert Spencer Ayres
William David Ayres
Gail Helen Ayres
Clark Spencer Ayres

CONTENTS

Carol Wax, *Singer 1.* Mezzotint, 11 ⅝ × 8" (30 × 20 cm), 1984. Courtesy of the artist. Photo: Robert D. Rubic, New York.

PREFACE AND ACKNOWLEDGMENTS

When I researched and wrote the book *Monotype: Mediums and Methods for Painterly Printmaking* (New York: Watson-Guptill, 1991), I learned about many printmaking processes and became intrigued with the artistic possibilities they presented. Before then I had held an undefined prejudice that printmaking was a lesser art, too technical to allow spontaneous creativity. Where this ignorance originated I cannot remember, but I know that there are other artists with the same misconceptions.

Such artists should realize that printmaking can be even more exciting, even more creatively challenging, than developing an image directly on paper or canvas. No longer should painters politely pass by prints hanging in galleries. Even a broad overview of printmaking, such as this book provides, will help you to understand the methods used for various kinds of printmaking, and therefore to appreciate finished prints. This was one of my goals in writing this book. Another was to inspire you to make your own prints—perhaps to take a printmaking class or workshop where some of the equipment is already provided.

This book tells you how to develop the surfaces from which you can print multiple originals. Each chapter starts with the most basic methods and then moves into many of the more advanced techniques used in printmaking today. We will be concerned with the hand printing of original prints, a field in which quality is more important than quantity. This same principle holds equally true for prints made on etching and lithography presses.

The artists whose work appears in this book are all interested in making original prints, as opposed to large, commercially salable editions. A few prepare their own plates and then collaborate with master printers in well-equipped shops for the printing itself. Others print in their own home studios. Some do not have a press, and print their work by hand; others work on a kitchen table or countertop with a few tools to make creditable work. All of them—like me—find printmaking a highly versatile and expressive art form, one well worth exploring.

The following special consultants helped this book become far more informative than I could have written it unaided, and I am grateful for their assistance.

Art and printmaking:
Mary Dryburgh
Ron Pokrasso
Betty Sellars
Ben Adair Shoemaker

Technical consultants:
Eliza Beghe (Solo Press)
Vern Clark (inks, tools, photo
 etching)
Richard Fleming (chemical engineer)
David Gamble (paper-plate
 lithographer)
Jack Hardy (professional
 photographer)
Judy Kaplan (Hunt printmaking
 supplies)
Vince Kennedy (Createx water-
 based inks)
Ann McLaughlin (Experimental
 Workshop)
Jim Noble (Dick Blick Company)
Gary Owens (Edward C. Lyons
 Cutting Tools)
Daniel Smith and others in his
 company
Judith Solodkin (Solo Press)
Sique Spence (Nancy Hoffman
 Gallery)
Al Spizzo (Hunt screen-printing inks)
Margaret Steinberger (Sarah
 Campbell Blaffer Foundation)
Bruce Taylor (computer art)
Kathleen Warner (Kathleen Warner
 Fine Arts)
Robert Webster (computer
 programming)

I am also grateful to all the contributing artists and museums for their efforts in helping me prepare this book.

Finally, I would like to thank the people at Watson-Guptill who worked on this book: editors Candace Raney, Marian Appellof, and Janet Frick; designer Areta Buk; and production manager Ellen Greene. They expertly turned my ideas, illustrations, and written pages into a finished book.

INTRODUCTION TO BASIC PRINTMAKING TECHNIQUES

What do all printmaking techniques have in common? First of all, printmaking—unlike, say, watercolor painting—allows the artist to create multiple, nearly identical impressions from the same block or plate. You can create variations on the same basic image by varying the color of ink, and by painting, printing, or collaging over parts of the image afterward. Even if you are not deliberately trying to vary the impressions made from a block or plate, multiple impressions made by hand printmaking methods are rarely *completely* identical. This is especially true in intaglio techniques, where wiping ink from the plate often produces subtle variations in the edition.

By contrast, a completely mechanical reproduction is done by the *photo offset* method of printing. The artist takes a painting in to be photographed. Color-separated transparencies are made, from which plates are developed. Computer-controlled offset presses then print the edition. This type of print, no matter how fine, should not be classified as hand-printed artwork.

Except in screen printing (for reasons you will learn later in this book), the image developed on the printmaking surface prints as a mirror image. If this is a problem to your design, you can correct it by reversing the original drawing on the plate, block, or stone. For instance,

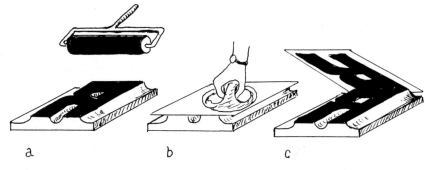

a b c

In relief printing, (a) the printmaker carves a block and inks the remaining flat surface. (b) Next a sheet of paper is placed over the block and either hand-rubbed or run through a press. (c) The image appears in reverse on the paper.

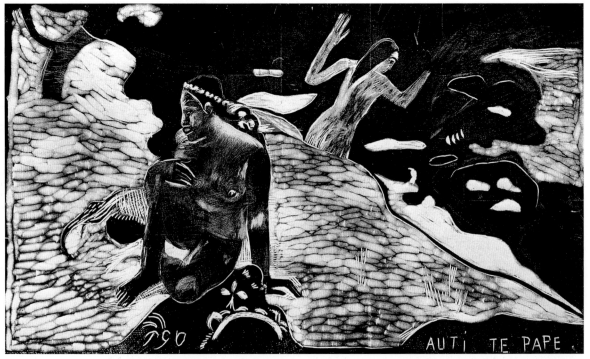

Paul Gauguin, *Auti Te Pape (Women at the River).* Woodcut, 8 × 14" (20 × 36 cm). All rights reserved, The Metropolitan Museum of Art, Rogers Fund, 1921. (21.38.6)

In this relief print, the light areas were cut from the flat surface with tools such as gouges and knives. The remaining surface was inked and printed, and appears dark in the finished print.

words must read backward on the plate to print correctly.

Printmaking encompasses a number of categories that describe the process used: relief, intaglio, lithographic, screen printing, collagraph, offset, monotype, and monoprint. It's a good idea to become at least a little familiar with all printmaking techniques, even if you're primarily interested in one. Some of the methods used to make colored prints in one chapter may be adapted in another technique. It is also common practice to combine different printmaking methods.

RELIEF PRINTING

The oldest, most direct method of printmaking is in *relief.* In this approach, you start with a block of wood, linoleum, or some other substance with a smooth, flat surface. (Even half a raw potato will do!) You then cut away all of the flat surface except the image itself, so that the image area becomes a flat raised surface that stands out from the background. When you roll ink onto the block's surface, only the image receives ink, and when you print it onto paper, the image appears in reverse.

INTAGLIO PRINTING

The *intaglio* processes work quite differently: The image to be printed is actually *below* the surface of the plate. Engraving, drypoint, and etching are all intaglio techniques. Lines and tones are hand-cut or acid-etched into the flat surface of the printing plate. The artist next spreads ink over the plate, and then wipes off the surface, so that the ink remains only in the incised design. The plate is placed face up on an etching press; a sheet of paper is placed over the plate and covered with felt blankets, and the whole ensemble is rolled through the press. Ink is thus delivered from the incised lines to the paper.

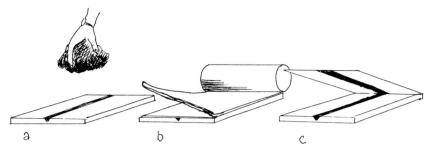

a b c

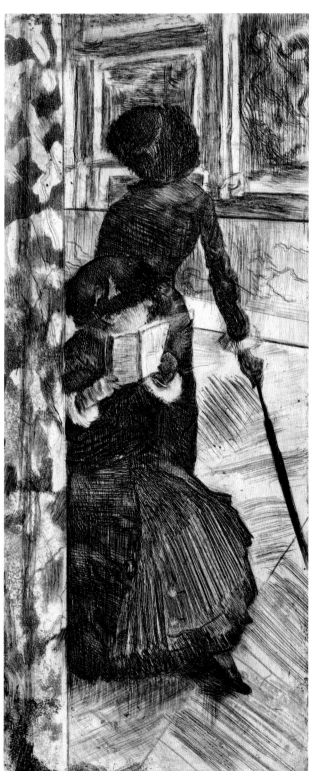

In intaglio printing, (a) lines and tones are incised into the plate. The printmaker then wipes the surface clean of excess ink, but ink remains in the incisions. (b) Moist paper is placed on the plate, and the paper and plate are run through an etching press, cushioned by blankets. (c) The printmaker pulls the intaglio print from the plate. The image appears in reverse.

Edgar Degas, *Mary Cassatt at the Louvre: Paintings Gallery.* Etching, drypoint, and aquatint, 12 × 5" (30 × 13 cm). Katherine E. Bullard Fund in Memory of Francis Bullard and proceeds from the sale of duplicate prints. Courtesy, Museum of Fine Arts, Boston.

Like many intaglio printmakers, Degas combined several intaglio techniques to create this image of Mary Cassatt. You will learn more about etching, drypoint, and aquatint in Chapter 3 of this book.

LITHOGRAPHIC PRINTING

The *lithographic* process involves the incompatibility of oil and water. The artist works with grease-based materials on a flat surface, while keeping the area not to be printed wet with water. When an oil-based ink is deposited onto the plate, it adheres only where the greasy design has repelled the water. This type of printing is sometimes called *planographic* because the image is developed on a flat plane.

SCREEN PRINTING

Screen-printing processes are sometimes termed silk-screen printing or serigraphy (the prefix "seri-" meaning silk). Silk fabric was originally stretched on printmaking screens, but it has now been almost totally replaced by more effective modern screen fabrics. The artist cuts a stencil and attaches it to the fabric screen. When ink is squeegeed through the screen to the paper on the other side, the stencil protects the areas where the artist wants no ink, thus forming a design. Ink can also be brushed or rolled through an open stencil not attached to a screen; the resulting image is called a stencil or pochoir print.

In lithography, (a) the image is developed with a grease medium and the areas not to be printed are kept wet with water. When ink is rolled over the surface, only the image areas created with the grease medium will accept ink. (b) The printmaker places paper on the surface of the plate, and runs them under the flat blade of a lithography press. (c) The lithography print is pulled from the surface of the plate. Again, the image appears in reverse.

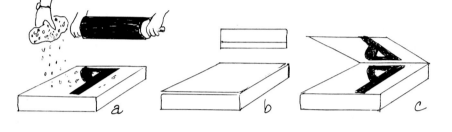

In screen printing, (a) the printmaker cuts a stencil, attaches it to a fabric screen, and places print paper under the screen. (b) Next a squeegee blade is used to draw ink across the screen, where it passes through the areas cut out of the stencil. (c) The image prints on the paper below, *not* in reverse.

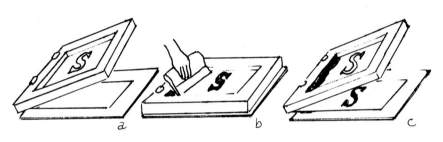

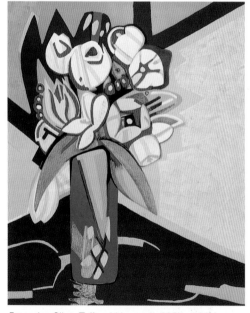

Françoise Gilot, *Tulips.* Lithograph, 22 7/8 × 18 1/2" (58 × 47 cm), 1991. © Françoise Gilot.

This seven-color lithograph was made on six zinc plates. Gilot painted directly on the plates with lithographic pencils and tusche. The work was hand-printed at the Fernand Mourlot workshop in Paris, France.

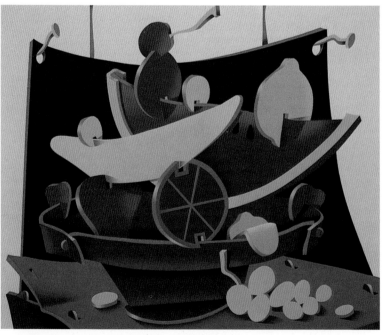

Lynwood Kreneck, *Picasso's Cardboard Still Life.* Screen print, 18 × 20 (46 × 51 cm). Courtesy of the artist.

Kreneck screen-printed 25 separate colors, one over another, to create this whimsical image that imitates a three-dimensional look.

COLLAGRAPH PRINTING

A *collagraph* printing plate has materials glued (collaged) onto a support: usually a thin, flat material made either of pressed wood (Masonite), metal, cardboard, or plastic. The artist can also cut into the printing surface. Next the artist rolls or paints on ink, puts moist paper on top of that, and runs the whole "sandwich" through an etching press with heavy blankets. The image on paper comes out in reverse not only from left to right, but from convex to concave. (What stood out on the plate is now indented on the paper, and vice versa.)

OFFSET PRINTING

Offset printing means that the image on the plate was first printed on one surface before being transferred to another surface for the final print. This is the basic method used in commercial offset printing, and in photo offset printing of paintings, as described earlier. However, the hand printmaker uses the same principle when printing a still-wet print onto another surface. Offset printing is especially useful for prints involving multiple colors done with multiple plates; this is one good technique for *registering* (lining up) all your colors accurately.

In another hand method of offset printmaking, you roll a clean brayer or large-diameter roller over an inked plate surface to pick up the image. First measure the width and outside circumference of the brayer or roller with a string or cloth tape. These measurements determine how large an area you can pick up in one roll before overprinting the image. Make small marks at the edge of the roller and on the wet inked surface to guide you as you roll out to print the picked-up image onto the next surface; you don't want to cut your image in half by starting to roll it in the middle!

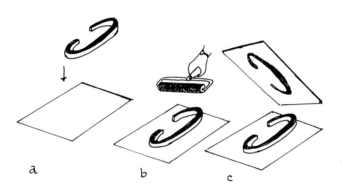

In collagraph printing, (a) material is attached to the plate surface. (b) The artist paints or rolls ink onto the printing surface. (c) Moist paper is laid on top of this, and the paper and plate are run through a press. The image on the paper is in reverse to the plate image and indents where the plate stuck out.

In offset printing, (a) the image is developed and inked on one surface and printed—or offset—onto a second. (b) The second surface is printed onto a third surface for the final print, which is an identical image to the first surface and a mirror image of the second.

Barbara Young, *Aperture 1.* Collagraph, 24 × 20" (61 × 51 cm). Photo: Richard Pucci.

Young developed this collagraph on mat board. She used modeling paste to create the textured border, and brushed acrylic medium in various densities on silk organza to establish the tones for the triangular shapes. The components of the design were inked separately and then assembled to print with one run through the press.

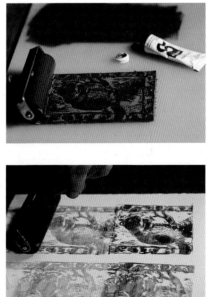

Top: Here is a cut linoleum block, already inked for an offset print. A clean brayer is rolled over it, picking up the image. The brayer then rolls the image onto the paper. Bottom: As the brayer enters its second revolution, the image becomes lighter because there is less ink left on the brayer. The pair of prints in the foreground were previously made in the same way.

Roger Guillemin, *Paradise Lost.* Computer painting printed by hand lithographic methods, 12 1/2 × 17 1/4" (32 × 44 cm).

Guillemin developed this painting on a Macintosh IICX computer with a Pixel Paint Professional program in an 8-bit mode. Color separations were made directly from the disk. Michael Costello then developed and hand-printed lithographic plates at Hand Graphics in Santa Fe.

COMPUTER-GENERATED AND PHOTOGRAPHIC PRINTING

Some artists work with *computer-generated* imagery to make their prints. *Photocopier* images are another growing art form. Positive or negative transparencies are used to develop printing surfaces with *photodeveloping* techniques. In this book we will cover these techniques only when they are incorporated into one of the more traditional procedures. One exception is cliché verre, in which the artist uses transparent inks to paint a negative that is then developed photographically. This is discussed in the last chapter.

Julia Ayres, *Charlie's Bouquet.* Monotype, 20 × 16" (51 × 41 cm).

This reductive monotype was made using the negative technique. After the plate was completely inked with black, I wiped the image from the surface with cloth and brushes, and then printed it by hand-rubbing onto paper.

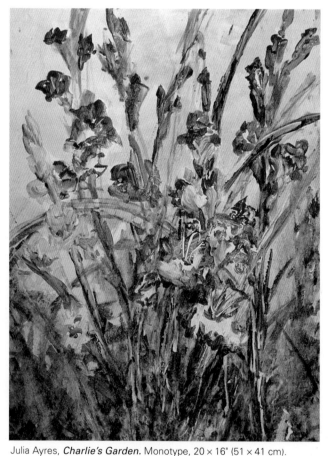

Julia Ayres, *Charlie's Garden.* Monotype, 20 × 16" (51 × 41 cm).

To create this positive monotype, I developed the image by painting directly onto the plate with brushes, brayers, and even my fingers. As with most monotypes, some reductive technique was used to complete the image.

MONOTYPES AND MONOPRINTS

If an artist develops a flat unaltered printing surface and makes a single print, it is called a *monotype.* The imaging is executed in two basic methods. In the subtractive (sometimes called reductive) method, the surface of the plate is completely inked and then the image is wiped from the dark field. In the additive (sometimes called direct) method of making a monotype, the image is painted directly onto a light field with brushes, rollers, or even fingers.

Works that combine monotype with other printmaking techniques are called *monoprints.* Ron Pokrasso developed his Russian Olive series of monoprints by using an intaglio plate in combination with monotype work made on an unaltered Plexiglas plate and printed under or over his intaglio print. The monoprint illustrations in this book reflect the growing interest in developing handmade prints as unique images.

PRINTING THE IMAGE

As the printmaking surface is developed, *proofs* are pulled to study the state they are in. These proofs are labeled *state 1, state 2,* and so on, and they form a chronological record of the development of the plate.

Historically artists have worked with master printers to execute the actual printing once the plate is complete. Because it takes years of experience to reach true perfection in printing an edition, some artists still believe collaboration with a printing expert to be the only way to make prints. Custom print shops are still working with artists to produce fine art prints.

However, a print need not be technically perfect to be of artistic merit, so this book encourages artists to develop and print their own work. A type of spontaneity occurs when you become your own printmaker and dare to experiment. I encourage you to view the actual printing of the work as part of the artistic and creative process.

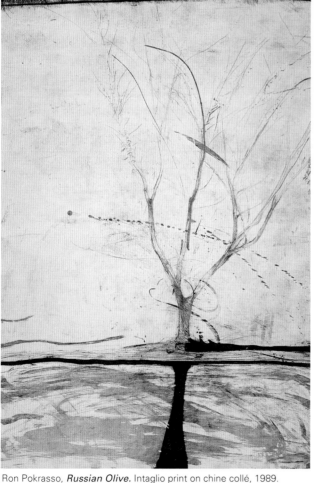

Ron Pokrasso, *Russian Olive.* Intaglio print on chine collé, 1989. Courtesy of the artist.

Pokrasso developed this print on a metal plate, using numerous intaglio techniques. It was printed on white paper with buff paper applied in chine collé (a technique for gluing two or more papers together as the print is run through the press).

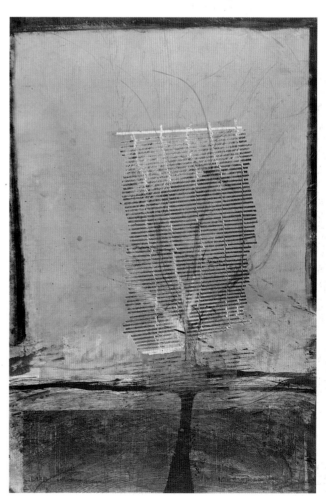

Ron Pokrasso, *Russian Olive with Blinds.* Monoprint on chine collé, 36 × 24" (91 × 61 cm), 1989. Courtesy of the artist.

The same intaglio plate was printed again on white paper and chine collé. This time the artist developed the image further by sending the paper through the press again, printing it from a Plexiglas plate developed with monotype techniques.

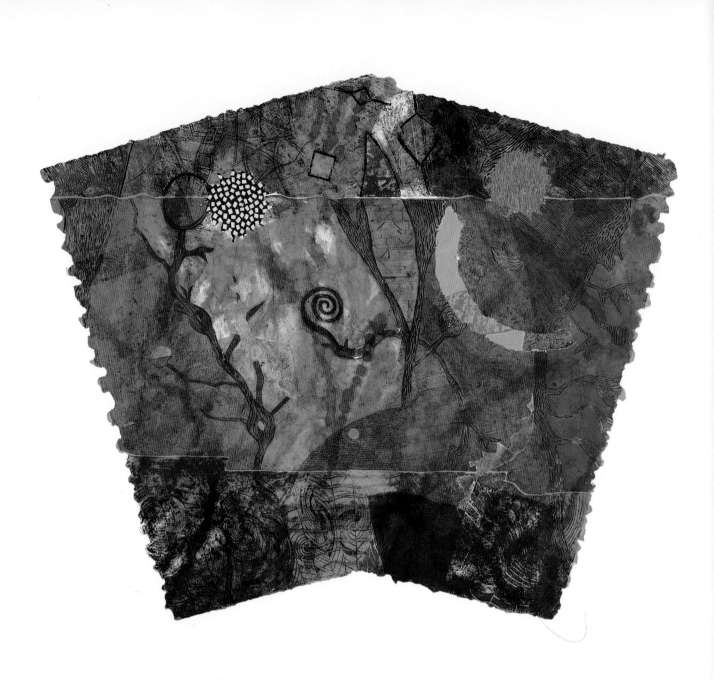

David C. Jansheski, *Kite for Neptune.* 40 × 48" (102 × 122 cm). One of a series of collagraphs made with dyed paper pulp in collaboration with papermaker Stephan Watson.

1 BASIC MATERIALS AND EQUIPMENT

One reason that printmaking is a fascinating area for the artist is that this general term encompasses many procedures, many combinations of tools and materials. The combinations you choose will considerably influence the look of your finished prints. A number of materials, such as papers and inks, are common to more than one process. Familiarity with these materials will serve as a good introduction to printmaking and expand your creative possibilities for making exciting prints. Later chapters will focus on individual printmaking processes and the materials needed specifically for them.

Perhaps you are taking a printmaking class in a school or workshop where facilities already exist. In that case, you should of course tailor your list of supplies to complement those already available to you. Or perhaps this book is your sole introduction to printmaking; it may inspire you to buy the basic materials you need to get started, and then to take a class later on. Either way, enjoy exploring the many ways to make prints, and the huge variety of effects that can be achieved by the curious and innovative artist.

PAPER

The overall feeling of a print is influenced a great deal by the paper. There are numerous textures and colors to choose from. Some of the papers are artfully handmade, while others are more cost-efficient and made by machine. Papers can be purchased in sheets or rolls.

PAPER FIBERS

Papers are made from a wide variety of fibers. Most available art papers are made from short cotton fiber linters, a by-product of the cotton industry. Linen fibers are longer and stronger, and are the basis for more costly papers. Cheaper papers are made with wood pulp, which for many years was not of archival quality. However, wood pulp can now be made neutral in acidity, which makes the paper more stable. This kind of wood pulp is termed "sulphite." It is the most common addition to cotton pulp not indicated as 100 percent rag—a term indicating that the paper contains only the longer, stronger fibers of cotton or linen.

Fiber content alone will not indicate whether a paper is of archival quality. In today's environmental conditions, acid in the air will gradually eat away at paper even if the paper itself is acid-free, so it is helpful to buffer the pulp with alkaline salts that will continue to neutralize acidity. If you want your prints to survive as long as possible, make sure the paper is labeled pH neutral.

Rice paper is a misnomer that probably dates back to early European traders with the Orient who were ignorant of how the fine paper was actually made. These fibers are actually bast fibers gathered from the inner bark of certain trees and plants. In Japan the strong long fibers are primarily kozo, from the Japanese mulberry. Mitsumata gives a soft, absorbent, lustrous characteristic to the paper. Gampi fiber imparts a strong, translucent quality. In recent years acid-free sulphite has also been added to some of these kinds of rice paper.

HOW PAPER IS MADE

When fibers are beaten and soaked in water, the individual filaments separate, and the mixture becomes a pulp called a slurry. A tray-shaped mold with a screen bottom is dipped into this pulp slurry and lifted out of the vat. A thin layer of wet fiber forms on the mold's screen as the water filters through it, and this sheet of intertwined filaments becomes the paper. When the frame (or deckle) of the mold is removed, a natural feathery "deckle" edge to the sheet is exposed where some of the pulp seeped under the frame.

The pattern of the screen used to form the wet paper fibers imparts characteristic texture to the paper. A "laid" texture is created when the screen is made of thinly stripped bamboo or wires that are laid closely side by side and fastened together with wires or thread sewn in evenly spaced straight lines running perpendicular to the strips. A "wove" texture is created with screens woven in a method similar to window screening.

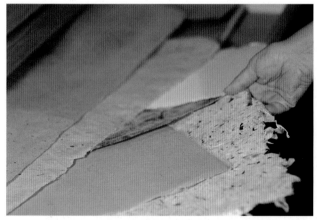

Special papers in my flat file drawer are (bottom to top) gray and then blue handmade papers from a cottage industry in New Mexico. The highly textured brown paper is made from bark in Mexico. The white paper is from Twinrocker hand papermakers in Indiana, and the top two are Kasugami papers from Japan.

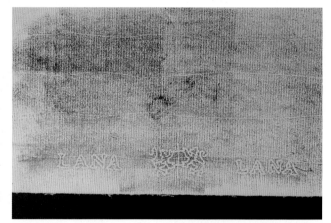

I have added a light transfer of ink to this Lana laid paper in order to show the pattern of the screen as well as the mill's embossed watermark.

A wire design fastened to the screen will leave an embossed mark in the paper known as a watermark. In past history some watermarks became elaborate artworks in themselves. Most often they are simple designs or letters signifying the manufacturer or the name of the paper.

SIZING

Paper that has not been sized acts like a blotter and is called waterleaf. Sizing, usually a warmed gelatin glue, is either added to the pulp mixture or coated onto the paper to decrease the absorbent nature of the fibers. Ink will stand on top of a highly sized paper, but will sink further into the fibers of a waterleaf. When paper is soaked in water, the sizing will dissolve and leave the fibers. Both sized and unsized papers can be used for printmaking; it all depends which specific process you're using, and what effect you want.

INDICATING PAPER WEIGHT

There are two methods of indicating a paper's weight. In the United States it is measured by the weight of a 500-sheet ream of that paper's standard size. Unfortunately this gives only an approximate indication of the actual density and thickness of the paper, since the standard sizes vary from one paper to another, and poundage varies according to the dimensions of a particular sheet. (A ream of 22 × 30" sheets will weigh less than a ream of 24 × 36" sheets of exactly the same paper.) In other parts of the world, paper weight is most often measured in the metric system at g/m^2 (grams per square meter). This system makes it possible to compare the density of papers no matter what the dimensions of the sheet. The popular Masa paper from Japan is 70 g/m^2. Unryu, on the other hand, is only 36 g/m^2—a very light, thin tissue.

Betty C. Bowen, *Losing Shiogama.* Woodcut print, 46" × 7' (117 cm × 214 cm), 1987. The large size of this print on a continuous sheet of paper is possible because Masa paper can be purchased by the roll.

PAPERS TO USE FOR PRINTMAKING

Rives BFK is a very popular contemporary unsized printmaking paper; its lack of sizing allows the ink to penetrate the fibers easily. Arches Cover, on the other hand, contains some sizing, so it allows less penetration of the ink into the fibers. Arches Cover has more surface texture than Arches 88, a smooth waterleaf paper often used for screen printing. There are also translucent sheets of Japanese gampi papers.

A number of supply houses sell paper samples. For example, Daniel Smith of Seattle sells sample packs of watercolor, printmaking, and oriental papers. Stamp-size prints may be made on these small sheets in order to become familiar with their transfer characteristics.

Betty C. Bowen, *Dryburgh.* Relief print and drawing on gold-leafed flax paper, 18 × 16" (46 × 41 cm).

This is a dramatic example of how paper can influence the overall feeling of a print. If the image on black had been prepared on a generic white sheet, it would have had nowhere near this much impact. This is not chine collé because the gold leaf was applied by hand, separate from the printing process.

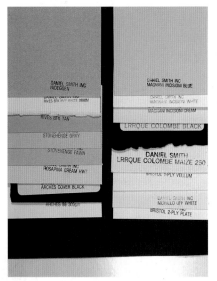

Samples of traditional printmaking papers assembled from a packet purchased from Daniel Smith Co.

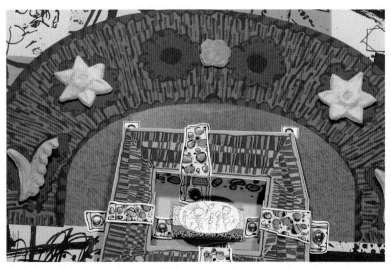

As Robert Schwieger developed this screen-print assemblage, he made small cast-paper shapes in cookie molds and glued them to the red-violet arch shape at the top.

MAKING SPECIAL PAPERS

There are many ways to make your own special paper with an individual project in mind. When David C. Jansheski prepared to make his "Kite for Neptune" collagraph prints, one of which appears on page 16, he first collaborated with his papermaker Stephan Watson in Albuquerque to make special support papers. Jansheski drew the design for the stencil, and Watson cut it out. Then Jansheski selected abaca and cotton linters to get the right texture and strength, and dyed containers of the slurry to achieve the colors he wanted. Next he applied dips of wet slurry onto the papermaking screen. Both Jansheski and Watson then formed and dried the wet fiber sheet it further by pressing (couching) it against felt.

Betty C. Bowen and Joan Hill have printed on papers with exclusively prepared surfaces. Bowen relief-prints on handmade flax papers that she has first gilded with thin sheets of gold leaf. She picks up the leaf with a gilder's tip (brush) and adheres it to her support paper with spray adhesive size. Hill first splatters her papers with thinned ink before she screen-prints on top.

Wet cotton linters, used to make sheets of paper, may be squeezed into a rubber, plastic, or plaster mold to make cast paper editions. When you drain or squeeze excess water from the mold, the fibers interlock and take on the form they are pressed in. After they are dry enough to be lifted, lift or dump the paper cast from the mold and let it dry further. Cookie molds or other found objects may be used to form castings.

Joan Hill, *Cherokee Cavalier.* Screen print, 29 3/8 × 14 1/8" (75 × 36 cm). Collection of William C. Hill. Photo: Shane Culpepper, Gilcrease Museum, Tulsa.

Hill splattered thin ink on her paper before screen-printing this image.

To tear paper, first moisten the fold of the paper to soften the fibers.

Then tear the paper upward against a straightedge to get an evenly torn but slightly ragged edge.

To prepare moist papers for printing, place them between blotters and roll the surface to squeeze out excess moisture. This can be done with one sheet at a time or with stacked sheets, piled with blotters between them.

Marina Ancoma interleaves moist intaglio prints with clean newsprint paper and blotters. Heavy boards placed on top will help the prints dry flat. (Courtesy of Graphics Workshop, Santa Fe.)

PREPARING PAPERS FOR PRINTING

Most fine art papers have deckle edges left from where the pulp seeped under the mold frame. Handmade papers have four natural deckle edges; fine machine-made papers have a less pronounced, more even deckle edge on all four sides. This is a more desirable characteristic than cleanly cut edges. Thus, if you need only half a sheet, it's better to tear it than to cut it with scissors so that you get slightly ragged edges that will be aesthetically compatible with the remaining deckle edges. Fold the sheet along the dividing lines, and then brush the fold with water. Let it sit a moment while the water penetrates the fibers. Next open the sheet with the outside of the folded edge up. Finally align a straightedge with the fold line and tear the paper upward against the edge.

A print made on a press with damp paper will form around indentations in the printmaking surface. A dry sheet will tend to stay flat, printing only the relief surface. Some printers print relief prints with

Here you see moist blotters hung to dry with clothespins strung on wire. Similar methods are sometimes used to dry screen prints. (Courtesy of Graphics Workshop, Santa Fe.)

moist paper, while others prefer a dry sheet. Intaglio techniques require a moist sheet; lithographs may be done on either moist or dry sheets; and screen printing is done on a dry sheet. You will find out more about all these techniques later in this book.

When the printing process requires moist paper, paper that has been damp but just lost its sheen is usually most receptive to the ink. You can spritz or sprinkle unsized papers with water to moisten them. Sized papers are usually soaked in water for at least twenty minutes and then rolled between blotters to remove excess surface moisture. A day's worth of moist papers may be stacked, encased in a plastic wrap, and kept ready as needed for the press.

When moist papers or still-moist prints are stacked, they must be placed under weights to keep them flat. A heavy board to cover the top of the stack with added weight on top is the usual method for doing this. Moist prints are stacked by interleaving them with clean newsprint and blotters. The artist then changes the blotters and newsprint daily until the prints are dry.

CHINE COLLÉ

Thin, exotic, and different-colored papers may be collaged onto the support paper during the printing process. This permits printing to occur on top of the introduced sheet or sheets as well as the backing support for effects unattainable with only one kind of paper. To do this, moisten both the support paper and all the pieces to be collaged on. Dust the back of the collage papers with rice flour, and place them face down on the inked plate. Then lower the moist print paper on top, and run this "sandwich" through the press. The plate prints on the chine collé paper, which is now glued to the support paper. Applying collage under press pressure results in a smoother bond.

To do a chine collé print, dust the back of the moist chine collé paper with rice paste powder.

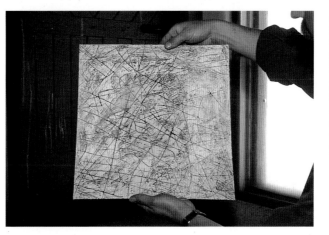

The back of the moist blue handmade paper on the center of David C. Jansheski's inked collagraph plate is lying with the paste side up. Here he is placing moist Rives BFK white paper on top. The paper on the plate in the background is another small collagraph that will be printed side by side on the press bed at the same time he prints the one he is now preparing.

Jansheski holds up the collagraph to see how the plate printed on both the support paper and the chine collé paper on top. (Courtesy of Graphics Workshop, Santa Fe.)

Exotic thin papers can be used for collage or chine collé. Here is a sampling: Papyrus, Mexican Bark Ivory, Mexican Bark Marble, T Unryu Tan, Mitzutama Black, Moriki Rose, Ogura Salmon, T Unryu Grey, and T Unryu Red.

PRINTING INKS

Printing inks are primarily mixtures of colorants or pigments in a number of recipes of fast-drying bases. They are formulated to work in specific applications. Intaglio inks are generally more viscous (stiffer) than other inks because they must remain in recesses of the plate when the surface is wiped. Screen-printing inks, which are pressed through fabric, have a consistency comparable to thick cream. Lithographic and relief inks are highly pigmented because they are designed to be rolled out thinly on the plate or block. Oil-based inks have been most widely used, but there is a growing interest in working with water-based formulas. Most inks can be altered to fit individual needs.

Oil-based inks are stiff when first removed from the can. Temperature and humidity have an effect on this. By working the ink with a spatula on a slab or palette, you can make them looser and smoother. This trait is called *thixotropy*. When left standing, inks will stiffen up again.

When an ink knife is dipped into a mound of ink and pulled upward, the ink pulls up with it. If the ink pulls up to a length of five or six inches, it is considered a *long ink*. This type of ink is suitable for commercial offset printing. If the ink pulls up just an inch before breaking from the knife, it is a *short ink*, more suitable for most of the hand printing described in this book. (It is harder to get long inks to leave the surface of the plate and attach to the paper.)

The *viscosity* of an ink refers to its flow characteristics. The most viscous inks are very stiff and hard to move; inks of extremely low viscosity flow quite readily. Viscosity characteristics may be altered—for

Mary Dryburgh works the ink on the glass slab with the knife until it rolls out evenly. (Photo taken at University of Tulsa Print Studio.)

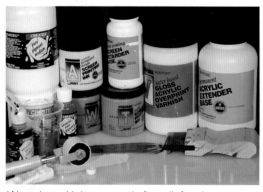

Water-based inks are made for relief and screen-printing techniques. The yellow ink rolled out in the foreground is Speedball block-printing ink from a tube; the blue streak of ink is Createx pure pigments mixed with Lyntex screen-printing base. Graphic Chemical & Ink Co. also manufactures water-based relief inks in tubes. Speedball screen-printing inks are classified by letters: W for water-soluble, A for acrylic, and T for textiles.

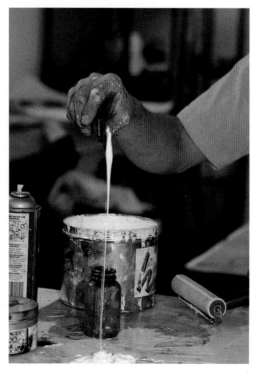

Ron Pokrasso shows me how long a low-viscosity white offset ink can be. Most inks used for hand printing would break from the knife when pulled up less than an inch. This offset white can be used to modify a shorter, more viscous ink.

instance, adding a thin offset ink to thick viscous inks will increase flow. Reducing oils and ink modifiers may also be used judiciously to cut viscosity for oil-based inks. Plate oil #00 is a light conditioner, while plate oils #3 and #5 are tackier and more dense; they can be used to thicken inks. Graphic Chemical & Ink's "Easy Wipe" is used by many intaglio printmakers to soften inks. Conversely, you can add cornstarch or magnesium carbonate (often called whiting) to stiffen both oil- and water-based inks. Dense varnishes can be added as firming agents for oil-based inks. Some of the denser inks can be added to a thinner ink to achieve the same effect.

You can take advantage of the differing viscosities of various inks. Thin, low-viscosity inks repel thicker inks. A thick, high-viscosity ink rolled over a thin ink will leave color only in the areas where the plate is clean. This characteristic permits multicolor imagery from a single printing with one plate. A thin ink on a hard rubber roller will deposit ink on the high surface of some intaglio or collagraph plates. A dense ink on a soft roller will deposit ink in the clean, lower recesses, not interfering with the thin ink.

An ink that is too tacky may "pick" the surface of the printing paper when it is removed from the plate, or it may actually work as an adhesive and tear off the outer surface of the paper. Reducing oils or Vaseline will reduce tack in oil-based inks. Extender or water will reduce tack in water-based inks.

Screen-printing inks should be altered according to the manufacturer's directions. Extenders, varnishes, and retardants are formulated for the individual brands of ink. It is also necessary to use the correct solvent for cleaning up.

Once a can of oil-based ink has been opened, it will tend to dry on the surface, leaving a skin. This can be avoided with anti-skinning sprays or papers that are on the market. When you are ready to use the ink, work the sprayed surface into the ink or remove the paper from the surface. Be sure to spray or cover the ink each time you store it, and to replace the lid tightly.

Some water-based inks remain water-soluble even after the print is dry. Acrylic-based inks, although water-soluble when wet, become insoluble when dry. Acrylic inks are made primarily for screen- and block-printing techniques. Some printers, such as Richard Royce in Massachusetts, are exploring how water-based inks can be used for intaglio printmaking. Artist's acrylic colors may be added to Speedball's screen-printing extender to obtain special hues. You can experiment with other water-based colors and extenders in the same manner.

Because papers, transfer methods, and environmental conditions will vary, test your inks before printing an actual edition. This is a good time to recycle by testing on the backs of unwanted prints. If you don't have any handy, use inexpensive newsprint paper.

Thin yellow ink is rolled out on a slab. Thick, more viscous green ink is repelled when rolled over the yellow thin ink. You can take advantage of this characteristic to print multicolor images from a single printing with one plate.

Joyce T. Macrorie, *Aerial: Leaving Chicago at Dusk.* Relief and intaglio print, Phase 2, 11 1/2 × 17 1/2" (29 × 44 cm).

Using her knowledge of viscosity characteristics of ink, Macrorie first applied thin, highly oiled black ink to the recesses of her metal plate. After wiping the surface of the plate, she then inked it with a thicker, drier roll of two colors subtly blending into each other. For this she used a hard roller that was large enough to ink the plate with a single rotation.

PRINTMAKING SURFACES

Except in screen printing, artists develop the image on a nonabsorbent surface before making the final print. Copper and zinc are the metals most often used for etching, a process in which acid eats lines and tones into the metal. Plexiglas plates may be used in nonacid techniques, such as drypoint and drypoint engraving. Linoleum and wood are the blocks used for relief techniques. Lithographs are made on limestone blocks, zinc or aluminum plates, or treated paper surfaces. Fabric is the primary support for screen-printing frames.

The thickness of plate materials is often a consideration in printmaking because some techniques demand a certain minimum thickness, and because thickness determines cost.

Metal plates sold by printmaking supply houses are usually between 16 and 18 gauge. The smaller number indicates a thicker plate. Plastic materials are measured by thousandths of an inch rather than by gauge. To compare numbers, 1/4 inch is .250, 1/8 inch is .125, and 1/16 inch is .0625. A sheet of 16-gauge metal material is the equivalent of .0625, while 18-gauge is comparable to .0475.

Storage of printmaking surfaces is as important as suitable storage for the finished prints. Generally a storage system where the metal plates, blocks, or stones may be held upright, much the way LP records are stored, will reduce warpage.

Before storing most printmaking surfaces, you should clean the surface of ink. (The exception is in lithography if you are planning to make more prints later.) Water clears water-based inks from the surface; isopropyl alcohol helps remove dried acrylic ink. Oil-based inks require petroleum solvents to clean the surface. There are less toxic citrus solvents available for poorly ventilated studios.

A scratch on a printing surface will often print, so a system of protecting the surface is needed. Most etching plates come carefully wrapped for protection. Make sure there is a buffer (of paper or plastic) between stored printmaking surfaces to reduce damage. Once a plate has been etched, some printers apply a thin coat of Vaseline as an extra protection before storing it.

Printmaking plates. top row, left to right: uncut woodblock, cut and inked linoleum block, etched zinc plate, unetched copper plate, and Litho-Sketch master. Bottom: Speedball screen-printing fabric over print, and gesso-covered mat board that is stained gray from printing.

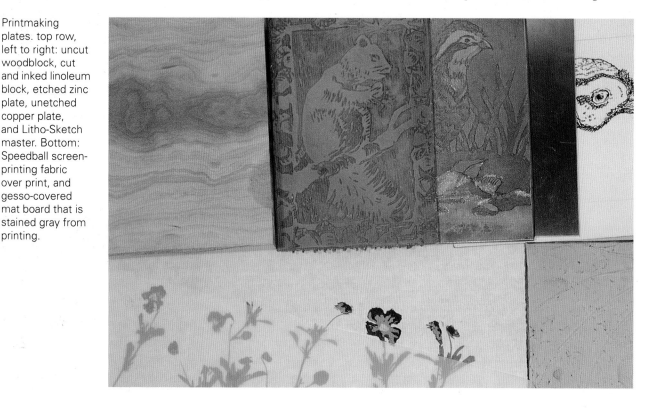

TOOLS

Printmakers use quite a variety of tools. The specific ones you need will vary according to the type of print you are making, but you are almost certain to need some form of brayers, rollers, cutting tools, and hand-transfer tools.

BRAYERS AND ROLLERS

Brayers and rollers are used to ink plates in most printmaking techniques. Each roller's primary characteristic is related to its durometer reading, or hardness of material. Most printmaking studios try to have several rollers of various widths and hardnesses for varying needs.

A brayer is made with a single, centered wooden or metal handle attached with metal bars to both sides of a roller made of rubber, leather, or polyurethane. Of these materials, polyurethane is considered the most sensitive for distributing and carrying ink. Older rollers were made of composition (gelatin), which not only is appealing to mice and insects as food, but easily breaks down in heat or moisture.

Larger hand roll-up rollers are much more expensive but are large enough to ink a plate with a single rotation. The first fully saturated roll spreads ink in an even layer, thus guaranteeing an evenly inked plate.

Such rollers are shaped like oversized rolling pins, and the outside circumference of the roller determines how far the ink can be rolled out before a second, less saturated roll begins. The handles are made of metal, plastic, or wood, and the roller itself of leather, rubber, or polyurethane.

Brayers and rollers should be cleaned with whatever solvent is appropriate for the ink you have been using. It is important to protect the round shape of these tools by not storing them on a flat surface; suspend them instead. Some handles are built for this; or you can buy holders.

Dewayne Pass draws a line of ink across the ink slab with a knife.

He then uses a Chameleon roller, available from Daniel Smith, to roll out the ink. By rolling quickly he picks up more ink. When depositing ink on his lithography plate, Pass will roll out the ink slowly.

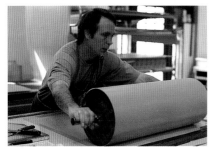

A roller with a circumference large enough to ink a 20 × 20" (51 × 51 cm) lithography plate with one rotation is used by Michael Costello at Hand Graphics in Santa Fe.

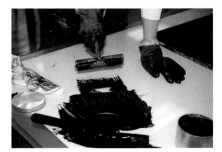

Mary Dryburgh uses a brayer to roll out ink, which she is about to apply to a woodcut.

Here she carefully covers the woodcut's relief surface. (Photo taken at University of Tulsa Print Studio.)

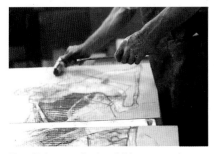

Ron Pokrasso "paints" his monoprints using his brayer on the flat roll as well as upended to make lines with the edges of the roller.

CUTTING TOOLS

Hard steel tools are favored for keeping accurate, sharp cutting edges for the longest period of working. It is better to have just a few really good cutters than a number of tools that quickly lose their cutting edge and make platemaking frustrating. Some fine engravers and cutters are designed with a half-round handle that fits into the palm of your hand for better control. Cutters with straight handles are appropriate for wider cuts. Cutting tools can be purchased singly or in sets at art supply stores.

Metal tools that are found often in a print shop are knives, needles, burnishers, gouges, gravers, and scrapers. *Knives* have a cutting edge met by a single bevel. *Needles* are pointed tools used to scratch into material. *Gouges* cut and scoop out material. *Gravers, or burins,* push out material in front of the leading cutting point. *Burnishers* flatten material by pressing it, and *scrapers* smooth surfaces by cutting.

I went to Jason Stone, a skilled, second-generation woodcarver, to learn his simple method of keeping tools sharp. First study the bevel and edges that meet to form the cutting edge. If light is reflected on the thin cutting edge, the tool is dull and needs to be sharpened. If there are nicks or unevenness, first hone the edge on a coarse Arkansas stone lubricated with light oil or water. Once the nicks are removed, sharpen the edge by rotating it slowly on a finer Arkansas stone, lubricated as before. Maintain the tool's bevel edge at its original angle during this process. Then pass it over extremely fine #600 wet-dry sandpaper to remove any slight burrs.

Many wood-craft shops provide tool-sharpening services. You can also buy tools to hold the cutters steadily at the correct angle on the

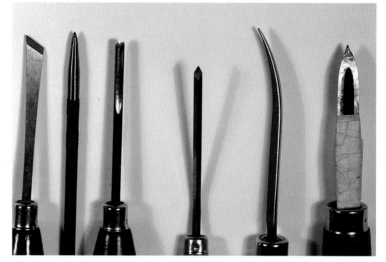

Cutting tools. From left to right: knife, carbon-tipped needle, gouge, burin, burnisher, and scraper.

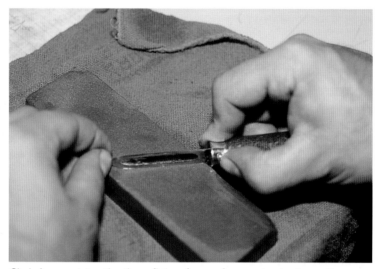

Clark Ayres rotates the three flat surfaces of a scraping tool on a fine Arkansas stone in light oil. The three cutting edges are made sharper when the flat surfaces are made level.

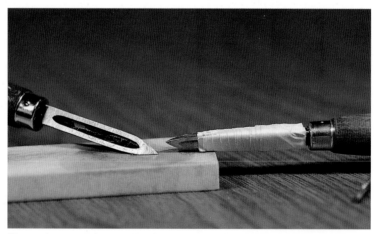

He continues to sharpen the three sides as they meet at the point. The scraper on the right is wrapped in tape so that the artist's fingers are protected while using the tool.

stone. A jig is an especially helpful tool that keeps the flat leading surface of an engraving burin at the correct angle in relation to the plate being cut.

The softer the material to be cut, the sharper the cutting edge must be. The thin cutting edge of a kitchen knife is an example of a tool needed to cut relatively soft materials, such as raw vegetables for vegetable stamps. Burins with a similar type of cutting leading edge can be used to remove hard wood and soft metal. Beveled edges of gouges can be altered to fit special needs.

HAND-TRANSFER TOOLS

Some printmaking processes do not require a printing press. Spoons and similarly surfaced tools can be used to transfer work on a plate to paper by hand. Barens are smooth, round tools made especially for this purpose. Relief blocks are often hand-transferred by rubbing the paper onto the inked image. Paper-plate lithography may also be printed by this method. In screen printing, on the other hand, the artist uses a squeegee to pull the ink across the screen, forcing it through the open areas onto the paper below.

My latest favorite type of "hand-transfer" printing is done not with hands, but feet. So far I have done this only with relief prints, but you could experiment with other printing techniques. First place an even stack of newspapers on a firm floor, top it with a clean sheet of paper, and place the print paper on top of it. Then add the inked block face down, and stand on it. Move your feet evenly. Make sure to hold onto something sturdy with your hands to keep you steady and under control to reduce any danger of smearing your print if it slides out of registration.

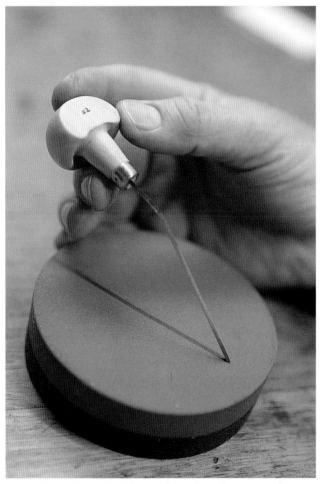

Tools to hand-print a plate to paper. From left to right: metal spoon, Hunt Speedball baren, and Japanese teacher baren.

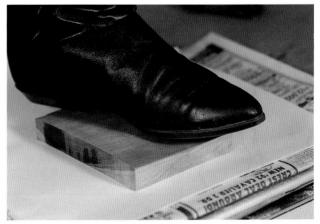

Evan Lindquist holds the flat leading edge of an engraving burin at the correct angle for sharpening. © 1993 Evan Lindquist/VAGA.

Foot stomping is another way to print some work. Here I have placed a layer of newspapers on the floor to serve as a cushion, followed by a clean sheet of paper and the print paper. Then I positioned the inked block face down. I make the print by bearing down on the block with full body weight while holding onto something sturdy for balance.

PRESSES

There are two types of presses most used by hand printmakers. *Etching presses* have a bed on which the work rides and is pressed between metal rollers. *Lithography presses,* on the other hand, have a bed that is driven under a stationary blade that forces the ink to transfer to the paper. A good press of either kind provides uniform, consistent pressure to transfer plate work to paper.

Presses are available in a wide variety of sizes and mechanical designs and are likely to be the most expensive equipment in a studio. Because they are such a significant investment, it is wise to become familiar with the differences in characteristics before trying to purchase one. Be sure to investigate the moving mechanism thoroughly. Some require a great deal of physical strength to operate, while others have complicated mechanical parts to keep in operation.

The frame of press should be strong enough so that it will not twist or flex on the floor. It is also important to have the press level with the floor. Presses usually carry special leveling instructions with them. Most often this is accomplished with shims placed under the legs.

Fortunately, alternate options are available when it is not possible to have a press in the studio. Printmaking classes and workshops provide instruction and equipment, and they allow you to experiment with a number of different presses under professional guidance to learn your own personal preferences. It is important to begin work on a press with an experienced instructor to direct the correct operation of the press mechanism. Local college facilities are probably the most available resource for such classes.

Many art-orientated cities also have custom print shops that offer classes and workshops.

Occasionally presses that will print wooden relief blocks are available for sale. Artists have even made small intaglio, relief, and paper-plate lithographic prints by rolling them through the rollers of old wringer washing machines. To do this, the artist first places the work between blotters for protection.

ETCHING PRESSES

The press size refers to the size of the press bed—the surface on which the plate and paper are placed and will ride during transfer. Press beds come in many sizes, and it takes a great deal of study to decide which is best for your needs. A press bed may be as small as that on Dick Blick's Econo Etch: a 10 1/2 × 19 3/4" (27 × 50 cm) bed that will make up to a 9 × 18" (23 × 46 cm) print.

A Takach-Garfield press with a 24 × 48" (61 × 122 cm) bed will safely accommodate a 22 × 30 (56 × 76 cm) sheet. Dick Blick's Master Etch bed for the same size paper is 23 × 36" (58 × 91 cm). The dimensions of the bed should be generous enough to accommodate the largest plate to be used, and ideally there should be a margin of 1 to 2" (2.5 to 5 cm) at each side and extra length to stay engaged under the roller at all times. (Larger beds require more leeway and larger margins.) If much smaller plates are used, the roller will have greater longevity and balance if strips of wood or metal the same thickness as the plates are placed at equal distance from each side of the plate, which is placed in the center of bed.

The bed should be made of warp-free, rustproof material. Phenolic resin laminated in many layers onto fabric is one material

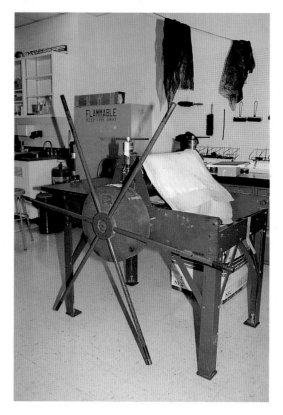

The Sturges etching press at Southern Missouri State College has a star wheel, a device for adjusting the pressure on each side of the press. The blankets are laid on top of the rollers when the press is not in use. Note the bright yellow metal cabinet in the background that is safe storage for solvents and acids.

Martin Green adjusts the pressure on both sides of his etching press so that the work will move evenly through the rollers. He is able to check his adjustments with the indicators marked on the screw-type mechanisms.

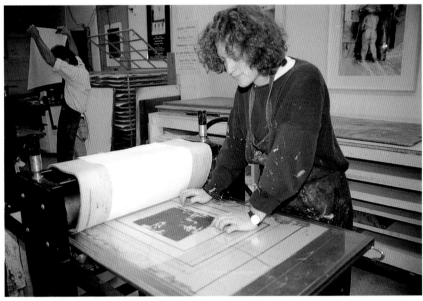

Marina Ancoma has the paper engaged under the edge of the roller and blankets of a Brand press. She is aligning the plate with the registration diagram made on graph paper, under the Plexiglas covering the press bed. (Courtesy of Graphics Workshop, Santa Fe.)

crank handle or a star wheel. Motor-driven presses are also available.

Three felt-type blankets are usually used, one of top of another, to cover the bed during transfer. Most printmakers prefer to protect the press bed first with a sheet of Plexiglas. The printmaker then puts the work on the Plexiglas and covers it with the blankets. The first blanket that is laid down on top of the plate and paper is the sizing catcher, which is made of absorbent material that catches the extra moisture and sizing from the paper. Next comes the forming blanket, made of thicker material, which functions as a forming pad to cushion the paper over the plate. The top blanket is the pusher blanket, which takes the abuse of the roller and protects the two blankets underneath.

REGISTRATION OF PLATES ON PRESS

When making press transfers, you must keep the plate and paper in the proper registration to have a successful transfer. *Registration* means the alignment of the printing plate and the paper. The plate and paper should always have some form of registration to keep the margins even, but registration is especially important for multiple-color or multiple-plate work. Many printmakers guide the placement of their plates and paper by a number of marks or strips of tape on the press bed, on the Plexiglas or paper covering it, or on the roller of an etching press. Some workshops have graph paper with ruled lines to act as guidelines placed under the Plexiglas covering the bed. You can also cut a template of metal or mat board to hold the plate securely. If you are using an etching press and the print is to have a white border, you can keep the paper engaged under the roller to keep the paper in the same position for subsequent transfers.

that meets these requirements. The bed should have a comfortably positioned work area, somewhere between the hips and the waistline of the operator. You can control the height of the bed by the leg size of the metal support under the press.

Etching presses are gear-driven. The gear ratio determines how many times the handle must be turned to operate the roller one complete

revolution. For instance, a press with an operating gear of two to one would require two turns of the handle to turn the roller one time. The lower the gear ratio, the harder the handle is to turn (assuming the same diameter of roller).

The roller pressure is controlled by adjustable screw-type mechanisms. The bed and roller are turned by hand with either a

LITHOGRAPHY PRESSES

Planographic techniques such as lithographic and monotype printmaking are best done on a lithography press. This type of press was used for commercial printing until the 1930s, when it was replaced with the offset press. Offset presses print first to a rubber blanket and from the blanket to the paper. The original lithography presses best suit the needs of fine artists.

Instead of a roller on top of the bed, as in the etching press, the lithography press uses a blade-shaped scraper bar. Hard fine wood, such as maple, was traditionally used to make this bar. A strip of leather was stretched on the thin sharp edge to act as the pressing edge. Today this bar is often made of a high-density plastic, usually polyethylene, with a replaceable polyethylene strap. This scraper impresses the ink onto the paper as the bed travels under it. A thin flexible plastic sheet, known as the tympan, is laid between the paper and the scraper bar to protect the paper.

If a stone is the printmaking surface, you can make a system of lines in the margin of the stone to align with lines on the back of the print paper. This is often done on metal lithography plates as well. Some shops use a system of holes punched in the edges of the margin that fit on pins purchased in stores that sell screen-printing supplies. Simple marks on the bed, such as described for etching presses, work here also.

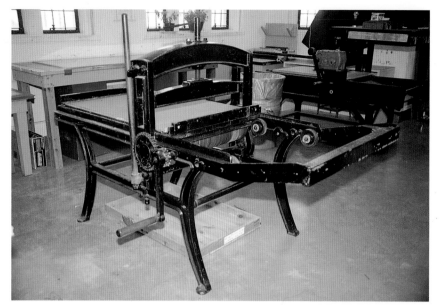

The Alexander Hogue lithography press at University of Tulsa Print Studio. The mechanism above the bed holds the proper size scraper bar that is chosen to accommodate the various sizes of lithography stones. This studio uses pressboard tympan sheets that are stored away from the press when not in use.

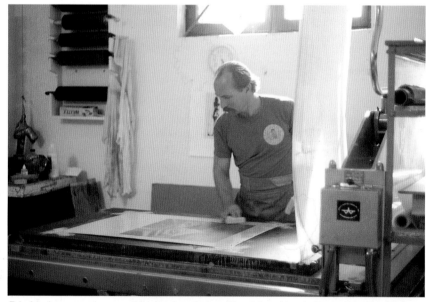

Eric Lindgren works on a lithography plate at Hand Graphics in Santa Fe. The large plastic tympan sheet, right, is used to cover the work when it is run under the blade of the lithography press; the tympan is automatically pulled upright when not in use.

OTHER STUDIO EQUIPMENT

Along with presses, papers, inks, and cutting tools, sturdy work tables or counters are the first order of equipment in any printmaking studio. It is desirable to have a separate place for preparing and inking the printmaking surface away from the area where the inking is done. Sturdy tables are needed for tabletop presses. Proper storage space to take care of tools and equipment is also needed. Some chemicals used in printmaking are toxic or fire hazards, and it is particularly important to store them properly. See pages 150–151 for more information about health and safety in the printmaking studio.

Clean-up is a constant task in printmaking, and this means that a sink is almost a necessity. When you are using solvents and most acids, you also need a hooded vent system for a safe environment. Cabinets should be sturdy to hold bottles safely upright.

You will also need drying areas for still-moist prints. Metal stack dryers are handy for many types of printing. A flat surface that will hold blotters and weights is another solution. Screen prints and relief prints done on dry paper may be hung with clothespins strung on a wire.

If you want to print editions of artwork, you will need space for storing dry paper and prints. Flat files are ideal for this but are a costly investment. After several of my works were torn or wrinkled from inadequate storage facilities, I made the investment. Flat shelves can be constructed to hold papers as a less costly substitute.

Lynwood Kreneck has a deep sink in his studio that is helpful for washing screens. (Courtesy of the artist.)

Here AnaMaria Samaniego stacks wet prints on metal drying racks at Graphics Workshop, Santa Fe.

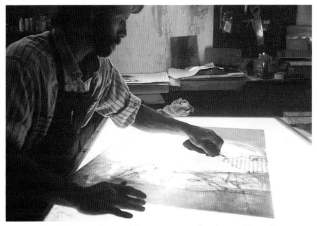

A light box is a studio tool for many applications. Here Ron Pokrasso is able to see though an inked plastic plate to work with guidelines underneath. (Courtesy of Graphics Workshop, Santa Fe.)

Joseph Raffael, *Crystal Lily.* Woodcut print, 24 3/4 × 32" (63 × 81 cm), 1987. Printed by the artist, with assistance from Will Foo and John Stemmer at Experimental Workshop in San Francisco. © Joseph Raffael. Courtesy of Nancy Hoffman Gallery, New York.

2 RELIEF PRINTMAKING

People have been making prints from incised wooden blocks for centuries. Fragments of printed linen survive from an Egyptian burial ground dating from the fifth century A.D. The earliest dated woodcut print on paper, The Diamond Sutra (A.D. 868), is from China, where paper was first invented. The makers of these early woodblocks cut away all the areas not to be printed, then inked the block and hand-printed it onto paper or fabric. This is still the principle behind relief printmaking today.

Modern relief printmaking techniques include stamps, linocuts, woodcuts, and cast blocks. Images may be dark shapes or lines in a light field or light lines or shapes in a dark field. While woodcutting is still a much-favored medium, new tools and materials, such as linoleum and certain plastics, have introduced intriguing new possibilities to relief printmaking. Cutting and printing techniques are straightforward, requiring a minimum of tools and materials. For these reasons, relief-carved blocks are an appropriate introduction to printmaking.

DRAWING AND TRANSFERRING AN IMAGE

Relief image designs may be dark shapes or lines in a light field, or light lines or shapes in a dark field. The German expressionist Karl Schmitt-Rottluff cut his woodblocks to leave strong dark shapes in relief. Editha Spencer, a Connecticut artist and printer, meticulously cuts her linoleum blocks to leave finely defined lines in relief. Thomas Bewick, an English artist of the early nineteenth century, is credited with the development of the wood engraving, where finely spaced lines are cut to build light line imagery in a dark field.

Remember that the print will be a reverse image to your block, so plan your design accordingly. If you find it confusing to work in reverse, you need a system to reverse the image from the drawing stage to the block face. You can draw with a 5B or softer lead pencil and then rub your drawing, face down, on the block to transfer guidelines. Another method is to place a drawing over a light box or sunny window so that the back of the paper is facing you, lay a second sheet on top, and trace the drawing in this reverse state. You can then use carbon paper or some similar substance to trace this reversed drawing onto the block surface.

Once you have drawn the outline of your image, it is often helpful to color in the parts of the design that are to be printed—felt-tip pens work well for this purpose—so that you will know to cut away everything else. The areas not cut out of the surface will receive a flat roll of ink that will print.

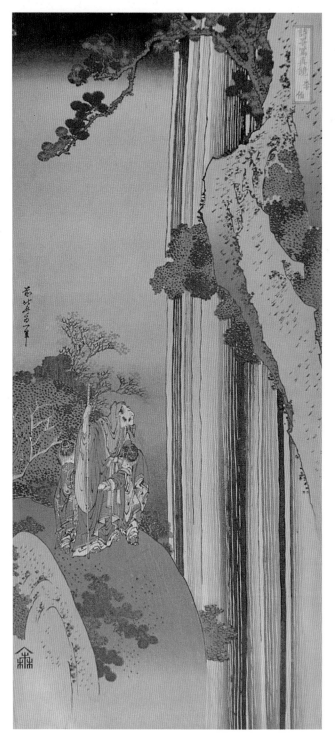

Hokusai (1760–1849), *The Poet Li Po.* Japanese woodcut print, 20 × 8 3/4" (51 × 22 cm). Private collection.

The poet is held up by two pages as he admires the waterfall. Li Po was said to have been always drunk with either wine or with surrounding beauty. Japanese woodcut prints have influenced contemporary Western art because they were greatly admired and studied by European artists in the late nineteenth century.

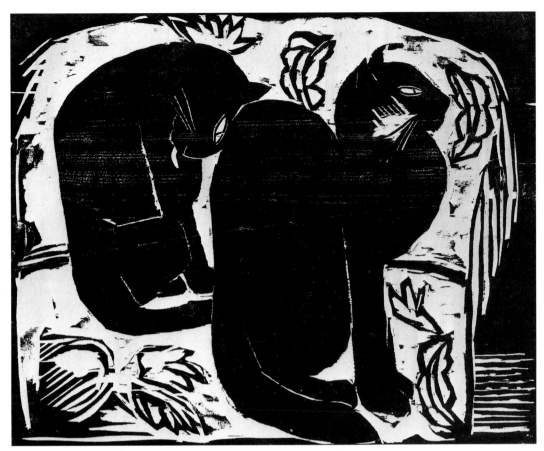

The work of this German expressionist is known for its strong images. Schmitt-Rottluff usually printed dark shapes with some cut-line detail on a light paper.

Editha Spencer, *William Benton Museum of Art.* Linocut, 9 × 6" (23 × 15 cm), 1981.

This is a more detailed print with some lines left in relief after careful cutting.

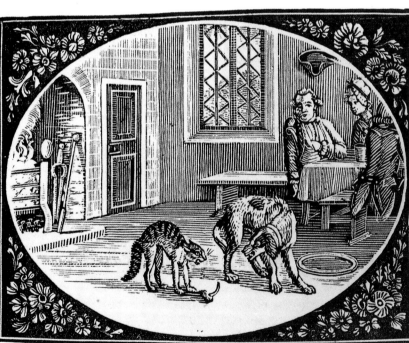

Thomas Bewick, "Dog and Cat" from *Bewick's Select Fables,* 1818. Wood engraving, 1 7/8 × 2 3/8" (5 × 6 cm). All rights reserved, The Metropolitan Museum of Art, Museum Accession, 1921. (21.36.120)

This English wood engraving is by an early and prominent developer of this technique, where engraved lines are made in the end grain of maple or boxwood blocks.

CUTTING TOOLS AND PRINTING INKS

Relief blocks can be cut with quite a variety of hand and power tools, and printed with either water-based or oil-based inks. Light inks transfer best to dark surfaces and vice versa.

HAND TOOLS

Good hard steel cutting tools may be used interchangeably to cut wood, linoleum, and plastic. In one popular style, the steel is mounted in a half-round wooden handle that fits well in the palm of your hand. Japanese cutting tools have straight handles. The V-shaped groove should have a raked front edge; the top points of the cut lead the bottom point, to help cut through the grain of the wood.

There is also the Speedball linoleum cutting set of gouges and knives with a handle and removable blades. These work in the softest woods as well as linoleum. I have a friend who prefers to replace rather than sharpen these blades when they become dull.

A small gouge serves best as a single tool for cutting away material. Gouges will remove material with one cut. Knives have a flat blade and therefore require two cuts; make the second cut at an angle so that it will meet the bottom of the first cut. A strip cut this way is similar in shape to a strip cut with a V gouge. Some artists use single knife cuts to outline the relief shapes, and then cut away the recessed area with gouges, usually by working from the cut line outward.

Safe cutting technique is the only rule that must be followed from the very beginning. *Be sure to direct the cutting edge of the tool away from your other hand to protect it from accidental*

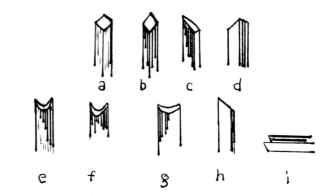

Here are the cutting edges of burins (top) used for engraving and gouges (bottom) used for cutting: (a) square graver, (b) lozenge graver, (c) knife graver, (d) lining graver for multiple line cuts, (e) V gouge, (f) U gouge, (g) C gouge, (h) knife. Gouges should have a raked cutting edge (i).

The primary rule that must be followed when cutting relief blocks is to have the hand holding the material in back of the cutting edge of the tool. If the block is held by other means, you can press the fingers of your extra hand on the shaft of the tool to increase control of the cutting.

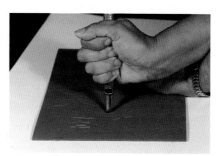

To cut a linoleum block with a knife, first draw the knife at a 45 degree angle away from the line.

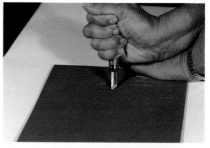

Then turn the block around and draw the knife to cut into the bottom edge of the first line, removing a V-shaped cut.

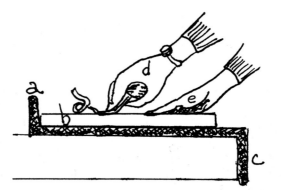

Cutting with a bench hook. (a) You can see the basic, almost Z-shaped bench hook design. The block (b) is pressed against the top hook, while the reverse hook catches the edge of the table (c). The hand doing the cutting (d) is always in front of the hand controlling the block position (e).

slippage. The time I forgot this, I got a V-shaped cut to remind me of correct procedure.

The hand that isn't holding the tool can be used to hold or move the block as you cut. If the block is firmly secured, use your other hand to direct or steady the tool by placing your fingers on the tool shaft behind the cutting edge.

There are several ways to hold small blocks in place. A bench hook has a raised edge to hold the block and a depressed edge to catch and hold against the bench or table. You can clamp the block in place, or prop in against some heavy object to keep it from slipping. There are wood bench tops made for woodcarvers that have wooden peg stops that hold the work in place.

There are several reasons for a tool tending to slip rather than cut.

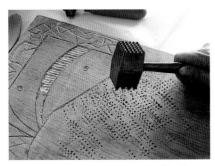

Barbara Young textures a woodblock surface with a meat-tenderizing cleaver, a modern variation of the criblé technique. (Photo: Richard Pucci.)

Perhaps you are holding the tool at too high or low an angle in relation to the cutting surface. You may also be attempting too long a cut for the pressure exerted. Finally, your tool may be dull and need sharpening. The chapter on printing materials discusses tool-sharpening practices. Refer back to page 28 for information on sharpening tools.

POWER TOOLS

Electric drills and small, hand-held grinding tools can be used to cut hard materials (such as wood, metal, and plastic) quickly. Engraving bits, burrs, and even wire disks have been used. *When using such tools, it is very important to wear safety goggles to protect your eyes.* I have experimented with power-tool cutting with a cordless, rechargeable tool (made by Dremel) and two small engraving cutters. I control cutting techniques by rotating speeds of the tool and how fast I move my hand. How much I enlarge my power tool collection will depend on my pocketbook.

TEXTURING WOOD AND LINOLEUM RELIEF BLOCKS

One of the early forms of relief printmaking was called criblé, where a sharp pointed tool was stamped in the surface repeatedly to produce an image with tiny white dots. A number of metal objects, which are harder than the block material, can be impressed into the surface for texture. You can also use tools for leather stamping in this way by tapping the metal object into the block surface with a hammer mallet.

INKS FOR RELIEF PRINTS

Linoleum blocks and woodblocks can be printed with either oil-based or water-based inks. If you're printing a woodblock with water-based ink, rub the block first with linseed oil to keep the water from swelling the wood and closing up the lines. (Cherry wood swells less than other kinds.) Daniel Smith and Graphic Chemical & Ink Co. are two manufacturers of good oil-based inks; some good water-based inks are made by Createx, Speedball, and Graphic Chemical & Ink Co.

Oil-based inks are stiffer when first dispensed from the can or tube than they will be later. Work them with an ink knife until they can be rolled out smoothly with a brayer. You can also thin oil-based inks with burnt plate oil to make them roll out evenly and thinly. Mary Dryburgh uses Sureset from Graphic Chemical & Ink Co. as an additive to open the paper fibers; it makes the ink bond better with the paper.

Barbara Young, **Silent Strength.** Woodblock diptych, each panel 20 × 21" (51 × 53 cm). Photo: Richard Pucci.

Here you can see the texture produced by the tenderizing cleaver in the rocks.

MAKING STAMPS

Try making a few small relief blocks to stamp designs onto paper or fabric. By using raw vegetables, plastic erasers, or bits of wood or linoleum, you can develop simple imagery quickly.

The image you create on your relief block will appear in reverse when printed. If you find this confusing, first make your drawing on paper using soft pencil. Place the drawing face down on whatever you are using as a stamp or block, and rub the back of the paper to transfer the image to the block, where it will appear in reverse. This way, after you incise the image into the block and print it, the print will then read in the same direction as your original drawing—having been reversed twice instead of once.

VEGETABLE STAMPS

If you slice raw potatoes, carrots, or turnips, you will expose flat cutting surfaces. Raw baking potatoes cut lengthwise produce the largest work surface. I enjoy letting the potato shape suggest the outline of the image.

Water-based block-printing inks work especially well on this surface. You can either roll or paint on the color. Then lay the paper on top and press it with your fingers to transfer the design, or stamp the block face down onto the paper.

Of course, vegetable material is relatively fragile and has a short printing life. However, I have kept cut potatoes in printable condition for a number of days by storing them in plastic bags at a cool room temperature or in the refrigerator. Before putting the potato stamps away, I wash them and then blot the surface dry with paper towels. Depending on the complexity of your design, you may be able to get several dozen prints out of one potato block.

PLASTIC ERASER STAMPS

Certain types of plastic erasers, such as the Factis eraser and Staedtler's eraser for paper and film, make a more permanent stamp material. Because these artworks are more expensive and will be around for some time, I do like to plan out the surface design. Small gouges are the most versatile tools for cutting away this material.

Eraser stamps can be inked with either oil-based or water-based inks and hand-rubbed using the methods described later for larger blocks. Ink pads from the stationery store can also be utilized for inking. Try using eraser stamps in repeated patterns or combining them with other kinds of artwork. For example, I have made them to use for bookplates, to put color or design into other artwork, and to hand-print collage papers.

A stamp made from a raw baking potato, cut in half lengthwise. The white lines were cut away with a small gouge.

Here you see another potato stamp and the print made from it. Let the oval shape suggest design possibilities.

Here is the print made from it.

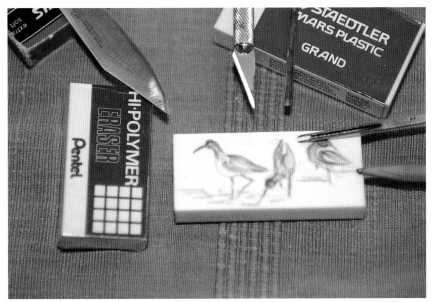

This small plastic eraser stamp of shorebirds was made with small cutting tools and knives. First I drew the design on the surface in pencil to help guide the cutting.

Here is the finished stamp and a couple of prints made from it.

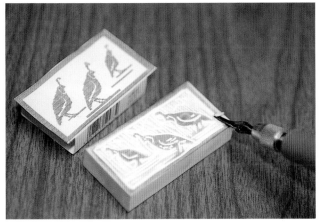

I transferred this dot-matrix computer printout drawing of quail to the eraser surface by brushing the back of the paper with alcohol and rubbing the image onto the eraser. I then cut away the light areas.

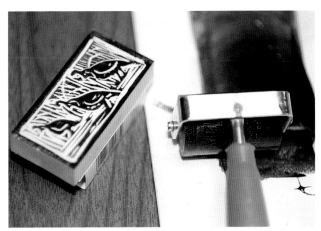

I then inked the stamp with a small brayer.

Finally I printed the eraser stamp by pressing the paper onto the relief surface with my fingers.

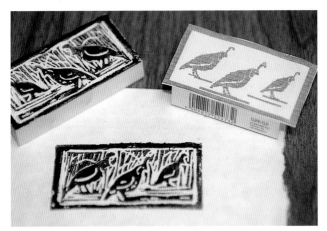

Here you see the cut stamp (upper left), the original computer drawing (upper right), and the completed print on the table.

LINOCUT

Linoleum, invented in 1863, was originally made from linseed oil mixed with ground cork on a burlap backing. Many of us remember cutting linoleum blocks as children. It would be a mistake to think the technique is reserved for students. A number of modern masters, including Matisse and Picasso, have produced notable linocuts. The soft, smooth surface of linoleum is easily cut with sharp tools similar to those used for wood, affording a great deal of freedom and flexibility in imaging.

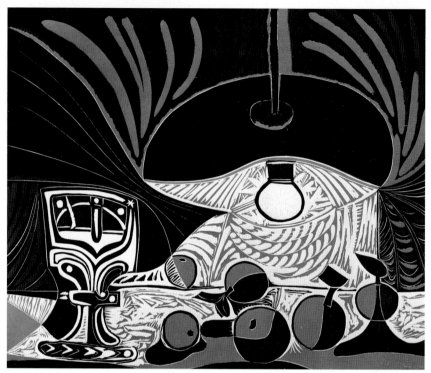

Pablo Picasso, *Still Life Under the Lamp.* Linocut printed in color, 20 7/8 × 25 3/16" (53 × 64 cm), 1962. Courtesy of the Museum of Modern Art, New York. Gift of Mrs. Donald B. Strauss.

Picasso made many linocuts using the reductive technique, in which more of the block is cut away each time a new color is to be added. This technique is explained more fully on page 56.

Nancy Friese, *Valley.* Linocut, 9 × 12" (23 × 30 cm), 1992. Collection of the artist.

Friese inks her linoleum blocks in the recesses with colored intaglio inks. She removes any surface color by pressing the block against newsprint and then rolls another color across the surface. The print is made with one pass through an etching press.

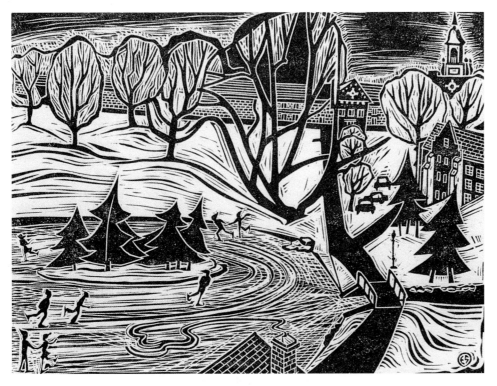

Editha Spencer, *Skating on Mirror Lake.* Linocut, 4 1/2 × 6" (11 × 15 cm).

Spencer worked on a mounted linoleum block from Hunt Speedball, doing much of the cutting with a fine #1 cutter and switching to a #5 when cutting larger areas. She rolled water-based ink on the surface and printed the block by first firmly pressing it face down on the paper, which was on top of a 1-inch cushion of newspaper. Finally, she turned over the paper and block and completed the transfer by rubbing them together with the bowl of a tablespoon.

David C. Jansheski, *Looking Towards Africa,* Linocut on chine collé and paper handmade for the series, 30 × 39" (76 × 99 cm).

This artist uses special papers as well as free-spirited cutting technique and patterns to achieve interesting prints.

Linoleum ¹/₈" to ¹/₄" (.32 to .64 cm) thick backed with burlap is available in various widths and sold by the linear foot. It can also be purchased cut into popular sizes, such as 9 × 12" (23 × 30 cm). This type of linoleum can be used for hand-rubbed prints or those done with an etching press. However, linoleum ¹/₈" to ¹/₄" thick mounted on blocks of wood is necessary for letterpress printing or stamping, because it must be firm enough to stay flat during these printing procedures.

Linoleum can be heated to soften it for easier cutting. One way to do this is to put a moist towel on the surface and run a slightly warm iron on top. The heat will soften the linoleum and the cutting tools will meet less resistance. Heating pads have also been used for this purpose. Even a warm sunny window will often provide the necessary warmth to soften the material.

Both water-based and oil-based inks can be used to print linoleum. When water-based inks are used, the burlap backing or block of wood will tend to warp. To keep this from happening, coat the burlap or sides and back of the wood block with acrylic varnish or polyurethane.

Linoleum is no longer used for flooring. I was curious about how new flooring materials would work for relief printing, so I experimented with some leftover printed vinyl from our kitchen flooring. Ignoring the printed pattern, I cut grooves into the thin vinyl surface. When the cuts reached or cut through into the paper backing, it was not a concern, because I could later seal them with acrylic varnish when the work was mounted on mat board. The material was also easily cut to shape with scissors. I used white glue to mount the vinyl on mat board. Then I coated all surfaces, front and back, with several layers of acrylic sealer to close all absorbent areas and gaps. (The sealer is thin enough not to fill in the gouges of the design, yet it seals any scratches and absorbent areas.) I then rolled the surface with water-based ink and printed it onto paper.

I gouged a design into a thin vinyl floor tile, mounted it on mat board, and sealed them with thin acrylic sealer.

Here is the resulting print.

CAST PLASTER BLOCK

Another material used in relief printmaking is plaster, generally in the form of cast blocks, which you can make yourself. Janet N. Siamis starts by making a frame; to do this, cut sturdy strips of wood, Styrofoam, or stiff plastic to size and hinge them together at the corners with tape. The strips should be at least 3/4" (2 cm) wide to accommodate the needed depth of the block. Then securely tape the frame on the outside to a sheet of smooth glass or plastic, so that it resembles a neat box with only the top missing.

Follow the manufacturer's directions to mix the plaster. Always remember to shake the plaster into the water to avoid lumps. Siamis finds that it takes 2 2/3 cups plaster in 1 1/3 cups water to fill a 6" × 9" × 3/4"

(15 × 23 × 2 cm) frame. Pour in half of the plaster mixture first and smooth it out with a disposable spoon or knife. Then place a piece of window screen on the surface of that much of the plaster, and pour the rest of the plaster on top to form a "screen sandwich." The screen adds strength to the block.

Let the plaster set up. The time required for this will vary widely according to the amount of water used, the temperature, and the humidity. When the plaster seems dry, test it by removing the tape that attaches the frame to the glass and sliding the entire block slowly across the glass. If the block moves freely, remove the frame carefully. The smooth glass side of the block becomes the surface for your work.

You can most easily remove large areas while the plaster is still soft; fine lines are cleaner when the plaster is dry.

Siamis uses different X-Acto knife blades for cutting out plaster, and inscribes lines with the sharp end of a compass. She uses Speedball water-soluble ink on copy machine paper to proof her prints. When she is satisfied, she prints on Masa paper.

Cast blocks can be printed with oil-based or water-based inks. Lay your paper over the block and roll across it with a brayer. Make as many prints as possible at a time, because every time you clean the plaster, you lose some of the design. You should be able to get several dozen prints from a cast block, depending on the intricacy of your design.

To prepare her plaster block, Siamis first filled half her mold with wet plaster. Here she adds a piece of screen for strength. The remaining plaster will then be poured on top.

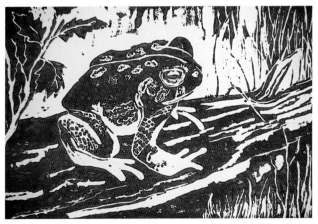

The smooth bottom of the plaster block becomes the smooth surface on which Siamis will cut her design.

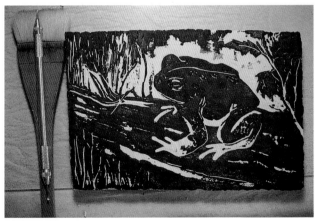

The surface was first inked in black so that the cut areas are easily seen. Siamis used simple, readily available cutting tools.

Janet N. Siamis, *The Toad.* Cast block print, final state, 6 × 9" (15 × 23 cm).

The extra-smooth surface of the plaster block is conducive to simple, clean designs.

WOODBLOCK

Once you begin cutting into wood, you might discover a real affinity for the material. Experiment with precut and leftover scraps of lumber to develop a working knowledge of different woods and cutting. Some woods are softer, while other materials are more dense. You will soon discover that some woods have strong grain patterns that are difficult to cut across, and other types splinter easily.

You can buy ready-made woodblocks intended for woodcutting. Some artists first stain the entire surface of the wood with a fast-drying wash, such as diluted acrylic paint, and then draw or transfer guidelines on top. As you make cuts, the exposed lighter wood helps you see how the work is progressing. Because it takes more strength to cut into wood than linoleum, make the cuts more deliberate, and print more proofs to make certain that the design is progressing as you intend it.

Some woodcutters like to emphasize the texture of the wood grain. In a plank cut of wood, the grain lines are harder than the softer material between them. A wire brush (either the type used in machine and wood shops or a small brush used for cleaning suede) can be run parallel with the grain to remove some of the softer material and leave the harder grain lines standing out slightly in relief.

By contrast, other woodcutters prefer to eliminate the suggestion of wood grain in their prints. To do this, they paint the block with a thin coat of acrylic gesso. Barbara Young uses gesso to establish different textures in some passages of the printing surface.

If you purchase wood in a less refined form, you will need to sand the printing surface. When I bought boards of wild cherry, I took them to the well-equipped wood shop of a friend, who machine-planed them so that they had a smooth, flat surface. This extra effort made them easier to cut and print evenly.

TYPES OF WOOD

The most available wood boards are plank cuts, which are cut along the length of the tree. Plank cuts are available in many sizes from your local lumberyard; Graphic Chemical & Ink Co. is a good source for more refined plank cuts that have been leveled and sanded. There is more grain pattern in plank wood than in the end cuts, which run crosswise to the tree trunk. *Woodcuts* are made in plank-grained woods using scoop-shaped tools, or gouges. *Wood engravings* are made in end cuts using solid tools called burins, which work best where they encounter less grain resistance than they would in a plank cut. Either a woodcut or a wood engraving is sometimes called a woodblock.

I have seen good work done in less favored woods, but there are types considered more desirable for working. The softest woods are the easiest to cut but will be the first to break down in printing. Oak is hard but has a difficult grain to cut. Mahogany cuts well but has a monotonous texture. The best woods are as follows:

Basswood is softest but will not stand up to many prints.

Poplar is medium soft.

Cherry is hard, cuts nicely, and is the best for water-based inks.

Pear and apple are most desirable but harder to find. Look for them at specialty lumberyards.

Birch plywood has the most even grain pattern.

Douglas fir pine is more common but has a wild grain pattern that can compete with your design.

Maple and walnut are the hardest to cut but are best for fine detail.

End-grain maple is a good substitute for the rare boxwood end cuts most desired for engraving.

Cuts of wood. Left: A plank cut for woodcutting. Right: an end cut for wood engraving. Purchased end cuts are usually separate pieces of walnut wood, carefully fitted and glued together. (One large piece would be far more expensive.)

Even inexpensive wooden spoons may become printing surfaces as you explore variations in woodcutting materials.

Sylvia Solochek Walters, *La Grande Cascade.* Woodcut print, 20 1/2 × 26 1/2" (52 × 67 cm).

This San Francisco artist uses one block of clear ponderosa pine for her complex prints, which employ multiple stencils as well as reductive cutting technique to print. See page 56 for more about reductive techniques.

Joseph Raffael, *Matthew's Lily.* Woodcut print, 32 × 37" (81 × 94 cm), 1984. © Joseph Raffael. Courtesy of Nancy Hoffman Gallery, New York.

Raffael chose woods of different textures for the multiple blocks used to make this image. In addition, he used inlays of exotic tropical wood for the lily and pads. Primary cutting was by Will Foo and John Stemmer at Experimental Workshop in San Francisco. Raffael made some final cutting and color adjustments before the work was printed.

WOOD ENGRAVING

Wood engraving is appropriate for finely detailed line imagery. The tool most commonly used for wood engraving is a four-sided burin with a solid, diamond-shaped leading edge. Fine strips of wood curl out from in front of the burin. It's important to note that burins (also called gravers) cannot push through the grain of the wood, whereas gouges can. This is why wood engraving is done on end cuts, where the grain does not interfere.

The ink for relief engravings should be thinner than the inks used for woodcut prints. Test it by printing it. If it's too thick it won't roll out easily on the surface; if it's too thin it will seep down into the engraved recesses. A hard rubber brayer is needed to roll ink on the surface and keep the ink from filling the intricate lines.

Dewayne Pass used an engraving burin and a cutting tool with multiple lines to develop this engraved woodblock.

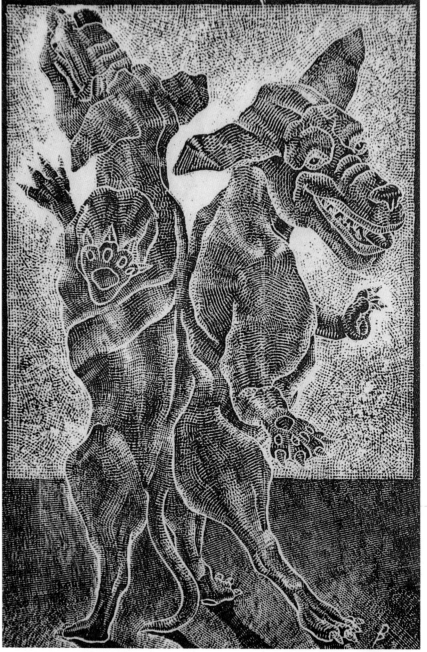

Dewayne Pass, *Give and Take.* Wood engraving, 9 × 6" (23 × 15 cm), 1991.

This is a fine example of a wood engraving. The closely spaced lines were done with a multiple-line cutting tool.

PROOFING AND DEVELOPING THE RELIEF BLOCK

All types of relief blocks can be printed several times as they are worked, to check their progress. These prints are called trial proofs. To keep accurate records, you can label your trial proofs state 1, state 2, and so on, thereby documenting the development of your work.

A second method to check the progress of the work does not require inking the block. Lay thin but strong paper, such as Speedball Printmaster paper, on top of the block. (Newsprint rips too easily for this.) Then rub a relatively hard pencil or stick of graphite across the surface to bring up the image. There are two advantages to having this type of proof. First, the block need not be cleaned. Second, the image will read in the same direction as it is on the block, so that this type of print is easier to follow when developing the block further by cutting out more material.

CORRECTING CUT AREAS

The best way to work in relief techniques is slowly and deliberately, to minimize mistakes. However, you may still cut away an area you meant to keep. With a little ingenuity, you can often incorporate wrong cuts into your design.

The most tedious method for correcting a mistake in linoleum or wood is to cut a plug of the same material. If you are working with wood, cut the area to be corrected from the woodblock, all the way through from front to back, and replace it with a plug of equal size that is glued into place. If you are working with linoleum, cut the linoleum through to the burlap backing. These plugs usually have straight edges and right-angle corners. If the plug is just slightly too small to fill the hole perfectly, you can fill the gaps with plastic wood. Cut and sand the top surface to make sure it is level with the surrounding relief before the recuts are made.

The simpler correcting method is to fill an unwanted cut with plastic wood, which is available in hardware stores. It works equally well for wood and linoleum cuts. If the cut is deep and wide, apply the plastic wood several times in thin layers. A thin painting knife makes an excellent tool for applying it. After the plastic wood has dried, sand it level to the surface and recut your lines.

If you make a small scratch or shallow bruiselike cut in wood, you can sometimes remove it by swelling that area of the wood with water. Heat from a hair drier sometimes helps swell moist wood.

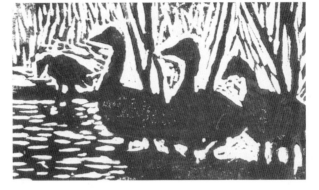

I first cut a small maple end-grain block with gouges and printed this first state.

After developing the block further, I rubbed a graphite stick over a thin sheet of paper on top of the block. This helped me see where more engraving was needed.

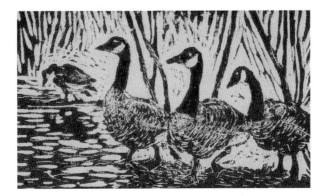

Julia Ayres, *Geese.* Woodcut print and engraving, 3 × 5" (8 × 13 cm).

The finished print. Once the background was cut, I used engraving tools to make fine line details.

PRINTING RELIEF PLATES

Relief blocks can be inked and printed onto paper by hand rubbing or on a press. You can make a relief print from one color of ink using one block, or a multiple-color image from several blocks.

The way you decide to print a relief block can affect the final print as much as the design of the image and the way it is cut.

HAND TRANSFER

Some printmakers prefer to hand-transfer a relief block so that they can bring about subtle changes in tone can by adjusting the pressure of the baren or spoon. To use this method, place the inked block face up and then lay the paper on the surface. Thin papers seem to be most effective for this. If the paper is very fragile, it can be protected by a thin piece of Mylar between the paper and burnisher.

Ink the relief block by rolling ink onto its surface with a relatively hard brayer. Most hand-transfer printing is done on dry paper. You can register the block by placing it face down on the paper. Carefully turn over the block and paper as the ink holds them in registration. Once the paper is on top, you can burnish it to transfer the image. Another method is to lay the inked block face up and set the paper directly on top of it, guided by registration marks on a template that holds the block in place. Such templates, the same height as the block, are used for both hand- and press-transfer methods.

You can also print thin papers by laying them on top of an uninked block and rolling a hard rubber

Joseph Raffael, *Luminous Journey.* Woodcut print, 42 × 62" (107 × 157 cm), 1985. © Joseph Raffael. Courtesy of Nancy Hoffman Gallery, New York.

This large woodcut was made with multiple wood blocks and printed by hand-rubbing at Experimental Workshop in San Francisco.

roller charged with ink across the paper surface. The ink will transfer in the relief areas, usually creating a print with softer edges than if you had used a more traditional method. This is a variation of the hand rubbings described earlier for proofing purposes, done by rubbing crayon or graphite across the paper. I have successfully used this technique for small prints. I have never had any problems with the paper adhering to the roller and lifting up off the relief block.

PRESS TRANSFER

Today relief blocks are most often printed on roller-type etching presses. Etching presses vary in how much block height can be run through the rollers. Mine will take a 1-inch (2.5 cm) block covered with a firm blanket. Trial printings determine the correct pressure.

When a woodblock is put on an etching press, the grain should run parallel to the roller. If you want crisp edges without embossing, use a firm blanket; if you prefer embossed edges, use a softer one.

If the block is severely warped, the underside can be packed with paper to make the block level for a more even pressure. If too much warping has occurred, it's better to make hand-rubbed transfers.

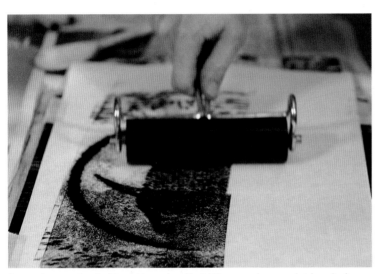

In another method of hand transfer, Kurt Nilson makes a print by placing the paper on top of his woodcut block and rolling across it with a brayer.

AnaMaria Samaniego uses an etching press to print a multicolor linocut by Bette Brodsky, one single-colored block at a time. The edges of the press bed are lined with wood the same thickness as the block, to ensure even pressure under the roller. (Courtesy of Graphics Workshop, Santa Fe.)

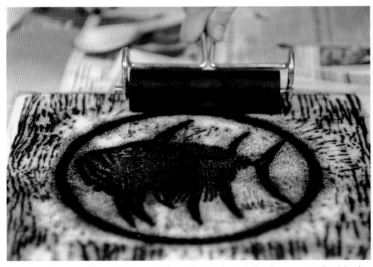

The resulting print duplicates (rather than mirrors) the image on the block below, and has softer edges than a print made by inking the block and then pressing the paper against it.

PRINTING IN COLOR

Many relief images are completed with a single color of ink contrasting to the paper color. However, a rainbow blend of colors or values may be used to ink the surface for another variation.

In the Japanese art of Ukiyo-e, the block is painted with different colors that all print simultaneously. Dry pigment mixed in rice paste produces the water-soluble inks used for Ukiyo-e. The craftsmen who use this method are meticulous and able to produce editions of nearly identical prints in this fashion. Western-style art painting brushes can be used to paint different colored inks on blocks. I found Colorcraft Monoprint colors worked well painted on a relief surface first coated with release medium from the Colorcraft company. The release medium makes more of the color transfer to the paper and tends to seal the block.

You can paint additional colors into the shallow recessed areas of the block. These colors will be picked up and print on soft moist paper with an etching press transfer. This latter technique is sometimes used for monoprinting, with colors changing from one print to the next.

There are other options for printing multiple colors. For example, you can cut the block like a jigsaw puzzle and ink the pieces separately before placing them together for the printing. Or you can ink the block and drop it a little off register to a previous printing in a different color. This method tends to give a dimensional effect to the print, since the colors shadow each other. You can also cut stencils and use them to cover portions of the block to protect them from unwanted color.

I experiment on a woodcut block by painting with water-based inks and a Western-style watercolor brush.

The resulting print offers possibilities.

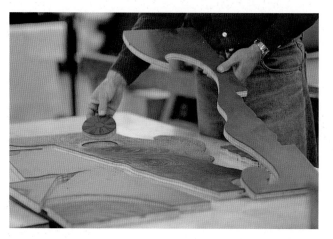

David C. Jansheski shows me the cut linoleum pieces, mounted on plywood, that he is about to ink in separate colors and then assemble to print simultaneously.

Hiroshige (1797–1858), *Rain Scene of Tsuchiyama.* Ukiyo-e woodcut print, 1833. Private collection.

In the traditional art of Ukiyo-e, or Japanese woodcut printing, the cut block is skillfully inked in multiple colors with brushes, and then all the colors are printed simultaneously.

Sylvia Solochek Walters, *Claudia R.* Woodcut print, 20 × 22 ½" (51 × 57 cm), 1984.

This multicolor print was made by hand-rubbing from a single block. Walters set the block in a wood template the same thickness as her block, similar to the one used for my *Queen of Hearts* (see page 57). She then attached a stencil between the inked block and paper. The paper was hand-burnished through the stencils, facilitating the multiple color nuances she achieved with her reductive cutting technique.

HAND COLORING

The first prints with more than one color were hand-painted after the print was made. This is still a valid method of adding colors. Thinned oils, watercolors, acrylics, and colored pencils have all been used for this.

Dry mediums such as colored pencils are applied to the front of the print. Liquid mediums such as watercolor may be applied directly on the front or painted on the back of the paper if the paper is thin. However, never use this technique with water-soluble inks! When the paper is larger than the print, I have found that drafting tape applied at the edges of the print area keep color from bleeding into margins.

Sometimes the tape must be applied on both the front and back surfaces.

Mary Dryburgh thins colored printing inks until they are similar to liquid oil stains. She then brushes them through the back of her prints made on thin Japanese paper. The heavy inks printed on the front prevent the stains from spreading beyond the desired passages.

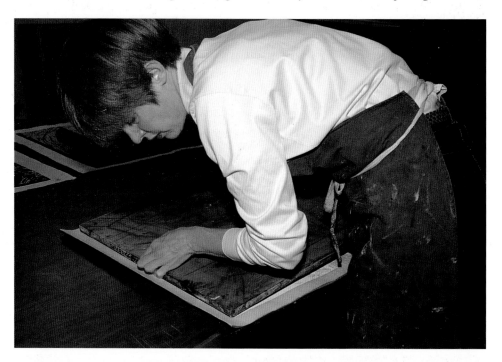

Mary Dryburgh first presses her black inked block face down, deliberately off register to the white-ink print made from the same woodcut. This "double drop" of the woodblock causes the white ink to become a reverse shadow to the black printing, adding a sparkle that is especially needed when the print is finished with the staining technique. (Photos on these two pages taken at University of Tulsa Print Studio.)

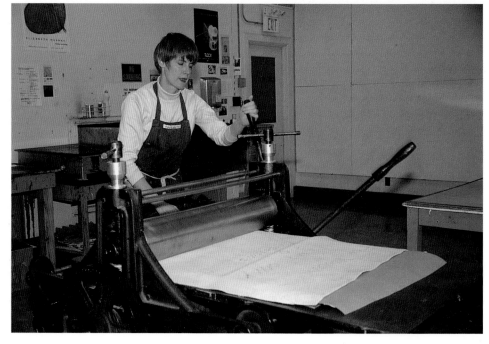

She turns the paper and block face up and then places them on the etching press. A clean sheet of kraft paper is laid on top, followed by a relatively stiff blanket.

After carefully lifting the edge, Dryburgh decides that the work printed well except at the leading edge.

Dryburgh burnishes the edge with a spoon to complete the print.

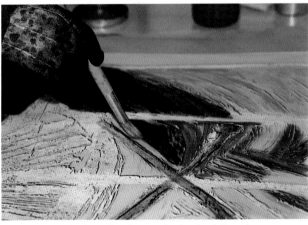

Now she thins colored printing inks until they are similar to liquid oil stains.

Dryburgh paints the oil stains on the back of the print.

Because the paper is absorbent the stains penetrate to the surface of the print. The heavier black-printed ink acts as a resist barrier to keep the stains in designated areas.

PRINTING MULTIPLE COLORS WITH THE REDUCTIVE TECHNIQUE

The reductive technique for printing multiple colors requires the entire edition to be printed at once because the surface is cut away for each hue. Suppose you are printing an edition of 12 prints on white paper. The first areas you cut away from the block will be white in the print. Next apply your first color of ink (say, yellow) and print that on all 12 sheets of paper, and then cut away from the block the areas that you want to remain yellow. Perhaps your next color is green, which appears on an even smaller surface area of the print; print the green areas and then cut those away.

You must plan ahead in working out your design so that you print first the colors that cover the greatest surface area of the block. (Once you cut something away, it cannot be reinstated.) If you want covering power, use opaque inks. Transparent inks permit colors to show through each other and create new colors—which can also create beautiful effects if that's what you're after. It's advisable to make a swatch testing and recording of the ink sequence you plan to use before committing yourself to the entire edition. You can use an uncut plastic eraser inked and stamped with overlapping colors to make such a swatch.

To begin a reductive linoleum block, I drew directly on a square of unmounted linoleum. The peony and rose flower arrangement would print in reverse, but that didn't concern me. I kept a wide assortment of cutters ready in case I needed them. The tools at the top have handles that fit into my palm as I cut; those on the right are Japanese-style tools. These first cuts will print the color of the paper.

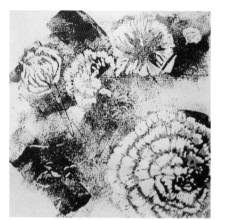

I printed one red, cut away more linoleum, and printed the second red. At that point my prints looked like this. If I had wanted a traditional edition I would have inked the entire surface with each color. For this work I was striving for a more painterly effect and a varied edition. This technique also allowed me more ways to avoid printing colors on top of each other without cutting the area off the block.

I tested my colors by rubber-stamping them onto the paper.

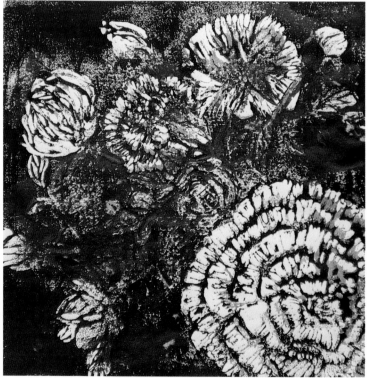

Julia Ayres, *Peonies,* varied edition. Linocut, 12 × 12" (30 × 30 cm).

After the dark green printing, in which I inked some parts of the block not previously touched, I cut away most of the remaining linoleum and then rolled black to cover the remaining surface to complete the prints.

MULTIPLE-PLATE PRINTING

If you are going to use more than one block to print different colors, make a key, or most detailed, block first. This key block shows all of the finished image, or at least guidelines from which it can be drawn. Ink this block and print it on smooth paper. Then offset-print it face down onto the next block. Repeat this method until all blocks have printed imagery to guide the needed cutting, being careful to line up the image the same way every time so that the finished blocks will register correctly.

Carve each block with its own color in mind, in sections or variations of the original design so that when the colors are printed on top of each other, they form a complete, multicolor design. Your imagination is your guide for how to make the various colors fit in together.

Here I have hinged paper on a corner template made the same thickness as my unmounted linocut block. I then ink the first cut block and print it.

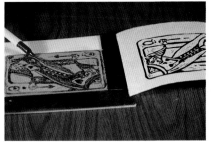

While the hinged print is still wet, I offset-print it onto a second linoleum surface. Here I am using a red pen to designate the surface to be left after this second block is cut.

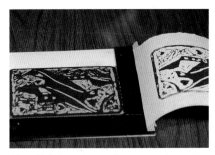

Next I hinge a second paper to the template. The second block, now cut, is inked red and printed. I now have a proof print of each of my two linocuts.

Now I am ready to surprint the black on top of the red. Again I ink the first block with black ink and print it.

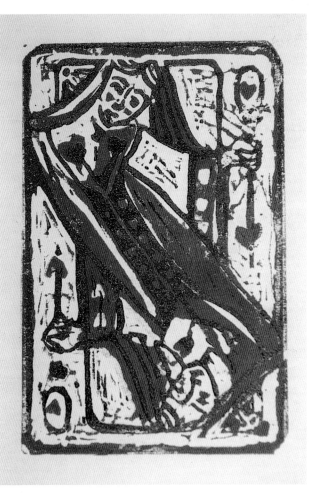

Julia Ayres, *Queen of Hearts,* 6 × 4" (15 × 10 cm). Linocut.

Here is the finished two-color print. Some of the earliest European relief cuts were playing cards. I'd have only 106 more blocks to cut to make a two-color deck!

Scott Fitzgerald, *A Summer Evening.* Color etching, 12 × 18" (30 × 46 cm). Photo: Veronica Chiang.

3 INTAGLIO PRINTMAKING

Lines and textures incised in a smooth plate will catch ink wiped across the surface. After the surface itself has been wiped clean, the ink remains in the lines and textures, which can then be printed as imagery on moistened paper, assisted by an etching press. This is the principle behind all intaglio techniques, including drypoint, engraving, mezzotint, etching, aquatint, and photogravure.

Some intaglio techniques use acid to incise imagery into the plate; others use tools. Many intaglio plates are made with a combination of both techniques.

Tones in either procedure may be made with drawn lines. Hatching, cross-hatching, or stippling (dots) may be used to fill designed areas. The quality of these lines contributes to the merit of the print.

Nor is intaglio limited to lines: Aquatint can be used to create subtle shades of tone, similar to a halftone. Intaglio offers many possibilities to artists who want to explore and combine different techniques in the same print.

PLATE MATERIALS AND PREPARATION

Intaglio plates can be made of metal or plastic. Copper and zinc are the metals most often used for acid etching techniques. These same metal plates, as well as Plexiglas, are used in nonacid methods, where the surface is scratched with a cutting tool.

The unworked surface of an intaglio plate should be smooth and clear of unwanted scratches, which will print. The thickest material used is 16 gauge, or .0625". It is most economical to buy larger sheets and cut them to the sizes you need; 6 × 9", 9 × 12", 12 × 18", and 18 × 24" (15 × 23 cm, 23 × 30 cm, 30 × 46 cm, and 46 × 61 cm, respectively) are examples of common precut sizes. A power-driven scroll saw may be used to cut the metal or plastic quickly. A draw tool (a special curved knife) run against a straightedge is used for hand-cutting. If you are fortunate

enough to have a metal shop available, sheet metal shears will quickly cut metal to shape.

Before working on a plate, you need to remove any sharp edges that might cut your hands, the paper, or the press blankets. This is done by beveling edges and rounding corners. After a plate has been etched in acid, its edges tend to be more irregular because of accidental biting from the acid, so it should be given a final beveling and smoothing then. With nonacid techniques, you can complete the beveling before the work begins.

The beveled edges form the embossed plate mark surrounding the print. Badly formed, irregularly edged bevels will detract from the print. Printmakers tend to develop their own style of bevels, but in general the bevel starts at the top edge of the plate and is cut almost to the bottom edge, where the metal is

rounded out smoothly. The bottom edge is just slightly rounded. It is important to remove scratches that will catch ink and print.

If you have access to a motorized grinder with a fine tooth, use that for beveling. Otherwise, you can use a hand-held metal flat file at a 45 degree angle to the top edge, cutting in strokes away from you. Or you can make the bevel by scraping the top edge of the plate with a scraper run along the entire edge toward you.

After making the bevel shape, use fine steel wool to remove scratched lines near the beveled edge that will catch ink. Any scratches in the image area should be removed by burnishing. You can also use burnishing tools to smooth out beveled edges further. A piece of a fine sharpening stone, used to sharpen tools, can be run across the top edge of the metal plate until a smooth bevel is made.

Bevel the edges of metal plate with a metal file to remove the sharp cutting edge.

Here a scraper is being drawn at a 45 degree angle across a plastic plate to remove the sharp edge.

DRYPOINT

In drypoint, the design is scratched directly into a Plexiglas, copper, or zinc plate with a sharp needlelike tool called a scribe, which is held like a pen. A burr, or thin metal ridge, is raised on each side of the incision when the scribe is held centered to the line. This burr makes a rich velvety line, characteristic of drypoint prints. The depth of the incision depends on how much pressure you apply when making the drawing. If the scribe is drawn leaning on one side of the line, it will produce a more fragile single burr on the opposite side. This single burr will print as a single ragged edge to the line. You can use a jeweler's loupe or other magnifying tools to check the burr quality while making your plate.

The burr as well as the incised line will catch the wiped ink when the plate is printed. In drypoint and mezzotint printmaking techniques, where fragile burrs are to be preserved, the plates are best inked with soft cloth daubers made of rolled felt or cloth. These types of plates also require extra care in wiping excess ink from the plate before printing.

Burrs quickly break down as the plate is printed. For this reason drypoint plates are generally made for small editions. If the burrs are removed with a scraper, the print becomes a drypoint engraving— that is, an engraving cut with drypoint tools but with no burrs remaining. In this case only the grooves are inked. This type of plate is often reworked many times to develop line and tone strength in the imagery.

Plexiglas and zinc are suitable for very small editions or for drypoint engravings. Harder metals, such as copper or brass, will last longer. Incised copper plates can be electroplated to receive a harder metal protective coating of steel. Watermark Editions in Shelton, Washington, provides this service for printmakers.

The typical drypoint needle is made of hardened steel. It needs to be kept sharp by rotating the beveled edge around the point on a fine, lightly oiled Arkansas stone. More expensive, but never needing to be sharpened, is a diamond-point needle. The diamond-point tool should be held upright with even pressure on the metal to avoid snapping off the tip. Another effective option is a tool with a carbide tip, which snaps off less easily and is less expensive than diamond. A tool with either a carbide or a diamond point makes it easier to inscribe drypoint lines, especially in copper.

The point of a drypoint tool should be round without flat sides so that the metal will separate and create the burr. If the shape is not correct, the point may cut and remove the material instead of parting it.

Tones may be made not only with closely spaced lines but by sanding the surface, or employing roulette and criblé techniques. Roulettes are metal tools with patterned rollers that cut into a surface. Criblé is an old technique where metal punches are hammered into the surface to produce a pattern.

Many artists use motorized metal engraving tools to make mechanical incisions. Different sizes of burrs and wire brushes can be used to develop line and tone. *It is especially important to wear protective eye covering when cutting plates this way.*

Susan Hodes, *Sunday Morning.* Drypoint, 5 × 7" (13 × 18 cm), 1970. The characteristic velvety drypoint lines are created by the burrs raised by the drypoint needle.

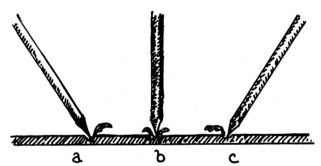

A drypoint needle creates different types of burrs, depending on the angle at which it is held. In (b), where the needle is held upright, it creates burrs on both sides of the incised line. By holding the needle at an angle (a or c), the artist creates a longer, more fragile burr on only one side of the line.

ENGRAVING

To engrave a metal plate, you push a sharp, solid metal tool called a burin into the metal, leaving a cut line. The burin scrapes out a curl of removed metal, which is raised ahead of the tool as it moves. This curl is very sharp and should be removed with a metal scraper. Burins have tips with different shapes: diamond-shaped, square, and elliptical.

The printed lines of an engraving are crisper than the ones cut with either acid or drypoint. A well-cut copper engraving will produce a large edition of several hundred prints. The lines made as you push the burin through the metal will vary in width as you vary the pressure on the tool and the burin is moved in the metal at various depths. (You are extremely unlikely to cut all the way through to the back.)

Engraving tools vary in shapes that influence line characteristics. Line tonalities are made by hatching (lines close together), cross-hatching (lines crossing at diverse angles), and stippling (closely spaced cut dots.) Cross-hatching at acute rather than right angles, as well as variations in hatching directions, gives more interest and life to the image. Slightly wavy or squiggly lines also add animation. You can widen an engraved line by cutting a second one along the edge of the first, as illustrated on the facing page. All these techniques require practice.

Engraving is a more time-consuming technique than drypoint, so engravers choose the harder copper metal to work on because it will produce more prints. Once an engraved plate is finished, you ink and print it using traditional intaglio methods, described later in this chapter.

Evan Lindquist, *Idea.* Burin engraving, 14 1/2 × 9 1/2" (37 × 24 cm). © 1989 Evan Lindquist/VAGA.
This engraving print from a copper plate demonstrates how far this technique may be taken by a master engraver. The lines not only are graceful in design but have sensitive width variations in their execution.

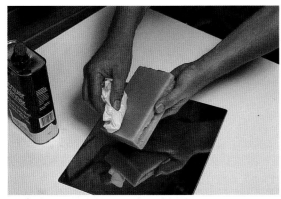

To transfer guidelines to the plate, Lindquist moistens a cloth with mineral spirits and rubs it on a cake of beeswax. He then rubs the cloth on the copper until a very light coat of wax is deposited on the plate. (This demonstration, and all the photos on this page, are by Evan Lindquist.)

A tracing done with soft pencil is placed face down on the waxed surface. Lindquist then uses a bone tool to rub the back of the drawing; a baren could be used for the same purpose.

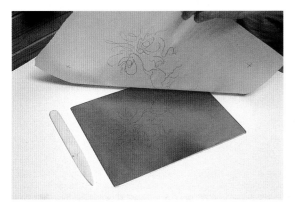

When the tracing is removed, the graphite tracing adheres to the beeswax.

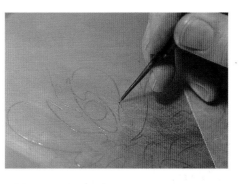

To fix the lines to the plate, he uses an etching needle to inscribe shallow guidelines on the surface. For this purpose the drypoint lines should not be deep enough to create burrs.

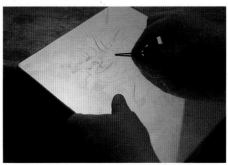

Some of the drypoint lines are visible here, as well as the thicker engraved lines cut with the burin. Lindquist holds and moves the plate with his left hand while his right hand guides the burin.

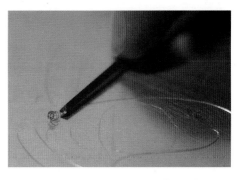

A "watchspring" burr is brought up by the point of the burin as the engraved line is made. On the right is a previously made curled burr, which should be brushed away so as not to risk scratching the plate surface.

The curls are sharp and should be cut from the surface with a scraper.

Swelling widths of curved lines are made with three or four parallel cuts to create a groove. Here a cut has been halted and the burin is backed out of the groove to make another cut along the line. The halted line is continued by reinserting the burin and continuing the cut.

MEZZOTINT

In traditional mezzotint, the whole surface of a metal plate is covered with burred dots made with a toothed tool called a rocker. In this state the plate would print a rich black. The artist then creates a design by scraping and burnishing the burred surface to make a range of lighter tones. This is in reverse to other intaglio techniques, where a wiped plate would print light before the imagery is developed.

Creating a mezzotint ground with a rocker is a time-consuming job, and a quality rocker is a large investment. Mechanically textured plates are available but costly. An alternative is to lay a mock mezzotint ground. This is done by sandblasting the plate, grinding it with a muller (a flat-surfaced grinding tool) and carborundum, or applying an overall aquatint (an etching technique; see below). As with other mezzotint grounds, a fine, evenly cut texture is needed to make the richest blacks. Images made with these grounds are also developed by burnishing and scraping in the lighter tones.

Carol Wax, *Zydeco Vertigo.* Mezzotint, 25 × 34 1/2" (64 × 87 cm), 1992. Courtesy of the artist. Photo: Robert D. Rubic, New York.

The artist achieved velvety black tones in this mezzotint because of the rich texture of her hand-rocked ground, for which she used a 65-tooth rocker. This technique is highly time-consuming. She believes it to be the largest hand-rocked ground done by a woman.

Carol Wax, *Remington Noiseless,* edition 75. Mezzotint, 19 3/4 × 15 2/3" (50 × 40 cm), 1975. Courtesy of the artist. Photo: Robert D. Rubic, New York.

Here is another of Wax's marvelously rich mezzotints. The ground for this one was prepared with a 40-gauge rocker.

MAKING A TRADITIONAL MEZZOTINT GROUND

To make the traditional textured ground, you work the rocker in careful overlapping patterns across the entire surface of the plate, producing multitudes of fine, burr-edged cuts that will catch the ink.

The metal rocker has a sturdy, slightly curved, serrated cutting head attached to a handle. The single row of teeth is in the flat side of the metal head. A sharpened beveled edge meets the teeth, producing the serrated cutting edge. The coarsest rocker has 28 cutting teeth to the inch, while the finest has more than a hundred.

Rockers come in various widths. A cutting edge 2" (5 cm) wide is for general use. Smaller rockers are used to cut around shapes. There are mezzotint roulettes that work for highly detailed passages.

To use a rocker, hold it upright with the serrated side toward your wrist. The degree of angle to the plate will regulate how close the cut lines will be to each other. To get the right pitch and rhythm is a matter of practice. Starting at one side of the plate, rock the tool so that the dots are cut in even rows horizontally, then vertically. Go back over the same area at a 45 degree angle in both directions, and then bisect each of the remaining four angles. By now you should have eight sets of equally spaced parallel lines, each dividing an earlier angle in half, like cutting smaller and smaller pieces of pie. You can do this by holding the rocker in the same position and turning the plate. Repeat these steps, feathering each section of the plate gradually into the next, until the plate is covered with fine, even texture.

Hold the mezzotint rocker so that its grooved, serrated cutting edge faces your wrist. The grooves and front surface of the tool form its cutting teeth and need periodic sharpening.

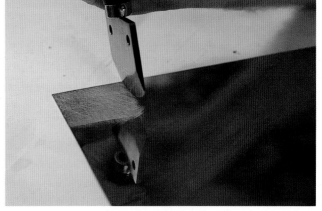
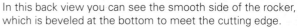

In this back view you can see the smooth side of the rocker, which is beveled at the bottom to meet the cutting edge.

As you rock the rocker back and forth in one direction, the row of teeth cuts burred dots into the metal plate. Gradually move the rocker forward to create parallel rows of dots. Then turn the plate at a 90 degree angle and rock the tool back and forth again to make new rows. The edge of each rectangular area should be deliberately left unfinished so that it can be integrated with the next rows of cutting.

Now rock the surface further at both diagonals to the first two directions. The rocker used in this example is of medium fineness and has 65 teeth to the inch. To make an even finer ground, you can bisect these diagonals with additional rows of rocking. A mezzotint ground prints as a rich, even black. Tones are produced by burnishing away the lighter areas.

WORKING THE MEZZOTINT GROUND

After the mezzotint ground has been made, a burnisher is used to press the burrs back into the surface. You can also use a scraper to shave a clean passage. The smoother the surface, the cleaner you will be able to wipe the plate of ink; and the smoothest surface will produce the lightest tones in the print. Some artists save white passages from being touched by the rocker when the ground is laid. This method guarantees that the plate will be truly smooth and saves a lot of work.

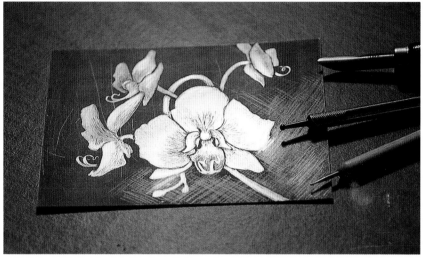

I did this mezzotint on a plate with a mechanically rocked surface that was already there when I bought the plate. The burrs were not as deep or as richly varied as those on a hand-rocked ground. I burnished this image with two round tools and a straight shaft burnisher, shown on the left. Here I am looking at the plate with light reflected from the back to check the progress of the burnishing.

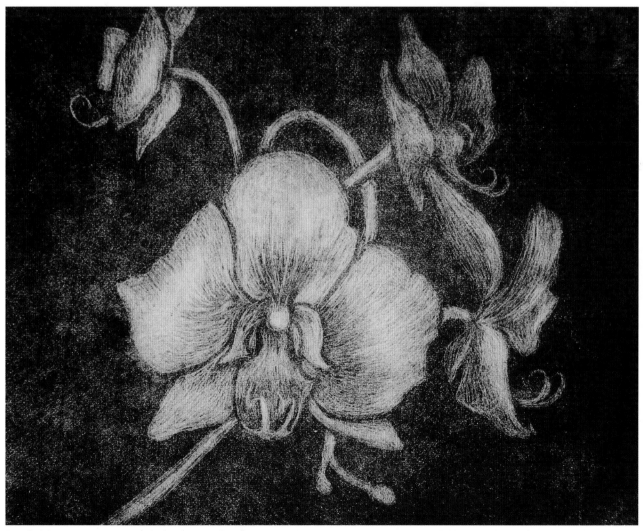

The finished print. I was able to print tones from the lightest to the deepest, shading them by controlling how much pressure I used on the burrs.

ETCHING

To create an etching, you coat a metal plate with an acid-resist ground and then draw an image into the ground with a pointed metal tool called an etching needle, exposing the metal. You don't have to press hard with your drawing tool to accomplish this, just hard enough to scratch away ground. When the plate is immersed in an acid bath, the acid "bites" or etches incisions only into the areas of the plate where the ground has been removed. Once the plate has been cleaned of acid and ground, the etched lines hold ink and transfer it onto paper when the plate is printed with an etching press.

Metal plates, most commonly copper or zinc, are the surface on which you develop an image. (Magnesium, steel, and aluminum can also be used but have various drawbacks.) Metal plates already cut to size for etchers have an acid-resistant material already on the back. Just as with uncoated intaglio plates, 6 × 9", 9 × 12", 12 × 18", and 18 × 24" (15 × 23 cm, 23 × 30 cm, 30 × 46 cm, and 46 × 61 cm, respectively) are some common sizes. If you use a commercial-grade metal, paint the back of the plate with hard ground or spray it with enamel or acrylic paint to resist the acid.

ACID-RESIST GROUNDS

The primary ingredient of acid-resist grounds is asphaltum. To this other ingredients such as beeswax, rosin, and solvents are added to make the material workable. *Hard grounds* dry to a firm coating that is suitable for scratched linear work to expose the metal. *Soft grounds* remain soft so that imagery can be impressed into the surface.

Rafael Ferrer, *Rio.* Carborundum etching, 29 1/2 × 34 3/4" (75 × 88 cm). Courtesy of Nancy Hoffman Gallery, New York.

When Rafael Ferrer worked with printmaker Betty Winkler at Yama prints in New York, he painted carborundum in a liquid form on a number of Plexiglas plates. The liquid dried hard and became the base for catching ink in traditional intaglio plate printing. Different grit sizes and densities can be mixed with acrylic medium to paint varying intensities that will print as tones. Ferrer painted carborundum on seven plates for the eight colors used to print *Rio* in an edition of 30.

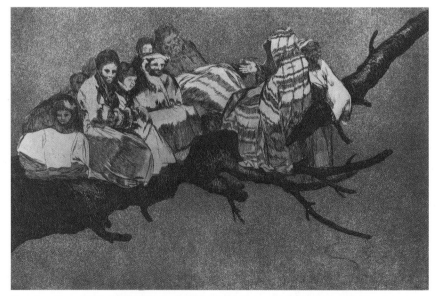

Francisco Goya (1746–1828), *Disparate Ridiculo* (Ridiculous Folly) from his collection *Los Proverbios.* Line etching and aquatint, 9 1/2 × 13 1/4" (24 × 34 cm). Courtesy of Sarah Campbell Blaffer Foundation, Houston, Texas.

This print is well worth studying for its sensitive variations in the line etchings as well as the richly toned aquatint background.

Hard and soft grounds should adhere firmly to the plate surface and resist the acid bath. A good ground will not chip or flake but hold the imagery of exposed metal. It is safer and more cost-efficient to use the ready-made grounds than to try to make your own. The process of heating and mixing the materials to make grounds produces toxic fumes.

The metal plate must be squeaky clean before a ground is laid. Ordinary liquid household detergent will remove unwanted fingerprints or grease marks. A five-minute weak acetic acid bath will also help prepare the plate. I buy a premixed solution of 30 percent acetic acid and 70 percent water from Graphic Chemical & Ink Co. near Chicago, and I use it in a glass or plastic tray. This bath is also helpful after the ground is worked but before the plate is put into the acid etching solution, to remove any traces of oil in the exposed lines.

High-quality grounds, both soft and hard, can be purchased in either liquid or solid "ball" states, so named because they look like a ball of wax when purchased. Liquid grounds are either painted or poured onto the metal surface. A ball ground is put on the metal that is first heated on a hot plate.

To brush on a liquid ground, use a soft brush. Lay the clean plate on newspaper, and paint the ground in even strokes across the plate in tightly spaced rows until the plate is completely covered. Graphic Chemical & Ink's liquid ground does not require heating to set the material. Some of the other grounds do, and *it is dangerous to breathe the resulting fumes.*

If you are using a ball ground, first heat your etching plate on a hot plate. (When Maxine Richard heats her plate for soft ground, she sets the temperature to 150 degrees F on her hot plate. For a hard ground she raises the temperate to 250 degrees F. This a matter of trial and error; you test it as it warms up.) Once the etching plate is hot enough, rub the waxlike ball across the heated surface, distributing it fairly evenly and leaving small "holes" rather than filling in one corner thickly. When about 30 to 50 percent of the surface is covered with melted ground, spread it over the rest of the surface with either a hard rubber brayer (reserved for this use) or a homemade leather dauber. These tools should be reserved for either the hard or soft grounds and not used for both.

Betty Sellars brushes liquid ground over her sugar-lift image, using a soft brush to coat the plate evenly. (For more about sugar lift, see pages 80-81.)

To apply a ball ground, first warm the surface of your etching plate on a hot plate.

A hard rubber brayer, a very expensive leather brayer, or a homemade dauber (as shown here) can be used to smooth out the ground. This dauber was made by stretching chamois cloth over half of a child's hard rubber ball, gathering the cloth at the top, and using it as a handle. Keep the etching plate warm while you are smoothing the ground over it.

HARD-GROUND TECHNIQUES

After the plate has been cooled and the ground has hardened, you can draw directly on the plate with an etching needle or make a drawing on paper and transfer these guidelines to the ground-coated plate. One good technique is to make a full-size drawing for the preliminary study of the print and then trace the drawing on tracing paper with a soft 5B pencil. Then put the tracing face down on top of the plate and run it through an etching press. The soft lead transfers the image (in reverse to the original drawing) to the top of the hard ground. Now you are ready to use metal etching needles to follow the pencil guidelines and develop the image by cutting with moderate pressure to remove the ground linearly. Your final print will face the same direction as the original paper drawing, having been reversed twice—but it will be a mirror image of the etching plate.

Photocopier prints of artwork or printouts of computer-generated imagery can be transferred onto a hard ground. Place the dry print face down on the ground, moisten the paper with solvent, and make the transfer by running it through the press. The problem is to find which solvent will work with the inks or toners of the individual photocopy machines. To avoid disturbing the ground, use just enough solvent to moisten the paper, not to soak the ground below. Make test copy sheets to find the safest formula. I found that isopropyl alcohol will dissolve and transfer the ink of my dot-matrix printer. I've also seen turpentine or lithotine used to transfer photocopier drawings. It is wisest to start your experiments with photocopy transfers with the least toxic solvents, and to use adequate ventilation.

Once you have drawn or transferred whatever guidelines you want to the hard ground, you draw

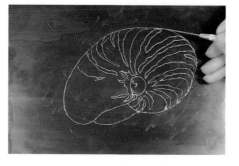

I am about to make an etching of a shell using the additive method. Here you see the shell shape traced with a needle to expose the zinc metal underneath the hard ground. These lines will be darkest in the finished print.

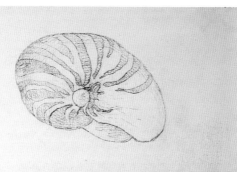

Next I exposed the plate for ten minutes to ferric chloride (copper etching solution from Graphic Chemical & Ink Co., straight from the bottle). After rinsing it off in water, I drew more lines in the ground. Another ten-minute bath in the ferric chloride etched in the new lines and darkened the first ones. Here is the first proof.

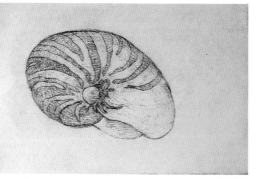

I made a third and then a fourth set of lines in the ground, exposing the plate to the ferric chloride for ten minutes each time and rinsing it off afterward. This proof was then made of the plate. You can see that some lines are darker than others.

The lines I planned to be the lightest were drawn last, and the plate received an additional 20-minute acid bath. Here is a proof of the plate at this point. You can clearly see the contrast between the lightest and darkest lines, with several intermediate levels. To develop this plate further, I would add aquatint tones.

Roulettes used to cut texture in metal may also be used with lighter pressure to cut texture in grounds. This is a copper plate covered with a hard ground.

through the ground with the etching needle, thus exposing the metal so that it will receive acid in a later step. (Acid baths are discussed further on pages 85–86.) Roulettes can also be used to expose patterns in the ground. Although these tools are made to cut patterns into metal, they can be used with lighter

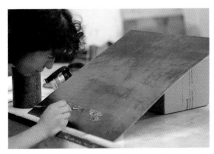

AnaMaria Samaniego lifts small areas of the ground with a brush and solvent and then blots the dissolved ground from the plate. She develops her plates by repeating and developing her grounds numerous times before she feels they are complete.

pressure on grounds. You can create patterns of bitten tone by rolling a roulette over the hard ground to expose the metal. Some roulette patterns are single or multiple rows of dots, others are closely spaced lines, and others are cross-hatched patterns. Also try cutting sandpaper to the shape and size you want, laying it face down over the ground, and running it through an etching press to produce an exposed tone pattern for the acid.

The longer the exposed line is in the acid bath, the deeper will be the bite, and consequently the darker the line will print. To develop interesting tonal variations, you expose lines to the acid for differing durations of time. These differing exposures to the acid can be made using either the additive or the subtractive technique. In the additive technique, you draw first

the lines that are to be darkest, expose the plate to acid, and rinse it off immediately with water. (See pages 150–151 for important safety information about working with acids.) Then, without otherwise tampering with the ground, draw the lines that are to be one shade lighter and put the plate back in the acid bath. Repeated immersions etch new lines for the first time and etch old lines deeper. After that acid bath the lightest lines are made for the last acid exposure. Each time you remove the plate from the acid bath, rinse it with water right away. This process can be repeated as many times as necessary to develop the image with varying shades of lines and tones—although it is possible to cut all the way through the plate if you are not careful. Or you could do this deliberately to cut an irregularly shaped plate.

This second-state proof of *La Caja Del Rio #25* by Samaniego contains some line etching in hard ground. After lifting some additional ground with solvent, she put the plate back in the acid for a surface wash etching.

AnaMaria Samaniego, *La Caja Del Rio #25,* final state, edition of 25. Etching on Arches Cover paper from a copper plate, 17 × 20" (43 1/2 × 51 cm).

The rich variation in tones in this etching is the result of the many layers of plate development, including aquatint and burnishing. Samaniego later made a monoprint from this plate by applying colored ink to a Plexiglas plate, printing that on the paper, and printing the etched plate on top.

In the reductive technique, you draw *all* lines on the plate before giving it a short acid exposure. After rinsing the plate with water and patting it dry carefully with a paper towel, cover the lightest lines with liquid ground or stop-out, a special form of liquid ground meant for covering lines, and return the plate to the acid bath. After the middle tones are etched, again rinse the plate and pat it dry. Cover the middle tones with liquid ground or stop-out, and return the plate to the acid bath. The remaining lines will receive the longest exposure to the acid. (Again, this process can be broken down into more stages—and more shades of line and tone—as long as you don't cut all the way through.)

Soft and hard grounds are applied similarly but are worked differently to achieve special effects. Both types can be used to develop the same plate. When changing grounds or after the acid baths are completed, clean the plate of all ground material before inking and printing it. I prefer to use the least toxic citrus-based painting thinner for this clean-up. For more information about cleaning plates, see page 87.

Dorothy Hoyal, *Laughing Afghans.* Etching, 6 × 9" (15 × 23 cm).

This etching was done using the reductive method. After laying a hard ground on the entire plate, Hoyal drew with an etching needle to remove all the lines that were to appear in the final print. She then applied stop-out varnish in two stages, to produce the three different line tones. The dog in the upper left was covered first after a short acid exposure. The dog on the upper right was blocked out after the next acid bath. The main dog received the longest and deepest acid bite.

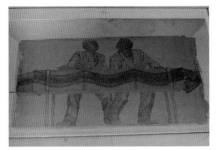

At AnaMaria Samaniego's platemaking class at Graphics Workshop in Santa Fe, Michael Berg decides to use loosely woven fabric and lace in soft ground. The plate was already etched using a hard ground, so these new textures will add a new dimension.

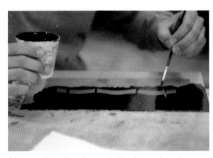

He impresses the materials into the ground on the press. The newsprint paper catches the excess ground.

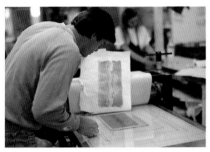

He applies hard ground where he does not want the texture to etch. The lace will print as etched lines, and the fabric will develop as a form of aquatint and print as a tone.

Joyce T. Macrorie, *Spirit of Garden,* 12 × 15 ¹/₂" (30 × 38 ¹/₂ cm).

Weeds were the texture in this soft-ground etching. Macrorie cautioned that when working with juicy plant material you must have plenty of protection for the press blankets. She covered the plants with waxed paper as well as cardboard when she pressed them into the ground by using her etching press.

SOFT-GROUND TECHNIQUES

Unlike hard grounds, soft grounds stay tacky on the plate. In a soft ground, even a fingerprint will leave an impression that will bite in an acid bath. Therefore the coated plate must be handled with care. Before putting the plate in acid, you can protect all small and large areas not to be bitten by painting on a layer of liquid hard ground.

One good way to draw on a plate covered with soft ground is to place a sheet of newsprint paper on top. Then use a pencil to draw the lines on the paper, either by drawing freehand or by tracing a drawing. The pencil pressure picks into the soft ground and transfers the linear work to the underside of the paper. The plate is now exposed where you have drawn, and the plate is ready for the acid bath.

One advantage of soft ground is that you can press found and organic materials into the surface. Many weaves of fabric have been pressed into soft ground to produce textured tones. Leaves, grasses, and flowers can be pressed into the soft surface for beautiful results. When you run organic materials through a press,

however, be sure to use adequate waterproof covering to protect the blankets from a surprising amount of juices that will be squeezed from the plant parts. Waxed paper is often used for this purpose but requires several layers for particularly lush material. If you are using dry materials, such as fabric or lace, cover them with newsprint instead, which is less wrinkly than waxed paper.

Let's assume that you have pressed some lace and flowers into the soft ground. At this point you should have a "sandwich" of (from bottom to top) plate, soft ground with your found materials and perhaps also a drawing impressed into it, and waxed paper. Set this carefully right side up on the press bed, cover it with blankets, and run it through the etching press. Then remove the fabric and leaves from plate, where their impression remains. Now the plate is ready for immersion in acid, which etches into the exposed areas. Once you are satisfied with the acid bite, clean the plate of acid and ground, ink the plate, and run it through press again, this time printing onto paper.

Ron Pokrasso's artwork expresses other aspects of his life. As a child he had a passion for baseball, and Mickey Mantle was one of his heroes; Pokrasso also played ball himself. In 1992, the year he began coaching his eldest son for Little League, he did this suite of prints.

Pokrasso also brings history from past work into his plates. He sanded down etched plates from previous work until the desired etched foundation for the new plates was left in the surface. He then worked on top with a soft ground. Pokrasso develops his monotypes on Plexiglas the same size as the intaglio print. First he prints the etching plate and keeps the paper engaged under the roller. Then he places the monotype plate in registration and prints it on top.

(All the artwork on these two pages is reproduced courtesy of the artist.)

Ron Pokrasso drew his image on paper laid on a soft ground.

The reverse side of the paper drawing shows how the soft ground adhered and was lifted from the plate.

Ron Pokrasso, *"Now batting, number seven, Mickey Mantle, number seven."* First panel of intaglio triptych, 36 × 24" (91 × 61 cm), 1991.

Ron Pokrasso, *"Now batting, number seven, Mickey Mantle, number seven."* First panel of monotype triptych, 36 × 24" (91 × 61 cm), 1991.

Ron Pokrasso, *"That ball is going . . . going . . ."* Second panel of intaglio triptych, 36 × 24" (91 × 61 cm), 1991.

Ron Pokrasso, *". . . gone!"* Third panel of intaglio triptych, 36 × 24" (91 × 61 cm), 1991.

Ron Pokrasso, *"That ball is going . . . going . . ."* Second panel of monotype triptych, 36 × 24" (91 × 61 cm), 1991.

Ron Pokrasso, *". . . gone!"* Third panel of monotype triptych, 36 × 24" (91 × 61 cm), 1991.

AQUATINT

Aquatint is an acid-bitten tone achieved with droplets of resist on the plate surface. It is marvelously suited for etching tones, rather than lines, and it is often used in conjunction with other etching methods to create prints that contain both. Rosin or asphaltum particles adhered to the plate, or a light paint spray, will produce this textured ground. The depth of tone is controlled by the fineness of the ground as well as the length of time the plate is exposed to the acid.

ROSIN METHODS

Rosin can be purchased in either lump or powdered form. Some etchers prefer to buy the lump rosin and hand-crush it so that the small particles will not be uniform. Others prefer the even particles of the powdered form. Whichever type of rosin particles you prefer, dust them onto the plate either with a hand-held rosin bag or by placing the plate in a rosin box. After laying down an even coat of rosin, carefully place the metal plate on a hot plate and heat it until the rosin particles melt and adhere to the metal plate.

You can make a rosin bag of two or three layers of nylon stocking or finely woven fabric. Place the rosin particles inside, hold the bag from two to five inches (5 to 13 cm) above the plate, and either shake or tap the bag with your fingers. The aim is to have an even coating of separate particles with well-defined metal surface exposed between them. Dry asphaltum particles are applied with a similar cloth bag.

The rosin dust box is often handmade and simply constructed. Boxes made by different artists vary in size but have several common features. The rosin particles are placed in the bottom and are agitated by either turning a crank on the box or blowing air into it. The artist waits several seconds for the largest particles to fall back and settle, and then places the plate (resting on a larger piece of cardboard) on a shelf in the lower end of the box face up. The cardboard tray under the plate helps the layer of rosin dust settle across the plate face more evenly. After about ten seconds, the artist carefully removes the plate and cardboard and studies the rosin dust with a loupe to make sure the coating is satisfactory.

After the plate has received the rosin or asphaltum, the artist gently sets it on a hot plate and watches it scrupulously. The melting usually begins in one spot and then travels over the plate. Once this has occurred, the artist carefully removes the plate with a spatula and/or hot pads and lets it cool. If the plate is heated too long, the rosin melts completely into an even layer and the dot definition is lost.

THE SPRAY-PAINT METHOD

The plate can be coated with a fine spray of enamel or acrylic paint. Adequate ventilation, as well as protection against spraying surrounding areas, is needed for this procedure. One way to solve these problems is to spray in a three-sided box outdoors. The bottom of the box should be larger than your plate. Practice spraying on paper first to study the size of the particles. Spray cans vary in the size of particles they spray. Be sure to use fresh cans of

Betty Sellars shakes and taps a rosin bag to apply rosin particles to her plate. The plate will then be heated until the rosin melts into droplets and adheres to the plate. The peach-colored surface is a template to keep the rosin in the designated area of the plate.

In this rosin box, a tray slides out to hold the metal plate, and a door flaps shut to let the rosin settle. (Photo: Veronica Chiang.)

paint because old, almost empty cans tend to spray erratically.

When you've found satisfactory paint and pressure, set your plate on the floor of the box. Start by spraying next to the plate, then sweep across it, then change direction of the sweeping motion on the other side of it. This way the "turnarounds," where the paint is thickest, will be off the plate, and the coating will be more even. Once the paint has dried, the plate is ready to be submerged in acid.

BITING THE AQUATINT GROUND

Aquatint grounds are bitten with weak acid solutions for shorter periods of time than are needed for linear bites. Close observation with a jeweler's loupe will tell you how long to expose the plate to acid. The bite should be even and complete around each resist droplet. When the edges of the resist particles begin to break down, the exposure has been too long.

You can create different aquatint tones by using the subtractive technique. After giving the plate a short exposure to the acid, rinse the plate with water and pat it dry with a paper towel. Then block lighter tones with hard ground so that they become no darker, and return the plate to the acid. This biting with acid and blocking with hard ground may be done several times for varying tones. The areas of the plate that are exposed to acid the most times yield the darkest tones when printed. Once you are satisfied with the levels of tone, you remove the aquatint from the plate with solvents before inking and printing.

When aquatint and other etching techniques are used on the same plate, the lines are usually etched into place first. You can also create an effect similar to aquatint with mock mezzotint techniques of scraping and burnishing in the lighter tones.

WAX OR GREASE CRAYON RESIST

A wax or lithographic crayon may be used with aquatint grounds to make lighter areas or drawn lines. You can apply crayons as tone to soften the transition of one aquatint passage to another, where an abrupt line is not wanted. The crayons act as a resist to the acid with a generally softer effect than painting with liquid grounds.

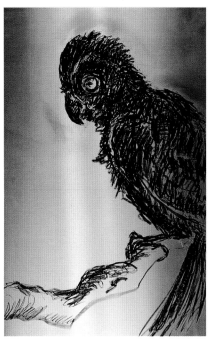

To demonstrate a crayon resist drawing on an aquatint plate, I worked fast with lithographic crayon to catch Simon before he flew from his perch.

I then lightly sprayed the drawing and plate with enamel paint to make an aquatint ground, and put it in ferric chloride for the acid bite.

Julia Ayres, *Simon.* Aquatint with lithographic crayon resist, 6 3/4 × 11" (15 3/4 × 28 cm).

The variations in the background tone correspond to how the resist particles were applied with the enamel spray paint. The light blob under the branch is an example of what happens when spray particles are too close together. This area will be textured when I develop the plate further.

First state in a burnished aquatint etching: line work. Scott Fitzgerald has etched his line drawing onto a copper plate with Dutch mordant acid, which is known for its clean-cut etching characteristics. (For more about Dutch mordant, see page 86). Photos on these two pages: Veronica Chiang.

Second state: plate work. He has made a rosin aquatint ground on the plate, and the resulting tone shows on this print. In this technique, areas that are to remain white may be blocked out with stop-out or liquid hard ground before the artist puts the plate into the acid.

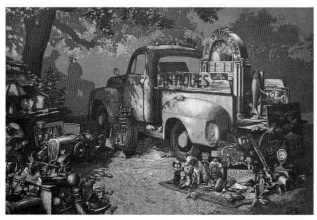

First burnish proof. The artist begins to burnish in the light tones.

Detail of Fitzgerald burnishing the plate in progress.

Scott Fitzgerald, *At the Flea Market.* Etching and burnished aquatint, 12 × 18" (30 × 46 cm).

Here is the final proof. Fitzgerald burnishes all his aquatint plates to remove bitten aquatint and produce subtle transitions between printed tones. The process is meticulous and time-consuming. However, it is particularly effective for Fitzgerald's detailed imagery.

LIFT GROUND AND SPIT BITE

For years intaglio printmakers have relied on lift ground and spit bite, two techniques to develop painterly, subtly toned imagery with aquatint. Lift ground can be painted onto the plate with a brush to define painted tone areas, or drawn with a pen to produce more linear imagery of less regular lines than are made by scratching into hard ground with an etching needle. In spit bite, the printmaker paints acid directly onto an aquatinted plate to develop washlike tones. In another related technique, the artist paints solvent onto a designated area of a hard ground and pats it with towels. This method produces an exposed area with soft edges.

LIFT GROUND

After applying lift ground in whatever way you choose, let it dry. (Most lift ground formulas have ink in them so that you can see what you're doing as you paint or draw.) Then add a hard acid-resist ground to coat the entire plate surface, including the lift ground. Next place the plate in tepid water and allow it to soak. In about half an hour, both grounds will begin to dissolve where you applied lift ground, but the hard ground will remain undisturbed elsewhere. You can encourage this by touching a soft brush across the surface.

When the lift is complete, some printmakers prefer to immerse the plate in an acid bath for a few seconds, just long enough to define the edges of the exposed areas, before they rinse off the plate. If the lift was made with very fine lines that will print evenly without an aquatint ground, or if the plate was made for uninked embossing techniques, the printmaker may choose to leave the plate in this first

acid bath until the desired bite is achieved. However, most plates developed with lift ground are next coated with an aquatint ground over the exposed surfaces. The aquatint gives the artist freedom to coax out subtle variations of tone by using the reductive method, in which stop-out or hard ground are used to vary the length of exposure to the acid. After the bite is complete, the plate is cleaned of hard and aquatint grounds with solvent. It is then ready to proof-print.

Left: Pat Schoen uses a pen to draw lift ground on a plate prepared with a rosin aquatint ground. Next Schoen covered the image with hard ground. Right: In the water bath, the drawing lifts from the surface as the lift ground removes the hard ground. Here the lightest spots are where the lift has completely risen.

Here are two formulas for lift grounds:

1. To one part gum arabic, add one squirt liquid dishwashing detergent, then mix in liquid poster paint to color. (I used Hunt Speedball water-soluble black screen-printing ink.)

2. Betty Sellars's Sugar Lift Recipe
 To ½ cup sugar,
 add ¼ cup water.
 Boil until just soft ball.
 Add india ink to color.

Pat Schoen, *Doe.* 6 × 8" (15 × 20 cm).

When the plate is put in an acid bath, the acid bites only the areas where the hard ground was lifted off. Here is the resulting print.

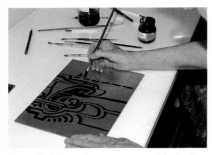

Betty Sellars paints on a sugar-lift design with a brush.

Sellars removes some of lift that has not yet dried to give texture to her painted lines. Here she has laid a paper towel over the design and is rolling over it with a brayer. She will then discard the paper towel.

After only part of the lift ground has worked, Sellars puts the plate in acid for a short exposure.

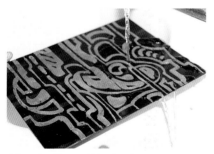

After the first acid bath, she removes the rest of the lift ground by running water over the plate and returns the plate to the acid bath.

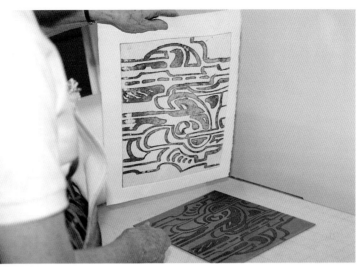

The resulting print shows interesting variations in textures and tones. Sellars will develop the plate further with other intaglio techniques.

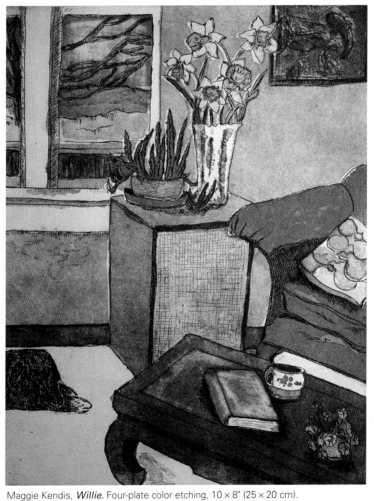

Maggie Kendis, *Willie.* Four-plate color etching, 10 × 8" (25 × 20 cm).

Kendis made the first plate as a line drawing in hard ground. Prints from this plate were offset-printed as the key drawing on the three remaining plates. She then developed these last three plates using sugar-lift and aquatint techniques. Sugar lift was applied where she wanted that plate's color to print.

SPIT BITE

A spit bite is used to make washlike effects by painting with acid. You are painting in positive the shape that you want, rather than scratching it out from a ground—although it still prints backward. In general, spit bite is more effective when the image is defined first with a lift ground. After the lift, immerse the plate in acid for a very short time just to define the edges. Then lay an aquatint ground over the area whose edges you have just defined, to prepare it for the spit bite. Now you are ready to paint the spit bite on top to create painterly effects against the aquatint.

Spit bite got its name because artists used to spit onto the plate and mix a few drops of acid with their saliva; the more viscous saliva served to keep the acid from running. Nowadays artists first brush on gum arabic to which they add drops of full-strength nitric acid, which they immediately disperse with a brush or disposable cotton swab. This is hard on brushes, so old synthetics work best here. If you work with nitric acid, ventilation and safety precautions are crucial.

For safety reasons, I prefer not to have nitric acid in my studio, so I use slower-acting ferric chloride instead, applied with synthetic watercolor brushes. I use the premixed copper-etching strength solution available from Graphic Chemical & Ink Co. Ferric chloride can be painted directly on an aquatint ground without gum arabic. As long as bubbling occurs, the bite is occurring. When the bubbling action stops, rinse the plate to clean out accumulated sediment before adding the next dose of ferric chloride.

After lifting this image of an eagle dancer from a hard ground, I laid an aquatint ground over the plate. Here I brush ferric chloride on the exposed plate to produce an acid bite with a wash effect.

Carolyn Brady, *Blue and Yellow.* Spit bite aquatint, 29 × 37" (74 × 94 cm). Courtesy of Nancy Hoffman Gallery, New York.

The spit bite process is appropriate for Brady's images, which are reminiscent of watercolor. She developed the three plates with spit bite and a rosin aquatint. The plates were then steel-faced before being printed by Jennifer Melby and Maurice Payne.

PHOTO ETCHING AND PHOTOGRAVURE

Imagery can be transferred onto an etching plate photochemically in two processes called photo etching and photogravure. In photo etching, a black line drawing is exposed on a photosensitive plate for a direct transfer of lines and shapes that will print black after exposure in acid. In photogravure, a complete tonal range of a photograph or a transparently painted image is bitten into the surface of the plate. Aquatint grounds are needed in both techniques.

PHOTO ETCHING

To develop a photosensitive plate for etching in acid, you need a positive transparency the size of the plate—that is, a transparent sheet of a material such as Mylar with an opaque black drawing on it. You can get a transparent positive made from a drawing on paper at a photocopy shop. The opaque black will block light from exposing the photosensitive plate underneath it. After the plate is developed, the imagery protected by the lines in the transparency will be washed away, and the remaining surrounding surface is similar to a hard ground.

The Mitsui PS (for PhotoSensitive) zinc plate available from Graphic Chemical & Ink Co. tolerates low-light studio conditions and does not require darkroom facilities. (That is, turn off lights and cover windows so that the room is as dark as possible but you can still see what you're doing before taking the covering off the plate.) Place the positive transparency on top of the plate surface and cover it with a sheet of glass or clear Plexiglas. Position a photoflood light 15" (38 cm) above

the glass for 13 minutes. (For a photo of a similar set-up, see page 126).

While the plate is being exposed, dissolve 8 gm of lye in one quart of water in a glass or plastic tray. The water should be between 99 and 104 degrees F. After the plate is exposed, slide it carefully into the lye solution, face up. As soon as the metal lines become visible, remove the plate, wearing rubber gloves, and rinse the plate under running water. The plate will need to have stop-out or hard ground painted on exposed metal not to be bitten, such as the exposed metal edges of the

I took this drawing of a deer grazing outside my window to a photocopy shop to have a positive transparency made. Here you see me raising the transparency from the drawing.

plate and unwanted scratches. Then put the plate into acid to develop the bitten image. If shapes as well as lines have been exposed, first add an aquatint ground.

Photosensitive plates that do require darkroom facilities are also available from Graphic Chemical & Ink Co. Developing directions accompany the various types and brands. It is also possible to employ the services of a specialty shop such as Watermark Editions in Shelton, Washington, to make a photodeveloped plate from your original line drawing on paper.

To make a photo etching, the transparency was then exposed to a Mitsui photosensitive plate with a photoflood light and developed without elaborate darkroom facilities. When the plate is developed, the areas under the opaque black lines of the drawing can be washed away, and the remaining areas resemble a hard ground. Liquid hard ground will be painted on the exposed cut edges of the plate. Then the plate is ready to be etched in acid.

PHOTOGRAVURE

Positive transparencies are also needed for photogravure work. In contrast to the positive transparencies made for photo etchings, these transparencies have a complete range of transparent tones instead of black opaque ink. They too need to be the size of the plate. You can go to a special photo lab to have a black-and-white transparency made from a photograph. You can also paint a positive transparency on clear Mylar with transparent ink.

The positive transparency is exposed to a gravure emulsion that is made on a carbon tissue available from Autotype, U.S.A., in Schaumburg, Illinois. Willis F. Lee, a Santa Fe photogravure artist, photosensitizes the carbon tissue with a 3.5 percent solution of potassium dichromate in water. This becomes a gelatinous solution on the tissue, which is next exposed to the positive transparency. The amount of light reaching the potassium dichromate will cause the gelatin to harden in various thicknesses, becoming a varied acid-resist ground. The lightest areas in the transparency will result in the hardest, thickest ground, which will break down last in the acid and therefore result in the lightest tones on the finished print as well. After the dichromate on the carbon tissue has been exposed, the tissue is rolled or squeegeed onto a clean copper plate. The plate and tissue are then put in water, where the carbon tissue is developed off to leave only the hardened gelatin ground. Ferric chloride is commonly used to bite photogravure plates.

In most cases, an aquatint ground is laid on the plate before the exposed gravure emulsion is attached. A photodeveloped aquatint can be made by exposing the gravure emulsion to the transparent positive as well as a photo screen that will break the image into dots. Willis F. Lee uses the photo screen method to develop his plates.

When you remove the plate from the acid bath, the gelatin will be gone. Rinse the acid from the plate with water. If you used an aquatint ground, remove it with solvent. You can add hand-drawn work in various grounds to the photo-positive images. You can then ink and print the plate just as you would in other etching techniques.

Willis F. Lee, *Untitled.* Photogravure, 10 ³/₄ × 14 ¹/₂" (27 × 37 cm).
A screen produced an aquatint tone for this print.

ACIDS AND
OTHER ETCHING AGENTS

There are three common etching agents used in intaglio printmaking. *Dilute nitric acid and Dutch mordant baths are strong acids; they must be used only where there is strong hooded ventilation systems that will evacuate fumes outside the building.* Ferric chloride is a different type of etching agent, slower to react with the metal but safer where excellent ventilation is not possible. For purposes of this book I'll use the term "acid" to include ferric chloride.

Safety in working with acids and other strong chemicals is extremely important in the studio. Turn to pages 150–151 for guidelines on storing and handling acids.

FERRIC CHLORIDE

Ferric chloride (copper etching solution, or iron perchloride), is the etching agent I prefer to use in my home studio. It is most commonly used on copper plates, but also works chemically with zinc. Some etchers complain that sediment deposits tend to build up in the etched lines, but you can avoid this problem by etching the plate face down but elevated from the bottom of the tray of liquid with wood or wax blocks so that sediment falls out naturally by gravity.

When ferric chloride crystals are mixed with water, they can produce a dangerous amount of heat. *Never mix them in a bottle, because the bottle may explode.* A solution of the correct concentration, at 42 degrees Baumé, is economical and available from Graphic Chemical & Ink Co. near Chicago. A solution of 30 percent acetic acid to 70 percent water is also available from Graphic Chemical & Ink Co. It is a good bath to clean metal plates before putting them in this etching solution.

I prefer to etch my plates face up. In order to do this I must remove the plate from the bath more often and wash away the surface residue with water. An acetic bath is also helpful here. At these times I study the etched lines with a loupe or catch a needle point in the lines to determine their depth.

My countertop is protected with newspaper. The setup is by my sink with running water. As always when working with acids, *protect yourself from splashes with heavy-duty rubber gloves, eye gear, and a thick apron.* I pour the ferric chloride into an oblong glass Pyrex baking pan that is larger than the plates to be etched. You can etch more than one plate at a time in the same acid bath as long as they don't overlap each other. You can buy white plastic acid trays whose unbreakability affords an additional measure of safety. After the work is done, I pour the ferric chloride back into its container through a funnel and replace the cap tightly. Once a chemical bath has been used with a specific metal, reserve it exclusively for that type of metal, since it is no longer pure.

Ferric chloride will cease to etch under two conditions: when the solution becomes saturated with iron oxides, or when too much water has evaporated. When the biting action slows down, try adding small amounts of water. If that doesn't help, discard it and use a fresh supply. Ferric chloride can be poured down the drain and flushed with a great amount of water. Some cities may prefer that you confer with them on how to dispose of toxic waste, although this solution has not been rated hazardous. A Baumé hydrometer, which measures specific densities of the solutions, is available from chemical supply houses. The Baumé reading for a good ferric chloride working solution is about 42 degrees Baumé.

NITRIC ACID

If your studio does have a strong ventilation system, you can consider etching with dilute nitric acid. *You must wear heavy rubber gloves, protective clothing, and a face mask with cartridges designed for vapors when working near an open nitric acid tray.* When the acid is not being used, keep the tray tightly covered. Some studios find it necessary to keep their ventilation system working even when the trays are covered. The acid fumes will corrode metal, so keep exposed metal away from the tray.

Graphic Chemical & Ink Co. sells nitric acid. Pure solutions must be shipped by truck. The safer half-strength solution (50 percent nitric acid and 50 percent water) may be shipped by conventional carriers.

GUIDELINE TABLE FOR NITRIC ACID BATH

Add one part half-strength nitric acid to the following parts water:

Metal plate material	Hard rapid bite	Medium bite	Slow bite
Copper	2	3	5
Zinc	5	10	15

Rapid biting is best for strong linear cuts, and slow biting is for sensitive textures such as aquatint techniques. If you want to do more than one type of work on the same plate, use separate steps. For example, you could etch linear work in a rapid-biting solution, and then protect these lines with hard ground when you make an aquatint etching with a slower bite.

DUTCH MORDANT

The formula for Dutch mordant, a slow-biting acid for copper plates, is (by volume):

To 88 percent water,
add 2 percent potassium chlorate
and then
10 percent hydrochloric acid.

THIS PROCESS PRODUCES DEADLY CHLORINE GAS. For this reason, mix and use it *only* under strong exhaust ventilation, with a protective mask, as well as heavy rubber gloves and protective

This is Scott Fitzgerald's strong, hooded ventilation system for the toxic Dutch mordant acid bath he uses to etch copper plates. Note that he also wears a face shield for protection when pouring the acid into his tray. (Photo: Veronica Chiang.)

clothing. The chlorine gas will continue to escape after the solution is mixed, so continue the exhaust ventilation for a good half-hour. The chemicals needed for mixing Dutch mordant are available from chemical supply houses.

Store Dutch mordant in a sturdy plastic bottle. For extra safety, buy unused bottles from chemical supply houses. Check that they don't leak by filling them with water, and also check the cap's seal by laying the bottle on its side and inspecting it for leakage. Remove the water before adding the acid.

Dutch mordant does have its advantages. California printmaker Scott Fitzgerald has equipped his studio with strong ventilation to handle this type of acid because he likes the close control he can achieve with the slow-acting etch.

ETCHING THE PLATE

Lowering plates carefully in ferric chloride is a simple matter with the protection of heavy rubber gloves to keep your skin from staining yellow. Use bent metal or plastic tools or other devices when working with the stronger acids. (The tools are in the acid only a fraction of a second and should be rinsed immediately in water.) The correct procedure is to lower the plate by sliding it into the bath one end first, working slowly and carefully so as not to risk splashing the acid. If splashing occurs, immediately flush the area with water.

Bubbles tend to collect along exposed metal, and if they are not brushed away they will cause the etched lines to be uneven. A bird feather is the common tool used to brush away bubbles. If the bubbles are very rapid, as if they were boiling, the reaction is heating the plate. In that case, remove the plate immediately and cool it under running water. If you leave it in the

A feather is a handy tool for brushing bubbles away from etching lines. Feathers wear out from exposure to acid and must eventually be discarded.

acid, the heating and boiling will escalate rapidly, causing a dangerous situation where the ground and ultimately the plate and surrounding materials are in danger of breaking down. If the acid bath is nitric acid, nitrogen dioxide—a dangerous, colorless, odorless gas—is released into the air when the solution becomes heated. *This is one reason never to leave an acid bath unattended.*

TIMING THE ACID BATH

When you are working with ferric chloride the timing is usually in terms of minutes for aquatint and five-minute increments for line etchings. With nitric acid baths it is in terms of seconds for aquatint and minutes for line etchings. In both cases the strength of the bath, surrounding conditions, and type of work contribute to the variables that only experience will recognize and use successfully.

A kitchen timer is helpful in keeping track of time. A large wall clock with an easily read second hand is also helpful. A diary of timed etching experiences will be helpful in making future plates.

Always wear heavy rubber gloves when removing a plate from a tray. Lift it slowly and carefully, tilted so that the acid runs off into the tray rather than splashing. Then immediately rinse the plate under running water until all possibility of lingering acid is removed.

PRINTING THE INTAGLIO PLATE

Regardless of whether an intaglio plate is made with drypoint, engraving, mezzotint, or acid-etched techniques, it is printed in the same manner—with a few minor variations. Once you have created the image on the plate, you remove any remaining grounds with solvents and then proof-print the plate to determine whether more work is needed before the final printing. Drypoint and mezzotint techniques do not have grounds to remove; however, since they have burrs to protect, it is preferable to proof-print them as few times as possible.

CLEANING INTAGLIO PLATES FOR PRINTING

All grounds used to develop the plate are removed by wiping the surface with cloths or soft paper towels and paint thinner. The less toxic citrus thinner works well here. After removing all traces of ground, wipe the plate with liquid dishwashing detergent, and rinse it under hot running water to remove all traces of oils, solvents, and soaps. Then pat the plate dry, ink it, and proof-print it. If you aren't satisfied with the results, you can add more ground, develop more imagery, clean the plate, and proof it again.

PREPARING THE PRESS

Intaglio plates are printed on an etching press. To review a few facts stated about presses, they have rollers that move the press bed. Felt blankets used over the plate and paper contribute to the pressure placed on the printing. The direct pressure is controlled by maneuvering measured mechanisms at each end of the roller.

A sheet of $1/8$" (0.3 cm) hard clear plastic that completely covers the press bed is a benefit to protect the bed as well as offer an easy surface to wipe clean after each printing. Many studios use graph paper to place some system of registration guidelines under this clear plastic. The inked plate goes in place next, face up, and the paper is positioned over it, with blankets pulled down to cover the work. All this is then rolled through the rollers to print the image on the paper.

You may remember from Chapter 1 that there are three basic felt etching blankets. Sometimes printers need to increase or decrease the number and type of blankets they choose in order to vary printing pressures. However, for most intaglio printing the first blanket chosen to cover the work and paper is the thinnest blanket, known as the sizing catcher. It should be washed in cold water when it becomes stiff with sizing seepage from the moist paper. The second blanket is a little thicker and is called a forming blanket. The top felt blanket is finely woven and serves as the pusher blanket. Many printers place a protective sheet of clean newsprint on top of the paper before lowering the blankets.

The pressure of the press rollers will vary slightly from plate to plate. This is one of the reasons artists' proofs are made. Additional soft blankets or flat foam rubber may be used on the press to add extra pressure when you are printing a deeply bitten plate, or if you want an embossed print (in which the inked or uninked plate leaves depressed areas on one side of the paper and raised areas on the other). However, be careful not to force overload pressure on the rollers; make sure the drive handle still turns smoothly. Here is where help from an experienced printmaker is helpful.

In general a heavier pressure is needed when printing intaglio plates than with relief or smooth-surface (planographic) techniques, because the paper has to be pushed slightly into the incisions on the plate to pick up ink. If the plate is thinner than $1/16$" (0.16 cm), a blotter below it is useful for increasing pressure.

PREPARING THE PAPER

When interviewing for this book I found Arches Cover and Rives BFK white, both 250 gm/m² weight, to be the popular all-around papers for intaglio printing. Printmakers have experimented successfully with many other types of paper, however. Paper for intaglio prints needs to be moist when printed so that it can be pushed around the plate edges and into the inked lines without wrinkling.

Some printing papers have sizing and others do not. If you are using a sized paper, such as Arches cover, soak it in water until well saturated. Keep the paper clean and preferably flat when put in water. Large plastic trays are available for this purpose, but they are costly. Plastic storage bins from discount stores will work for smaller prints; mine will handle up to a 14 × 20" (36 × 51 cm) paper. If you use a bathtub or sink, be very careful to clean it well first of all residue of body oils and soaps. You can also make large paper-soaking trays with sturdy wooden sides lined with plastic sheeting. Hang the sheeting inside the tray by closely stapling or gluing it in the top edge of the wooden sides, folding or gathering the material at the corners, so that there are not holes where the water will be held.

Once the paper is well soaked, take it from the water bath and allow it to drip over the tray, and finally place it on a blotter. Put another blotter on top, and roll the "sandwich" of blotters and paper with a rolling pin.

Most paper is allowed to soak for at least twenty minutes. If the paper is heavily sized, it may need extra soaking to make it more receptive to the ink. When you remove the paper from the water bath, hold it over the water briefly until it stops dripping. Then place it on a dry blotter. Put another blotter on top and roll the "sandwich" of blotter and paper with a rolling pin. The paper should still be moist, but should have lost the wet shine on the surface to be ready for printing.

Another method of moistening papers is to interleave dry and then wet papers in a stack. You can moisten the wet paper with water and a sponge. Then wrap the stack of papers in plastic (large garbage bags work here) and put a board with extra weights on top to keep the stack flat. Leave the stack overnight. The next day all the papers should be evenly moist and fully prepared for printing.

If you are using an unsized paper, do not put it in a water tray, but instead mist it on both sides with water and cover it with plastic until the moisture is evenly distributed. Some unsized papers are sturdy enough to be stacked and then covered, while others are so fragile when wet that they have to be handled individually. The fibers of a moist fragile paper will start to pull apart when it is handled.

INKING THE PLATE

Intaglio plates are almost always inked with oil-based inks, although there is increasing experimentation with finding ways to use water-based inks for this technique. In general, intaglio inks must be thick

enough to stay in the incised lines of the plate, but still be soft enough to be wiped from the plate surface. Study proof prints carefully to make sure your inked lines and tones transferred as you expected.

If the plate surface is not wiping smoothly, you can add judicious amounts of Easy Wipe compound from Graphic Chemical & Ink Co. Another softening agent is thin #00 burnt plate oil, which is raw linseed oil that has been slowly heated. If inks are not catching and staying in incised lines, you can increase their

body by adding small amounts of whiting, a form of calcium carbonate available in paint supply stores. Faust etching inks are softer and juicier straight from the can than most other inks. Charbonnel Etching inks are available in tubes. Graphic Chemical & Ink Co. and Daniel Smith produce quality, reasonably priced inks in various can sizes.

To experiment with water-based inks, keep in mind that they can be thickened with whiting or thinned with water or extenders made for that brand of ink. The water-based

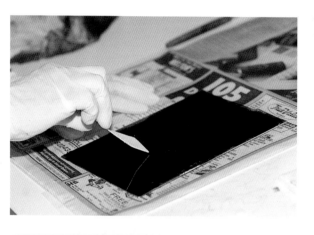

The ink is applied first with a piece of mat board.

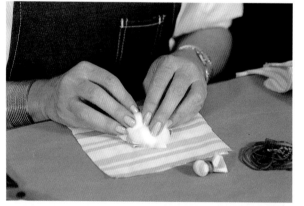

Dianne Haralson makes *à la poupée* cotton daubers for inking her plate. She stacks squares of old sheeting, puts a generous wad of cotton in the center, and fastens the "little doll" with a rubber band.

You will need one dauber for each color of ink. Here Haralson is using a dauber to pick up ink from a Plexiglas plate.

inks closest in consistency to oil-based intaglio inks are the water-based inks made for relief prints. The Colorcraft Company is developing water-based intaglio ink for the market. Many printmakers hope that intaglio water-based inks will be available shortly.

Engravings, drypoint engravings, and plates with acid-etched lines and aquatint tones have incised areas but no burrs sticking up. Small squares of mat board are most often used to pick up the ink and draw it evenly across the face of such plates. This is referred to as the carding method. The ink should catch in the lines while less ink remains on the surface. Practice will tell you how much ink to apply on the plate to fill the recesses but not leave too much on the surface that is to be wiped away. The plate can have a clean surface or a thin layer of ink left as surface tone.

The carding method is not used with drypoint and mezzotint because it might press down or remove the fragile burrs. Felt or *à la poupée* cloth daubers are more effective to press ink completely into the interstices of the plate without damaging the burrs. "Poupée" is the French word for doll, and the small cloth daubers made for this method of inking do resemble miniature dolls.

Although soft daubers are necessary with drypoint and mezzotint plates, they can be used with any kind of intaglio plate. They are often used to apply different colors of ink to different parts of a plate, for instance. Dianne Haralson uses *à la poupée* daubers to ink her acid-etched plates with more than one color. After inking, instead of a surface wipe, Haralson places the plate face down on clean newsprint and pushes it slowly across the paper surface. She then turns it upright and finishes the wipe with her hand, which she has dusted with whiting.

Richard Royce applies water-based Createx inks for the engraved work in his Plexiglas plate. (Photos on this page: Dwyer and Klein.)

First he blotted the surface with dry newspaper. Here he removes the last traces of surface ink by blotting with moistened paper.

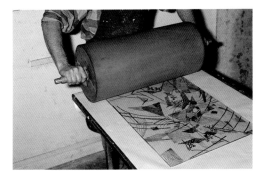

Next he rolls a rainbow roll of very thin yellow and violet water-based inks onto the surface.

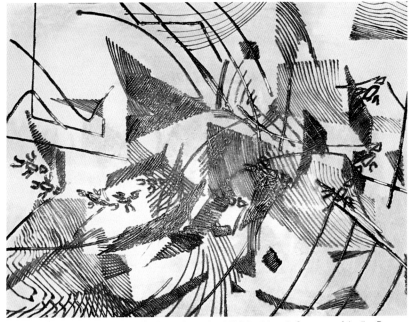

Richard Royce, *Sea Migration IV.* Engraving, 18 × 24" (46 × 61 cm). Courtesy of Atelier Royce. Royce is a forerunner in experimenting with how water-based inks can be used to print intaglio plates. Here he has achieved a soft watercolor effect.

After the plate is inked, most printmakers wipe the surface with cloth tarlatan, an open-weave cotton fabric that is stiff when purchased but is worked with the hands until it is in a softer and more pliable condition for this use. More care with a softer cloth and touch is used when printing plates with fragile burrs. However, the basic method for intaglio plate wiping is the same.

You can heat the plate at a low temperature to cause the ink to move more smoothly, but do not heat it above a temperature that is easily handled by hand or that would cause the ink to start drying.

Fold the softened tarlatan into a smooth wad-shaped pad, and wipe it in circular motions across the inked plate. Most printmakers lay the plate on newspaper for this;

some dexterous ones hold it in one hand and wipe with the other. The tarlatan forces the ink into the plate's recesses while simultaneously absorbing the excess from the surface. You can unfold and refold the wad different ways during the wiping to open up fresh surfaces to pick up ink. If the plate is lying on newspaper, the newspaper also picks up ink from the cloth when

Betty Sellars shows how she crushes new tarlatan in many directions for a good length of time to soften it.

She then holds the smooth round pad that she will use to wipe the plate.

Michael Ward demonstrates an age-old practice of smoothing the plate tone with the warm edge of a hand. This method is called a hand wipe. Don't do this if your plate has burrs, however.

Here she is wiping a plate with tarlatan, which simultaneously pushes ink deeper into the etched lines and removes unwanted ink from the surface.

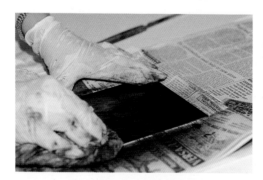

AnaMaria Samaniego uses old telephone book pages to wipe her plate further.

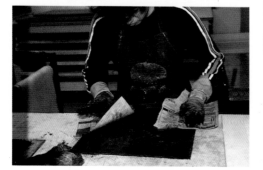

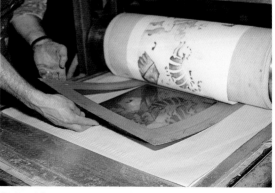

Richard Royce cut a metal template to hold multiple plates in registration. Here he lifts the flexible template to remove the plate that has just been printed; it slides neatly out. He will then drop the next plate in the template opening. The paper stays in registration by remaining engaged under the press roller. You can see the copper color of the plate and the images on the paper reflecting off it. (Photo: Dwyer and Klein.)

it overlaps the plate. The side of a warm hand is sometimes used to give the plate an even plate wipe; the warmth helps smooth out the remaining plate tones. Pages from an old telephone book can then be used to give the plate a final clean wipe.

Once the plate has been inked and wiped, you are ready to lay it plate-face-up on the press bed, carefully position your moistened and blotted paper over it, cover it with blankets, and roll it through the press.

MULTIPLE-PLATE PRINTS

If you are using more than one plate for the same print, you need an exact system of registration. A template, usually the same thickness or thinner than the plate, is one method to make sure the plate is put in correct registration with the previous printing.

When printing multiple plates for a colored intaglio print, ink all plates before working on the press. Have the plates lined up in the sequence they are to be printed. Next place the paper face down in registration over where the plate is to be placed. This is done by engaging the leading edge of the paper under the blankets and press roller, pulling the blanket back over the roller, and then pulling the paper back over the blanket.

Now set the first plate in registration on the press bed face up, and pull the paper down on top of it, followed by the blankets. Roll the paper and plate through the press, but leave the last edge of the paper engaged under the blankets and roller. Pull back the blankets over the roller. Then carefully pull back the paper and make sure the transfer of ink was complete. If it was not, increase roller pressure and send the paper and plate back through the press. Be careful to keep the paper engaged under the blanket and rollers until all plates have been printed.

 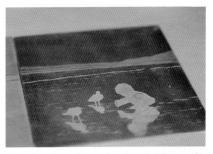

Dianne Haralson has two copper plates to ink. She developed them by drawing into soft ground and by using aquatint techniques. She heats both plates on a warming plate.

Left: Three colors are used to ink the first plate. Right: Haralson pushes the inked plate firmly face down on clean newsprint to remove excess ink while evenly blending the edges of the colors.

She sometimes completes plate preparation with a hand wipe.

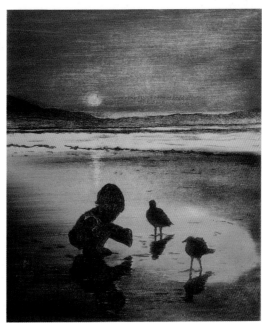

Dianne Haralson, *Stalking the Under Toad.* 11 × 15" (28 × 38 cm). Photo: KC Lab.

The two plates were inked *à la poupée,* inking more than one color on each plate. This allowed the artist to achieve a greater range of blended tones than if she had used one plate.

Betty Sellars developed this 12 × 18" (30 × 46 cm) aquatint plate to work in conjunction with a second plate. Here is a print of the aquatint plate alone.

Her second plate, the same size, was developed with line etching. This is how it prints alone.

Betty Sellars, *Winter Path.* Two-plate intaglio print, 12 × 18" (30 × 46 cm). Photo: KC Lab.

Here is the result with the second plate printed over the first. This two-plate technique gives the artist more options for handling color than etching both lines and tones onto the same plate. If Sellars had printed the plates in reverse order, the lines would be softer with aquatint tone printed on top.

Handle moist prints carefully as you take them to the drying space. Here Ron Pokrasso holds a newly made print with folded thin aluminum grippers that help keep the borders pristine.

Multiple-plate printing gives the printmaker virtually unlimited possibilities for combining colors and textures. Even changing the sequence in which several plates are printed can influence the look of the finished print, especially if you are working with several colors of opaque ink. I have seen both light ink printed over dark ink and dark colors printed over light ones.

Trial proofs are useful in any kind of printmaking, but this is particularly true when you are working with multiple plates. Experiment first before printing an edition.

DRYING THE PRINT

Lift your print carefully up from the press and lay it on a clean blotter, face up. Place a clean sheet of newsprint on top, then another blotter. You can put the next print on top, and repeat these steps until the day's printing is completed. A heavy board put on top of the pile will ensure that the papers dry flat. Change the blotters and newsprint papers daily until the prints are dry. Printing ink dries fast enough so that the prints do not stick to the paper above them; only the first set of newsprint coverings will have some transferred shadows of print ink.

Françoise Gilot, *Le Nuage Pourpre* (The Purple Cloud). Ten-color lithograph, developed on seven 30 × 24" (76 × 61 cm) zinc plates, printed at Fernand Mourlot Workshop in Paris, France, 1991.

4 LITHOGRAPHY

Alois Senefelder developed the process of lithography in the late 1700s. Senefelder was a playwright looking for an inexpensive means to reproduce his plays. In the process of cleaning a limestone slab, he discovered how an area that had once held greasy printing would still accept oil drops, while the clean wet stone rejected them. He went on to refine the process he termed both lithography and chemical printing. Although Senefelder did not immediately see how lithography could be used to reproduce artwork, the process quickly spread into the art centers of the world.

Stone lithographs are still being printed today. A number of lithographic studios and shops are equipped to afford and handle the stones. However, because the stones are expensive to buy and heavy to handle, many lithographers have switched to working on specially treated metal plates. In the recently introduced Litho-Sketch procedure, the artist works on sheets of heavy paper coated with a claylike substance. This makes lithography more available to schoolrooms and the home studio.

DEVELOPING THE LITHOGRAPHIC IMAGE

The lithography process is based on the principle that grease and water do not mix. The lithographer develops an image with materials that have an affinity to grease. After the image is completed, an "etching" solution of gum arabic and acid is applied over the entire surface. This mild etching solution does not etch away the surface as in intaglio printmaking. Instead it breaks down the fatty acids in the drawing materials and causes them to bind into the surface, while simultaneously opening up the areas that are not part of the image and making them receptive to water. This etching process is also referred to as desensitizing the plate.

Next the lithographer uses solvents to wash out the pigments and other nonessential ingredients from the drawing materials, but the fatty acids remain embedded in the surface. When the lithographer sponges water onto the stone or plate and then applies the first roll-up of ink, the ink sticks to the fatty-acid hydrophobic image and is repelled by the wet hygroscopic areas. (Even though the image was originally drawn in black, by the time you print, the black pigment has been washed away, and you can print in any color of ink you like.) To secure the image completely into the surface of the stone or plate, the lithographer repeats the entire etch, wash-out, and roll-up process before printing the edition. The drawn or painted strokes print much as they were first created.

Lithographic imaging materials are black, wax- and grease-based mediums with lamp black colorant added so that you can see what you are doing. You can draw on a plate or stone with lithographic crayons and pencils, or paint on liquid tusche—a liquid ink formula of grease, black pigment, and soap that is suspended in water or solvent. Charbonnel, Stones, and William Korn are popular brand names for tusche. The oils in hand and finger marks, though not always visible, may pick up ink later, so it's a good idea to protect the surface under your hands with a piece of paper or a shallow bridge.

Gum arabic acts as a resist to most of the imaging materials. Not only can you use it to block out margins, but you can paint it to fully protect areas that are to remain white. A margin of gum arabic around the edges of the printing surface creates a grease resist that makes the work easier to handle as well as provides a white margin around the print.

Splattered gum arabic will print as white dots if placed first under a dark crayon or tusche field.

MEDIUMS

You can use litho pencils and crayons, wax crayons, and soft graphite pencils to draw images. When the stone or plate is inked properly, the identical tones and sketched nuances—the lightest shades to the darkest blacks—will print as placed on paper, but in reverse imagery to the plate.

Liquid tusche can be painted in brushstrokes of varied toned washes or drawn with a pen, as in an ink drawing. You can splatter tusche, drybrush it, or dip textured materials in it and print them on the plate. You can also let tusche puddle and then dry in patterns. Dropping in

For this print, I painted liquid tusche on the plate with a brush and drew it on with a pen. I scratched white lines into the dark grass with a knife. Tusche was also splattered for additional texture.

I drew directly on a plate with a lithography crayon. Here is the resulting print. This was the fifth one pulled from the plate; in lithography the first few prints from a plate or stone are usually weak.

I used a Litho-Sketch ball-point pen on the plate to draw this printed image.

solvent or water during the drying time develops other effects.

Litho crayons can be dissolved and used with a brush. Rub the crayon on the bottom of a saucer and then work it with a brushload of water. The material melts quickly and can be painted using the same brush. If you use an oil solvent such as turpentine instead of water to dissolve the litho crayon, you will produce a greasier material that will attract more ink. Dissolved litho crayon can serve as a handy substitute for tusche.

You can create offset images by rolling a clean brayer over an inked image (either already on another part of the plate or made on a different surface) and rolling it out on the printmaking surface. Laces, organic materials, and flat found objects can be used in this process; simply ink the object with one brayer, roll a clean brayer over it, and roll it onto the lithographic surface. You can lighten dark areas by scratching with a knife or razor blade. This does not damage the plate or stone.

The process of developing imagery from a dark inked field is called manière noire. The lithographer first paints the surface with dark tusche and then uses X-Acto knife blades, sandpaper, and other scraping devices to bring out the lights. Shading can be made by painting and manipulating the ink with solvents such as mineral spirits or turpentine.

TRANSFERRING AN IMAGE FROM ANOTHER SURFACE TO THE PLATE OR STONE

Computer printouts, newspaper prints, and photocopy prints can be transferred to a lithographic plate or stone. Place the image face down on the plate and sponge the paper with an appropriate solvent—mineral spirits, acetone, isopropyl alcohol, or turpentine, depending on what ink was used to create the image

you're transferring. (Make test sheets to determine the correct solvent.) The transfer can be done by hand-rubbing the moistened paper and plate together or by running them through the press.

You can also develop imagery on coated or uncoated transfer paper before transferring it onto the printing surface. Coated papers have a layer of water-soluble material that will dissolve and transfer the imagery. Draw on the paper with lithographic crayon or some other greasy medium. Then put the paper face down on the printing surface, and moisten the back of the paper until its coating begins to dissolve. By peeking under a corner of the paper, you can tell when this starts to occur. Next run the printing surface, with the paper still on top of it, through a press. The coating and the greasy image will be transferred from the paper to the printing surface. During the wash-out step later on, the water-soluble material will wash off, and only the grease from the imagery will remain. Uncoated transfer paper works in a similar way, except

that it requires heavier pressure to transfer the image.

Although transfer paper is helpful for transferring prints that have dried, lithographers more commonly offset-transfer wet prints. For this technique you do not need special transfer paper. Make the print you want to transfer on a relatively smooth paper surface. While the ink is still wet, lay the print face down on the second printing surface. Then make the transfer by running them through the press. These techniques are useful for transferring a master print onto more than one surface for registering multiple-plate prints, or if you are using parts of another print to develop new imagery.

Still another approach is to develop the image on Mylar sheets with oil-based inks, and then transfer it to the stone or plate while the ink is still wet. My book on monotype suggests the many ways that work can be developed by painting or rolling ink on such material. It is believed that Degas occasionally used the monotype process as a first step in making his lithographs.

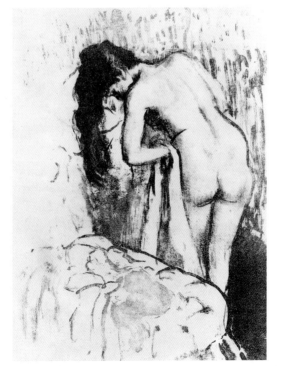

Edgar Degas, *Nude Woman Standing Drying Herself.* Lithograph, fourth state, 16 11/$_{16}$ × 12 1/$_{16}$" (42 × 30 cm). Courtesy of The Fogg Art Museum, Harvard University Art Museums, bequest of Meta and Paul J. Sachs.

This was one of six states of a tusche and crayon drawing believed to be done first as a monotype on a celluloid plate and transferred to stone for the first state.

PAPER-PLATE LITHOGRAPHY

An uncomplicated introduction to lithographic printmaking techniques is with the Litho-Sketch process. The plate is a coated paper "master" that is receptive to litho crayons, litho pencils, tusche, and other drawing materials. The techniques of applying these grease-loving mediums are similar or often identical to those used on stones or metal plates. You also apply Litho-Sketch desensitizing solution, which comes in a bottle and makes the image hydrophobic and the rest of the plate hygroscopic. The plate work is printed on paper by hand-rubbing with the back of a spoon or with an etching or lithography press. The edition limit is between 10 and 30 prints; the crayon and pencil work breaks down first and the tusche holds the image the longest.

THE PAPER MASTER

The white side of the Litho-Sketch master paper is a receptive, clay-coated surface where you draw with Litho-Sketch or other brands of lithographic crayons or tusche. The back side is colored. You can easily cut the paper into desired shapes, which means that it is more economical to buy the larger sizes. To avoid a plate mark on the print—a visible embossed outline of the edges of the plate—the master should be the same size as, or larger than, the print paper. Some artists prefer to mount the larger sizes of masters with spray adhesive on materials such as thin Plexiglas; they find that the plate can later be removed and the Plexiglas reused.

DESENSITIZING THE SURFACE

Once you have developed an image on the paper master, the surface is ready to be desensitized with the Litho-Sketch solution. This is where paper-plate lithography is considerably simpler than that done on a metal plate or a stone. In the other processes there is a wash-out stage where the drawing material is washed away, leaving only a grease-loving but nearly invisible image. This doesn't happen with Litho-Sketch. The desensitizing and etching phases are combined into one, and the drawing materials themselves stay on the plate. Because the Litho-Sketch solution must be kept clean, it is best to pour the amount to be used into a saucer. Use lintless cloths such as Webril Handi-pads to wash the plate. Do not let the nonimage areas of the plate dry before you finish inking them, or the ink will also deposit in the dry areas.

INKING THE SURFACE

To ink a lithographic stone or plate, roll a brayer over the surface a number of times until a good, even layer of ink is established on the image. Whether the lithographic surface is stone, metal, or paper, the first few prints are usually weak, but the stone or plate holds more ink after it's been inked, desensitized, and printed several times. At that point the stone or plate is up to full printing strength.

You will need a soft roller or brayer the width of the image for the most effective inking. If the brayer you are using is narrower than the

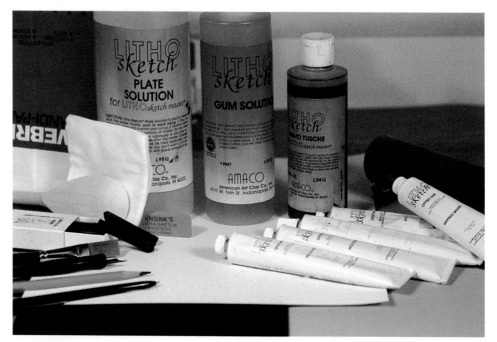

The materials needed for a paper-plate lithograph. Back row, left to right: Lintless cloths used to apply the plate solution, the plate solution, the gum solution used to preserve whites, and liquid tusche. Front left: suggested drawing materials include lithography crayons, a synthetic brush, a dip pen, a pencil, a ballpoint pen, and a special eraser. The white sheet underneath is the printing surface of one plate, and the blue sheet underneath on the right is the back of another. The tubes contain the printing inks. The flat wooden spoon is for hand-rubbing plates if you don't have access to a press. On the far right is a large rubber brayer for rolling ink onto the plate.

After painting the paper plate with tusche, Kurt Nilson wipes the surface with plate solution.

He then inks the plate and lays the paper on top. If a press is not available, the plate and paper can be rubbed with the back of a spoon or a baren.

Nilson pulls the print from the plate.

image, you can roll across the paper master repeatedly, establishing a pattern of inking. You overlap the "stripes" of ink, but not always in the same place, until the ink is evenly distributed over the whole design. Unless the brayer's circumference is large enough to cover the entire surface with one roll, you will be limited to inking one color at a time.

The Litho-Sketch inks are made nontoxic for the school trade by removing the driers (varnishes). You can experiment with other thin, well-pigmented oil printing inks. Roll out the ink on a slab until a full charge is evenly picked up on the roller, and then roll it onto the image. Repeat this process several times, always desensitizing the plate to keep it moist between recharges of the brayer with ink. Before you print the plate, it should have several layers of ink and desensitizing solution, so that it looks moist in the nonimage areas and dry, the same as drawn, in the image areas. Colored ink will show up on the plate better than black ink.

Print the image onto dry paper. Printmaster paper with a hard surface works well and is a popular choice for low-budget projects, but finer papers can also be used. You can print by rubbing the paper on top of the paper master with a baren or the back of a spoon. The image can also be printed with an etching press using a firm blanket, or transferred with a lithography press. After making the first print, ink the plate once, desensitize it with Litho-Sketch solution, ink it again, and print it again on a new sheet of paper.

Ink eventually sloughs off the image and floats into the wet area, where it will attach if it is allowed to dry. Give the plate a heavy wipe with the desensitizer to pick up unwanted ink and bring back the image. Then firmly run the inked brayer over the surface and continue to roll it beyond the plate edge. Both these steps help restore printing quality.

STONE LITHOGRAPHY

The stones used in stone lithography are finely grained limestone. The favored stones are especially dense as a result of being from the oldest geological formations subjected to intense pressure. Most lithographic stones are from Bavaria and are still mined and carefully rated as they were over a hundred years ago. They are available in the United States through Graphic Chemical & Ink Co. in Villa Park, Illinois.

The stones are particularly heavy and need special handling. Some of the larger stones require a mechanical lift to move them. The $12 \times 18 \times 3''$ stone used for demonstration illustrated on this page weighed forty pounds.

We are invited to observe as Mary Dryburgh demonstrates stone lithography procedures to her students in the print studio at the University of Tulsa. Five class sessions will be used to complete the ten steps involved in the process.

The studio is well equipped with a large "library" of numbered stones. There is a special sink for graining the stone. A sturdy cart is available to hold the stone as it is developed. There is a well-kept, beautifully crafted Alexander Hogue lithography press that has served students for several decades.

STEP 1: GRAINING THE STONE

Dryburgh places the stone on a wooden rack in the graining sink. Because a great deal of slurry will be washed down the drain, the sink has special plumbing. There is clear imagery left on the stone, which Dryburgh initially removes with solvent and scouring powder. She then checks to see whether the stone is level.

Dryburgh lays a metal straightedge upright first across each diagonal and then across the centers of the width and length. Each time, she places small slips of paper under the metal edge at short intervals. Dryburgh tugs at the papers to see which hold firm and which pull free, indicating high and low places in the surface. She repeats this process through the graining process to make sure the needed corrections are made.

She then flushes the surface of the stone with water and sprinkles the coarsest grit (number 100 carborundum) on top to make the first grinding slurry. After placing a second smaller stone face down on the slurry, Dryburgh moves the smaller stone in a lazy eight pattern across the surface, spending extra time in any high spots that need to be leveled.

Some printmakers prefer using a circular grinder with an eccentric handle called a levigator. Power levigators are also available. These are generally used by the most experienced printmakers and in professional shops.

After the first slurry, a finer grit of number 180 carborundum is used, and Dryburgh continues the measuring and grinding periodically to see how the stone is progressing. She makes the final refinement with number 220 grit slurry.

A flat file is used to make a slight bevel along all the edges of the stone. This will prevent damage to the leather ink roller and smooth out any nicks in the edge of the stone.

Now Dryburgh thoroughly rinses and dries the stone and moves it to a table-height cart. This is the end of the first class session, so the stone is covered with clean newsprint to protect the freshly receptive surface.

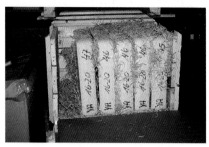

Cut blocks of dense limestone from a century-old Bavarian mine have arrived at Graphic Chemical & Ink Co. near Chicago. They have special markings as part of the traditional grading system classifying their suitability for printmaking. (Photos on pages 100–103 taken at University of Tulsa Print Studio.)

Mary Dryburgh demonstrates how to check that a stone is level. She lays a metal straightedge over a line of paper slips. If the paper can be pulled out from the metal edge, the surface of the stone is not level.

Dryburgh demonstrates how to resurface a stone on a wooden rack in the graining sink. Here she is using a smaller stone to rub carborundum slurry against the stone's surface.

STEP 2: DEVELOPING THE IMAGE

Dryburgh begins the next session by painting a 1-inch margin of gum arabic around the borders of the surface, so that any fingerprints or accidental inking can be wiped away and will not print on the paper. The students proceed to develop the image in a joint venture, investigating various mediums as they work. Lithographic crayons, gum arabic, and stick tusche are all put to use. Some students draw with the crayons and then dissolve the lines in water or solvent to paint washes. Others use pens to draw with liquid tusche on the stone. Keep in mind that lithographic drawing materials are black, and in this demonstration the stone will also be printed with black ink, but that need not necessarily be so; the color of the drawing materials is completely unrelated to the color or colors of the finished print.

Dryburgh demonstrates how to rub stick tusche on a glass saucer and then dissolve it by working it with distilled water. She also shows how to flip gum arabic from a saturated brush to create splatter. At the end of this second session, the stone is again covered with newsprint for protection.

STEP 3: THE FIRST ETCH

Dryburgh first dusts the stone with powdered rosin and brushes the excess off. She then powders talc over the image, again brushes the excess off the stone, and briefly polishes the stone with cheesecloth to make sure all loose particles are removed. She works briskly, but not so hard as to smear the image. Both the rosin and talc serve to set the greasy drawing material and keep it firm so that the edges of the image are less likely to break down in the etch.

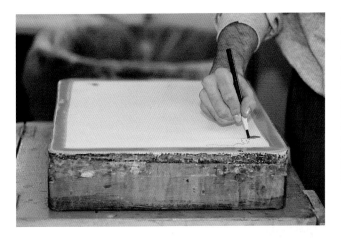

Afterward the edges of the stone were beveled with a file so that they slant crisply downward. Next a 1-inch (2.5 cm) border of gum arabic was painted on the surface, and the drawing begins here with a lithography pencil.

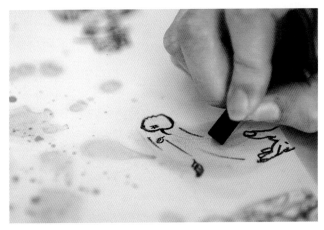

Lithographic crayon is being used to draw directly on the stone face. You can see where gum arabic was splattered to act as a resist to the ink.

Dryburgh dusts the stone with powdered rosin and brushes off the excess. This helps firm up the image so that it will stand up to the etch.

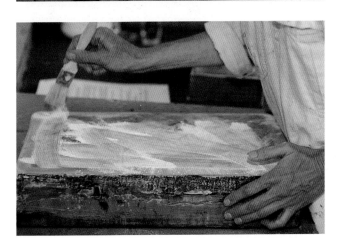

Then she powders talc over the image; this sets the image still further. Again she brushes the excess off the stone. Then she briefly polishes the stone with cheesecloth to make sure all loose particles are removed.

At the sink, Dryburgh opens a small glass bottle of full-strength nitric acid. *I strongly recommend using heavy-duty rubber gloves whenever working with acid.* Carefully she drops 15 drops into the already measured 1 ounce of gum arabic. This is a rather hefty etch formula to accommodate this particular image, which has been drawn and painted on quite heavily and thus needs a stronger etch to break down the fatty acids. Half this amount of nitric acid in gum arabic would be sufficient for light pencil work.

Dryburgh tests a few drops of the etch on a clean edge of the stone. A small amount of effervescence is apparent as the mixture reacts chemically with the limestone, so she uses an inexpensive commercial acid brush to paint the etch onto the stone. She starts where the imagery is heaviest and gradually works outward to the untouched parts of the stone. When the entire surface is covered, she continues to manipulate the etch delicately to make sure no spots have been missed. The etch solution of nitric acid and gum arabic breaks down the fatty acids in the greasy drawing materials and makes the image adhere to the stone, while simultaneously making the rest of the surface receptive to water.

Dryburgh leaves the etch on the stone for another two or three minutes. She then fans the surface dry and polishes it with cheesecloth, leaving the etch in a thin dry layer of film. She then lets the stone sit for half an hour, allowing the etch to cure the surface further.

STEP 4: THE FIRST WASH-OUT OF THE IMAGE

Lithotine, a solvent commonly used for this purpose, is then wiped across the surface of the stone. It penetrates the drawn image and washes out the black pigment and other nonessential ingredients of the original drawing materials. However, their colorless fatty acids remain and are now embedded in the stone surface.

Next Dryburgh sponges water onto the stone. While the surface is still wet, she wipes on liquid asphaltum, which is repelled by the moist nonimage areas but adheres to the grease-loving imagery. The asphaltum becomes a protective coating on the image and a strong base for inking. After the asphaltum has dried, Dryburgh washes the gum etch from the stone with a sponge and water.

STEP 5: THE FIRST ROLL-UP OF INK

Dryburgh keeps the stone moist while rolling ink onto it by alternately sponging the surface with water and rolling on the ink. The right amount of water will permit the ink to roll only onto the image. Too much will interfere with the roll-up, and too little will cause dry areas where the ink will deposit incorrectly. Dryburgh uses a stiff roll-up lithography ink for this step and rolls it onto the stone with a leather roller. After the image is fully inked, some lithographers make a first proof print, though the stone is not ready to print an edition. Dryburgh elects not to make a proof but to continue to the second etch.

STEP 6: THE SECOND ETCH

The ink on the stone surface acts as the originally drawn imagery did in the first etch. Dryburgh dusts the image first with rosin and then

Dryburgh uses a solution of nitric acid and gum arabic as the etch to make the image adhere to the stone and open the water-receptive surface. Although she works bare-handed, *I strongly recommend heavy rubber gloves for this procedure.*

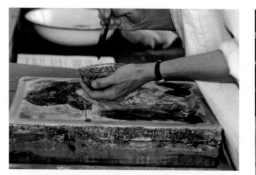

As the surface is dried with a fan and hand-polished with cheesecloth, the etch solution dries in a thin film across the entire surface of the stone.

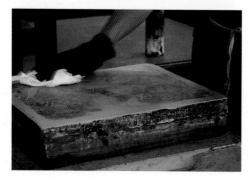

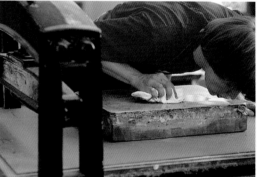

Lithotine is then used to wash out everything but the fatty acids from the image. Here Dryburgh applies hot breath to loosen a stubborn bit of imagery. Then she moistens the surface of the stone with a sponge and water. When all traces of dark pigment are gone, a colorless, water-resistant image will remain. A thin layer of liquid asphaltum is added to secure the image and form a base for catching the ink when it is rolled onto the surface.

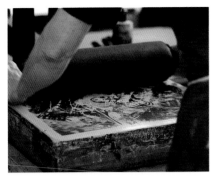

Before the second etch with a weaker gum solution, the stone is inked with a large leather roller. Before the stone is ready for printing, the steps of the first etch must be repeated: You dust the stone with rosin and talc, apply the etch and let it dry as a thin film on the surface, wash it out with lithotine, sponge off the stone with water, apply asphaltum, and then roll up the stone with ink.

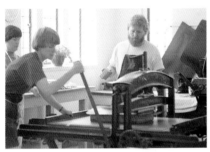

Students assist with the inking and sponging of the stone. Here Dryburgh lowers the blade of the Alexander Hogue press. The tympan sheet covers the inked stone and paper. Grease was applied to the top of the tympan sheet, away from the paper, to help the blade slide smoothly.

The finished print, a joint effort of Dryburgh's printmaking class.

with talc to firm the shapes and edges of the imagery in preparation for the second etch. This final etch completes the process of embedding the fatty-acid imagery into the stone so that it can serve as the foundation for the lithographic edition.

The second etching solution is a weaker formula. Dryburgh mixes 10 drops of nitric acid in 1 ounce of gum arabic and applies it with an acid brush in the same manner as the first etch.

STEP 7: THE SECOND WASH-OUT

After the etch has dried on the surface as a thin film, Dryburgh washes out the image with lithotine. She then sponges the excess lithotine and gum etch from the surface with water.

STEP 8: APPLYING ASPHALTUM

Now Dryburgh wipes the stone with water and a thin layer of liquid asphaltum, which again adheres to and protects the image.

STEP 9: THE SECOND ROLL-UP

Making sure that the surface is kept moist with water, Dryburgh rolls up the image with ink. This is the inking that could produce proofs and even an edition, but in this case the stone is covered for the next class session.

STEP 10: PRINTING THE STONE

For this session, the stone is moved to the lithography press bed. The surface is sponged with 50 percent water and 50 percent gum arabic, which opens the surface. Dryburgh removes the dried ink from the last session with lithotine. The surface is kept moist as asphaltum is applied on the imagery to become the foundation for the inking. (This "backtracking" of removing dried

ink, applying asphaltum, and applying new ink is necessary only because of the time gap between the last class session and this one. Normally the inking in Step 9 would be the final inking before printing the stone.) Dryburgh pays particular attention to the nonimage areas and is careful to wipe out any smudges with gum arabic. Stubborn marks are removed by rubbing with a snake slip—a hard, claylike stone available in lithographic supply stores. In this class session, Dryburgh chooses two students: one to ink the plate and the second to sponge the surface with water.

Ink is slowly rolled on the surface five times, and the sponging is done between rolls. It is important to roll the ink in a pattern that will provide a good, even layer. Paper the width of the stone has been chosen for the printing, and it will be printed dry. Dryburgh positions the paper on the stone and puts a leather-covered blade the width of the stone in the press. She then lays a pressboard tympan sheet over the paper and stone. Mutton grease is spread in a line across the pressboard near the blade; the blade will smooth it out over the tympan sheet as it travels across.

Next the blade is lowered onto the printing surface, and the stone and bed are driven under the blade. The blade is released, the tympan removed, and the print pulled from the stone.

It is a weak print, as expected. Most lithographers print the first few proofs of each edition on newsprint or other inexpensive paper for this reason. It takes six more printings until the stone's image holds enough ink to make a full-strength print. Dryburgh and her students continue to repeat the steps of inking the stone, wetting it, and running it through the press until there are enough full-strength prints for each of the class participants.

METAL-PLATE LITHOGRAPHY

Zinc and aluminum used for lithography are treated ("ball-grained") to create a surface with a special tooth that is receptive to the technique of water resisting grease. Anodized and smooth, brush-grained plates are made for photo lithography techniques. Aluminum plates are currently the more readily available of the two metal surfaces for hand-drawn or painted lithographic work. They are made by specialty suppliers such as Takach Press Corporation in Albuquerque and Graphic Chemical & Ink Co. The latter company sells them in two sizes: 25 1/2 × 36" (65 × 91 cm) and 24 × 28" (61 × 71 cm). Metal lithography plates should be stored flat with paper protection from scrapes and damage.

COUNTERETCHING AND MOUNTING THE METAL PLATE

Before using an aluminum plate, use metal shears to cut its sharp corners slightly rounded. Then counteretch it to remove all traces of foreign material or oxides. This process will also make the plate more receptive to the lithographic imaging materials. A bath in a mild acid solution, such as 28 percent acetic acid in water, will accomplish this. Dewayne Pass simply runs his plate under hot water while wiping with cloth to remove traces of grease and oxidation; he finds this process a sufficient substitute for counteretching. After the bath, rinse the plate with clear water and fan or blow it dry.

Dewayne Pass developed the imagery for this demonstration on an aluminum plate with lithographic crayons. He had already counteretched the plate and drawn the image there before he demonstrated the rest of the procedure for us.

He begins by mounting the plate on a backing to give height to the surface; his backing block was purchased from Graphic Chemical & Ink Co. Some other printers use smooth stones, slate, or ground metal to back their lithography plates. Pass mounts this plate by sponging a mixture of 50 percent gum arabic and 50 percent water on the backing surface and manipulating the plate in small circles on the wet surface until the plate is held by suction to the backing. He then wipes the surface of the plate with the same solution to prepare it for the first etch.

Minna Resnick, *Still Life with Triangles #1.* Lithograph drawn on aluminum plates, 30 × 22" (76 × 56 cm). Courtesy of the artist.

This artist develops her own metal plates, showing a great deal of drawing mastery as well as knowledge of the lithographic medium. She uses Prismacolor drawing pencils and prints her plates on a Takach-Garfield lithography press on dry paper.

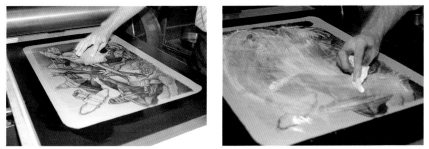

Left: After he has used a 50 percent gum arabic solution to secure his aluminum plate to the backing, Dewayne Pass wipes the surface with the same solution. The gum arabic, even without acid, is a mild etch that starts to open up the plate. Right: He then dusts talc onto the surface. (Photos on pages 105–106 taken at Tulsa Junior College printmaking facility.)

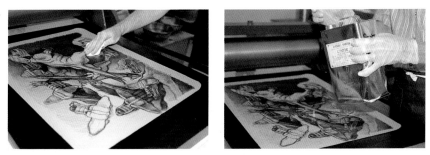

Left: After brushing away the excess talc, he wipes the surface with Hanco tannic acid etching solution. Right: Pass begins to wash out the image with lithotine. You can see that the black pigment is still strong in this photo but has been removed by the next one, where the image appears as a dull, greasy gray.

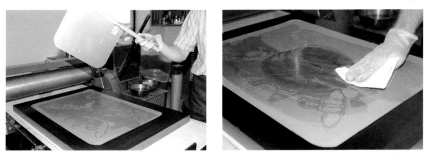

Left: The plate is dried by twirling the blade of a lithography fan. Right: Now Pass wipes the image with asphaltum, which secures the image further and becomes a base for the ink. He repeats the steps of dusting with talc, applying and drying the etch, washing out the image with lithotine, sponging the surface with water, applying asphaltum, and inking the plate.

THE FIRST ETCH

Pass dusts the imagery with fine talc. Starting with the denser areas of line and tone, he applies the etch to the entire plate with a lintless cloth; a soft brush can also be used for this. Just as Mary Dryburgh did when etching her stone, Pass covers the denser work first so that it will have the longest exposure in the etch. The most convenient and safest etch material for aluminum plates is Hanco tannic acid etch. After letting the acid set a couple of minutes, Pass wipes the plate and then buffs it dry to make a thin film across the surface. He then lets the plate sit for at least thirty minutes to cure.

Here Pass uses an extra step of wiping on Handschy fast-drying deep etch lacquer. This further sets the fatty acids in the metal plate surface, which is not as open to this process as the stone. He then uses a fan to dry the entire surface, buffs the plate again, and leaves it to cure for another 30 minutes.

At this point Pass sponges the plate again with the gum solution and washes it out with lithotine. Next he uses Dancolite lacquer thinner to remove the lacquer etch. The surface is then moistened with the gum solution, and liquid asphaltum is wiped on. Then he rolls on an even coat of lithographic ink.

THE SECOND ETCH

The plate is then etched a second time. Pass dusts talc onto the inked image and repeats the two different etch processes of Hanco tannic acid etch followed by Handschy fast-drying deep etch lacquer. Keeping the plate's surface moist just as before, he washes out the image with lithotine. Pass follows this wash-out with the lacquer thinner to wash out the deep lacquer etch. He then rubs up the plate with asphaltum, sponges it with water, and rolled it up with ink.

THE THIRD ETCH

By now many lithographers would consider the plate ready for the first print, but Pass prefers to make a third etch before he pulls a first proof on newsprint. In the third etch Hanco tannic acid etch alone is used. Lithotine is the only material needed for this wash-out. The plate is rubbed with asphaltum, butted down tightly, and dried. It is then sponged with water and rolled up with ink.

ALTERNATIVE ETCHING METHODS

Minna Resnick develops her plates similarly to Pass's with some exceptions. She prefers to use Alumiprep cleaning solution, in a ratio of 2 ounces to 1 gallon of water, to prepare her plate for the first etch. Alumiprep cleaning solution can be found in auto supply stores. For the actual etch, Resnick sometimes uses gum arabic solution at Baumé 14 as a mild etch, wiped on thinly and smoothly and then buffed dry.

This weaker etch is appropriate for the more delicate imagery on Resnick's plates. She then washes the image with lithotine, sponges it with water, and rolls it up with ink.

PRINTING

When you are ready to print your plate, sponge it with water and ink it in an organized pattern that will reach all surfaces as evenly as possible. Just as in stone lithography, set the plate and its backing on the press bed for sponging and inking, and set the paper carefully onto the plate. (Oil-based inks do transfer to moist paper; lithographers use either moist or dry paper according to preference.) Some form of pencil registration marks in the margins on the plate that will align with marks on the back of the paper will help here. The typman sheet of the lithography press protects the paper as the blade slides across.

Pass used an etching press to demonstrate the printing process because the studio did not have a lithography press. With the mounted plate on the press bed, he placed a sheet of dampened paper over the plate, aligning the registration marks. Over this he laid a sheet of newsprint, then a presswood tympan sheet. To increase pressure, he added a blotter or a thin blanket on top. The fifth print was at full ink saturation. For each additional print, Pass inked the plate twice and sponged it with water.

CORRECTING THE IMAGE

If corrections are to be made, you must bring the plate back to the state before the etching process, no matter what etching method you used. This is done by cleaning it with lithotine (and lacquer thinner if you used lacquer etch). The surface is now open for additional drawing. To make deletions, you can use Baron's image remover to

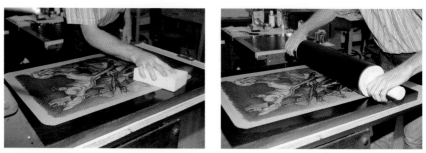

Left: When the plate is ready for printing, Pass sponges it with a mild gum solution, which helps secure the image; metal plates do not hold the imagery as easily as stone ones. Right: Then he inks it with a roller.

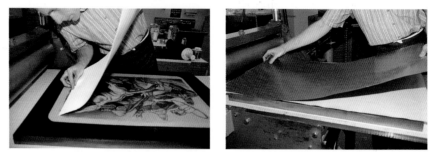

Left: There are registration marks on the back of the dampened paper as well as on the edges of the plate. Right: The tympan sheet is laid on top. Because a lithography press was not available, Pass used an etching press. This Sturges etching press has enough room for the backing block, plate, and tympan sheet to pass through under the rollers. Pass uses the tympan sheet on the etching press because it is hard and will press evenly across the planographic surface.

Left: Dewayne Pass pulls a proof. Below: A finished print. You can see that the imagery drawn with lithographic crayon was quite faithfully reproduced by the process of metal-plate lithography. Not only the lines but their varying tones show up beautifully.

Dewayne Pass, *Up and Away, Goodbye Joe.* Lithograph, 15 1/2 × 23" (39 × 58 cm).

remove the traces of drawing. This can be done by isolating the area with Contact paper and carefully wiping out the detail. After corrections and additions are made, repeat the complete etching process to prepare the plate for printing.

OPENING AND CLOSING DOWN THE PLATE

If the plate must be left for a short period of time—say, for a half-hour lunch—ink it twice and sponge it with a mixture of 50 percent gum arabic and water. Loosely dry it. When you return, "open" the plate by splashing on water, and then resume the printing steps.

If the plate is to be put aside for a longer period, "close it down." This is done by carefully sponging and inking the plate as if it were to be printed, and then fan-drying it. If you like, you can remove the plate from its backing material. To open a plate that has been closed down, reattach it to its backing material, if any, and repeat the steps of the last etch: Dust it with talc, etch it with the appropriate etch formula, wash out the image with lithotine, and roll up the surface with ink.

COLOR PRINTS

Color prints are possible in hand-printed lithography. A single plate can be printed by offset registration to print a shadow second color. You can also ink a plate with a rainbow roll of colors. Inked stencils can be used on top of an inked image to print in different colors. However, multicolor lithographs usually require printing more than one plate. Multicolor photolithography is described later in this chapter, and similar principles apply for hand-drawn work: Ink each plate in a particular color, and then print all the plates in registration and sequence on top of one another.

David Kapp, *Merge.* Lithograph, 25 × 36" (66 × 91 cm). Courtesy of Solo Press, Inc.

When Kapp worked at Solo Press, Inc., he worked with Nancy Bressler, printer, assisted by Laurie Switzer and Denise White. Judith Solodkin, master printer, was available for direction. Kapp worked on six aluminum plates, painting with water and solvent tusches and drawing with lithography crayon.

Rafael Ferrer, *Mercado* (Marketplace). Lithograph, 30 × 44" (77 × 1122 cm), 1991.

Ferrer worked with printer Bud Shark of Shark's Inc. in Boulder, Colorado, to make this lithograph by working directly on seven aluminum plates with lithography pencil and crayons.

PHOTOLITHOGRAPHY

Lithographic photodeveloped plates require transparent positives of the artwork. It is not only safer but more economical to buy presensitized plates than to try to coat plates with the chemicals yourself.

Eric Lindgren worked on multiple sheets of transparent Mylar. He made one positive transparency for each color of ink to be used, inking the sheets with black etching ink and wiping out the areas not to be printed with tarlatan. Remember, the colors used to *draw* the image are unrelated to the colors used to *print* the image. Lindgren's colors are not the same as those used in commercial four-color process printing (for instance, he used two blues), but you could work with four plates: magenta, yellow, cyan blue, and black.

Each positive transparency was exposed and developed on Fuji FPD coated aluminum plates at Hand Graphics in Santa Fe. (Each brand of photosensitive plate should be developed according the manufacturer's specific instructions.) After Lindgren's photosensitive plates were developed, they were inked and printed similarly to hand lithographic processes, except that the photodeveloping solutions replaced the etch and wash-out steps we have discussed in other lithography techniques. When developed, the plates were ready for the printing steps. Master printer Michael Costello was in charge of both the developing and the printing. The plates were printed one color at a time. Lindgren assisted Costello with the water sponging during the printing process. In this case each plate reached full ink saturation right away.

The finished print appears on the jacket of this book.

Left: Eric Lindgren painted on textured Mylar with etching ink and tarlatan to make the positive transparency for each plate image. This is a print from the first color plate. Right: It was followed by a yellow plate. (Photos: Robert Brady.)

Above: Michael Costello, owner and master printer at Hand Graphics, Santa Fe, secures the registration before lowering the print on the second plate inked in yellow. Right: Costello checks the print as it is pulled. The plastic tympan sheet on the right is raised by a pulley system. The Takach-Garfield press was made in Albuquerque. (Photos: Gail Ayres.)

Left: Costello inks the roller for the next plate. This roller has a large enough circumference to ink the plate with one rotation, which ensures that it will be inked evenly. Right: Eric Lindgren, the artist, assists Costello by sponging the plate with water. (Photos: Gail Ayres.)

Next in the sequence of colors was a dark blue plate. (Photos on this page: Robert Brady.)

Then came a red one. You can see the colors gradually building up on top of one another.

Lindgren drew on the next plate with lithographic pencil and inked it with salmon-colored ink.

Eric Lindgren, *Looking Back.* Lithograph on Arches Cover paper, 20 × 20" (51 × 51 cm).

The finished print. The last plate was inked with a blend of inks, transparent at the top and ultramarine blue at the bottom. All plates were printed by Michael Costello at Hand Graphics, Santa Fe.

Lynwood Kreneck, *Audience of the Clown,* 40 × 30" (102 × 76 cm). Courtesy of the artist. Screen printing was one of several steps used in developing this image.

5 STENCIL AND SCREEN PRINTS

One of our earliest ancestors placed a hand on a cave wall, applied pigment around the outside of the fingers, then removed the hand and left the earliest known stencil work. The hand served to block pigment from reaching the cave surface, leaving an image of a hand shape in a pigmented field. This is the same basic technique of stencil and screen printing used today: A stencil material blocks the areas not to be printed.

The hand shape on the cave wall was made with a positive block-out; the negative space around it was colored. If the hand had been placed on some thin material and the shape traced, cut out, and removed, the remaining shape would be a negative stencil. This type of stencil allows the positive shape to be printed through the "hole."

The technique of developing images with a number of stencils without a screen is referred to as pochoir, the French word for stencil. In screen printing the stencils are attached with tape to the bottom of the frame. Stencil and screen prints range from simple, flat-color designs to complex, screen-printed halftone photo images.

These techniques are sometimes used under or over other printmaking techniques to add color or special details. Cut stencils are used for airbrush work on prints as well as other artwork.

STENCILS

Making a single stencil print is the simplest introduction to this technique. Try using coated paper, Mylar, or oil board—a thin, hard-treated cardboard made for stencil work. Trace the design onto the surface, and then cut it out with an X-Acto type of knife. The knife cuts out the areas that are to be printed. You can then apply the paint with a brush, foam roller, or airbrush.

The image that faces you will be the one that prints on paper, so it need not be reversed. The open, cut-out shapes will allow the ink to pass through and print on the paper below. In most cases you will need a separate stencil for each color you want to print. This will require accurate registration, which can be accomplished by tracing a master onto each stencil. If you are using opaque inks, it is usually best to print the lighter colors first, then the middle tones, and finally the darker inks, so that the dark colors will not appear as shadows under the lights. However, you can experiment with different color sequences to get different special effects.

Some stencil materials can be run through a copy machine to transfer the design. Do your drawing on paper, then photocopy it onto card stock or transparent plastic, depending on what your copier can accommodate. If you are not using a professional copier service, it is important to refer to the individual copier manual to check which materials are compatible with that specific copier. A copier is especially helpful if you are cutting more than one stencil, because it allows you to repeat the design quickly and accurately.

CUTTING OUT THE STENCIL

Before cutting, make sure there will be protection against cutting the table surface. Many printmakers use cardboard for this purpose and discard it when it becomes too scarred; glass is used by others. The most pleasant to use are the self-sealing pads of translucent plastic made for this purpose, often made of five-ply PVC plastic. "Self-sealing" means that the plastic seems to close up again behind the scratch as you go, so that you still have a smooth working surface. X-Acto is the brand name of mine.

Try to cut through the stencil material but not into the backing surface. Some screen-printing stencils have attached backing material that should not be cut. A firm but light hand is needed for cutting. The knife should be sharp.

Multicolor prints can be done with more than one stencil. With additional stencils you can add details on top of dry previous work. It is also possible to cut many shapes within the same stencil and use it to print several colors, one at a time. Start as before by tracing the design onto the surface, cutting out all the shapes of one color, and printing the stencil. Then put the cut-out shapes back into the stencil and secure them well with tape. A low-tack tape such as an opaque

The stencil on the left is a positive block-out, while the one on the right is a negative block-out. I used these two stencils to make the print shown in the next photo.

On the left I inked the negative space around the positive hand shape. On the right the negative stencil allowed an inked image to be printed in the open area.

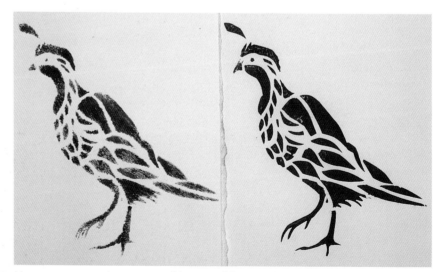

You can create varying texture with a stencil by using it with brushes or airbrushes. The bird on the left is a hand-brushed stencil print. In screen printing the ink prints in an even coat, as the quail on the right was printed.

drafting tape or clear Scotch Removable Magic tape 811 is helpful here. You can then cut new shapes from the stencil for the next color, print that color, tape those shapes back in place, and so on. The advantages of this method are that you don't have to trace the design all over onto a new stencil, and that registration is easier.

APPLYING COLOR

There are two general effects achieved with stencils. You can achieve a flat color with either soft rubber or foam rubber brayers, or you can get varying textures of dry brushstrokes with different types of brushes.

Thick paints such as acrylics or the more viscous printing inks can be used for the colors. Whether you are using a brush or a roller, dilute the paint or ink as little as possible. You can use flat-tipped round stencil brushes, flat watercolor or oil brushes, inexpensive foam brushes from the hardware store, or pieces of sponge.

In the dry-brush technique the brush is dry when it picks up the color. Brush the color on test paper or a palette until any runny ink tendencies are eliminated. Then brush the color over the stencil. All kinds of print papers can be used for stencil and screen-print work; the paper should be dry. It is usually best to paint the edges of the shape first and work toward the center. You can use a flat-tipped stencil brush to create a stippled (finely dotted) texture by gently touching the brush tip to the surface again and again. This technique is also called pouncing.

Most failures in stencil work occur when the paint is pushed under the stencil edge. This will happen when the paint is too liquid or when the stencil is not held firmly on the print paper. If you run into these problems, it is important to clean the back of the stencil before proceeding to the next print.

Kurt Nilson used a photocopier to transfer his design from an earlier intaglio print onto card stock. Here he is using an X-Acto knife to cut out the shapes through which the ink will pass onto the print paper. In addition to the black lines from the photocopier, he has added extra guidelines in red to help with cutting the right shapes.

He lays the completed stencil onto print paper, using registration marks. After brushing on thick, dark blue acrylic ink, he replaces the parts cut from the stencil and uses low-tack tape to hold them in place. He then cuts the shapes that will print light blue from the same stencil and dry-brushes on that color.

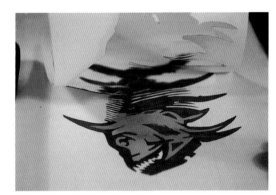

The last color printed was red. Here Nilson removes the stencil from the print.

Stencils can be used in combination with other techniques. For example, here I traced image shapes on two 22 × 30" (56 × 76 cm) sheets of Mylar and cut them out with an X-Acto knife. I tried to keep the stencils strong by not having too many cuts too close together.

Next I took a 300 lb. sheet of Arches watercolor paper and gave it washes and splattering, following traditional painting techniques. I spent less than five minutes preparing the paper for the stencils.

Julia Ayres, *Black-Necked Stilt.* Watercolor stencil painting developed as a varied edition, 22 × 30" (56 × 76 cm).

This method creates multiple watercolor monoprints from stencils. I was especially pleased with the contrast between the watercolor washes and the sharp-edged stencil cuts.

SCREEN PRINTING

In screen printing, the printmaker attaches a stencil to fabric stretched on an open frame. The screen fabric is a mesh of one set of parallel threads woven over and under another perpendicular set. Using a tool called a squeegee, the printmaker presses ink through the open areas to print on paper, board, fabric, plastic, or metal placed under the frame. The inks can be oil- or water-based.

Traditionally fine silk was the fabric used for screen printing. The process was called silk screening. Because this term was also used in commercial ventures such as printing posters and fabrics, fine artists labeled their work as a serigraph, meaning a silk graphic (from Latin *sericum,* for silk). Today man-made synthetic fabrics have replaced silk for most processes. This is why the technique is most often referred to as screen printing.

SCREENS AND BACKBOARDS

My first screen prints were done with a simple Speedball kit purchased in an art supply store. The packet contained the fabric screen already stretched on the frame, the backing board, two hinges with removable pins, and a leg stand—a simple wooden leg that can be snapped into place to hold the screen up at an angle. The hinges and stand needed to be attached with the screws provided. The Dick Blick Company and many local screen printers also manufacture moderately priced kits as well as screens in various sizes.

Any homemade or purchased screen should be strengthened for longer use. I filled in staple holes and joined corner gaps with wood putty to make sure that no ink could leak through. (Epoxy glue also works well for this purpose.) When the wood putty was dry, I sanded and then painted all wooden parts with several coats of polyurethane. On larger frames, metal corner braces can be added to prevent warping.

If you have modest woodworking skills, you can make your own screen. Select hard, kiln-dried wood clear of knots. Miter or lap-join the corners, and use recessed screws to assemble the pieces. Then attach the screen material tightly to the outside of the frame, either with staples or with a groove-and-cord system.

If you are using staples, fasten the screen fabric similarly to the way canvas is attached to stretcher bars for a painting: First tack the centers of the opposite sides, pulling the fabric tightly as you attach it, and then work evenly from the centers outward toward the corners. The staples should be pointing inward at an angle. You can buy staple tape to use between the staples and wood. This tape strengthens the stapled bond and makes it more convenient to remove the staples when replacing the fabric.

In the groove-and-cord method, the edge of the fabric is caught with a cord and pressed into a groove precut on the bottom side of the frame. Use special cord made for this purpose. You can press the cord into the groove with the back edge of a knife blade, but it is much

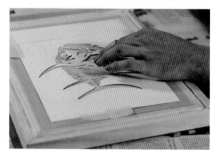

Kurt Nilson uses another photocopy of his *Fishbone* image on card stock to cut shapes for a screen-print stencil of the same image. He removes the frame from the backboard, turns the frame upside down, and tapes his paper stencil to the bottom of the screen.

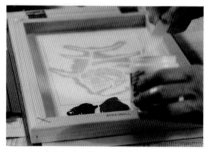

He dishes three Speedball textile inks into the inside margin of the screen, now reattached to the backboard.

He uses a squeegee to pull the colors across the screen and print on the paper underneath. The ink also firmly grabs and attaches the card stencil underneath. (For this technique the usual float stroke was not used because the stencil was not already firmly adhered to the screen as it is in many screen-printing techniques.)

Nilson wiggles the squeegee so that the colors continue to be blended and manipulated for half a dozen prints, and then Nilson prints this *Fishbone* on fabric. If he had pulled the strokes smoothly and evenly, just the edges of the colors would have blended.

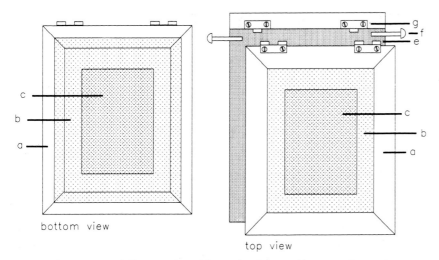

bottom view

top view

Screen and backboard. Bottom view: (a) wooden frame with groove for cord to hold screen fabric, (b) blocked-out margin, (c) open screen. Top view, with frame temporarily separated from backboard: (a) wooden frame, (b) blocked-out margin, (c) open screen, (e) backboard, (f) hinge pin, (g) one of two parts to hinge frame to backboard. (Art by Gail Ayres.)

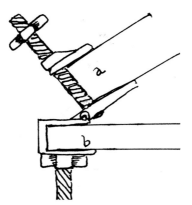

Wood screen corner drawing: (a) braced mitered joint, (b) shiplap joint parts, (c) shiplap joint assembled. (Art by Gail Ayres.)

Table hinge mechanisms to hold large screens securely: (a) is screen frame and (b) is tabletop or backboard. *Left:* The hinge on the left screws into the tabletop. *Right:* This model has the same style of hinge with an added clamp that holds onto the table. Wing nuts screw down to hold the clamp parts firmly.

easier and more convenient to use a special tool that rolls the cord into the groove. (The cord and the tool for rolling it are available from screen-printing supply houses, Dick Blick, and Graphic Chemical & Ink Co.) Tack or tape the fabric to the outer edges of the groove to hold it in approximate position so that the fabric will pull tightly into the frame.

You can leave the fabric edges raw and later seal them with the polyurethane coating or tape used to make the working margin. Because water and solvents are used in many screen-printing procedures, the joints should be tight and the frame coated and well protected with a material such as polyurethane.

The screen is attached to a backboard or table with a hinge system that allows easy lowering and lifting as well as removal of the screen and its frame for cleaning. Three types of hinges are available. The first is attached to the screen frame as well as to a wooden hinge board the same thickness as the screen frame. This hinge board is attached to the backboard, and the pin that holds the two hinge parts together can easily be removed. The second and third types of hinges have adjustable clamps to hold the screen frame. The first is attached to a backboard with screws. The other clamp system has a second clamp to attach to one edge of the table.

Part of the screen-printing process involves applying ink to the screen while it is held away from the paper. A leg stand is usually used for this. The simplest kind is a wooden strip screwed into the side of the frame. As you gain experience you can modify this and other parts to suit individual needs. More convenient leg stands have spring mechanisms that work with less effort. Some screen-printing workshops have pulleys and weights to raise and lower the screens.

SCREEN FABRIC

Some artists still use silk because they prefer its adhering properties for indirect stencils. However, silk is more costly and tends not to be dimensionally stable in more humid environments. It is also not used for direct photo emulsion or photo stencil techniques because it will break down when the screen is washed with bleach.

Today synthetic fabrics are most commonly used for screen printing. Polyester is a popular choice because it is resistant to solvents and stable under most conditions. Multifilament white polyester is the choice for most cut stencils and block-outs because the multiple filaments that form the thread have "grabbing" tendencies that help the screen adhere to the stencils. However, if direct photo emulsion screens are the primary technique used, a monofilament orange fabric, designed to cut light diffraction, should be considered. A white monofilament fabric is a good choice if both direct photo screens and other stencil techniques are used.

There are two methods by which the fabric is labeled. Monofilament fabric is graded by the thread count per square inch. (For example, a fabric with 10 threads crosswise per inch and 16 threads lengthwise per inch would have a thread count of 160.) Multifilament fabric has a number followed by X's. Lower numbers in both systems indicate a more open weave suitable for thicker inks used on fabrics and some metals. The highest numbers allow the thinnest inks to pass and are used for highly detailed stencils or sensitively drawn images.

Although both monofilament and multifilament fabrics are made of woven threads, the threads are different. Monofilament thread is—as its name implies—

Pushpins are used first to stretch new material on a used frame. Here you see an artist using a roller to push new cord into the groove on the bottom of the frame, thus securing the fabric tautly.

Dorothy Hoyal uses brown tape to protect her screen frame and make a working margin. This is a top view of the frame.

Hoyal applies shellac to seal the tape in this bottom view of the frame.

made of a single filament, while multifilament thread is made up of shorter filaments twisted together, whose loose ends grab. An XX multifilament fabric used for screen printing indicates a stronger fabric than the single-X standard grade. An XXX grade is given to a fabric with additional thread strength. Silk and multifilament polyester carry this label.

A 12XX multifilament or a 160 mesh count monofilament fabric is suitable for most printing on paper. Fabric inks are thicker and require an 8XX or 109 mesh count screen. A 232 thread count per square inch, or 16XX, indicates a finely woven, extra-strength fabric that would be suitable for fine detail printing and photo emulsion stencils.

Even if it is brand-new, scrub your screen thoroughly before attaching your a stencil. This procedure is called abrading and degreasing the fabric and is best done after you have attached the screen to the frame. The scrubbing will remove all signs of grease as well as abrade the fabric enough to help stencils adhere to it. You can use mildly abrasive household cleansers like Ajax or special products made for this purpose, such as Ulano screen degreaser liquid.

White screen fabric becomes discolored from staining pigments in some inks. Multifilament fibers stain more readily than monofilament threads. This is not of concern as long as the screen is thoroughly clean. Check the screen against the light to make sure the mesh openings are clear and clean. As long as color is only *on* the threads but not *between* them, it won't transfer to your next print.

THE SCREEN SURFACE

The screen fabric is the total working surface used in printing. It is important to block out a two- to three-inch margin on the top side, in from the frame, leaving the center for the image. This working margin holds a reservoir of ink and prevents it from leaking through to the paper below; this is also where the squeegee rests when you are not pulling it across the screen.

You can make the blocked-out margin with paper tape sealed with polyurethane or shellac. More costly but truly effective is a special polyester tape available from printmaking or screen-printing supply stores. This tape has pressure-sensitive adhesive designed to withstand exposure to both water and solvents.

SQUEEGEES

Squeegees are used to pull the ink across the screen surface. They come in many sizes, so you should choose one that meets the requirements of your project and screen. The squeegee should be wider than the open part of the screen but fit within the frame; mine clear the frame by ½ inch (1.3 cm) on each side. The handle should be made so that it is easily grasped. Buna (synthetic rubber) or polyurethane blades of medium hardness (50 to 60 durometer reading) are best for general printing. A softer blade is used for thicker applications of ink, and a hard, sharp blade is needed for fine details. Both ends of the blade should be slightly rounded to prevent the screen from being torn.

Different squeegee blade shapes are designed to press different types of ink through the screen. A thick fabric ink, for instance, works best if pressed through with a rounded blade. The corner of the flat-bottomed, rectangular blade works well for general printing inks; hold the blade at a 60 degree angle to the screen, so that the corner touches the screen. A blade like a chisel, with a V-shaped cross section, is best for thin inks, fine detail, or printing on a rough surface.

Blades can be kept sharp by running them across a medium sandpaper or garnet paper. Glue the paper to a flat wooden strip the length of the longest squeegee. Then run the blade back and forth on the paper in a sawing motion to sharpen the edges.

Squeegees have blades of different shapes.

INKS

The inks used to print on paper are often called poster inks. Reading labels is important when choosing screen-printing inks. Both water-based and oil-based inks are available. For example, the Naz-Dar Company supplies a wide range of oil-based inks. Each ink has a specially formulated extender and solvent. Some are designed for fabric and are quite common in art supply stores because of the large market for printed T-shirts. Pay particular attention to warning labels and necessary precautions to take when the product is used.

Many inks have specially formulated additives. Some extenders are added to make the inks more transparent; others increase the volume of ink without affecting the viscosity. A binding varnish is added for better adhesion on absorbent surfaces. Gloss-coating varnish can be coated over a dry completed print to change its natural matte finish. Retarder thinners slow drying time. Some inks and photo emulsions require that the screen be washed with special materials.

Some water-based inks are acrylic-based and will not dissolve in water once they have dried. Dick Blick, Hunt Speedball, Createx, and Naz-Dar make acrylic inks. Blick, and Hunt Speedball manufacture mediums that do remain water-soluble. All inks are in premixed colors except those made by Createx.

The Createx company also manufactures Lyntex screen-printing base, to which Createx pure pigments are added in liquid form. As with all inks, it is better to mix these in a transparent plastic cup so that you can observe the inside of the bottom and sides. Add the pure pigments a drop or two at a time because they are very powerful. There is an opaque base as well as a retarder to modify the mix. I have also modified Hunt colors with a few drops of the Createx pure pigments—but be careful not to mix oil-based with water-based materials.

Here I have painted an image with screen filler on the fabric of my new simple Speedball kit, bought in an art supply store. I have used plastic, pressure-sensitive, screen-printing tape to protect the margins. This is the bottom view of the screen.

Here the screen is raised so that its surface can be coated with a float stroke of ink. You can see the simple leg stand that holds the screen in this position.

Now the screen has been lowered so that the squeegee with ink can be brought back across the surface to make the print stroke.

My print illustrates how the painted screen filler served to protect the paper, so that the printed image is a negative version of the painting on the screen. (As it happens, the burnt sienna ink is a similar color to the screen filler in this particular case.)

USING BLOCK-OUT MATERIALS FOR DIRECT STENCILS

Stencils developed on the screen are classified as direct stencils, and this category includes painted block-out materials. Water-soluble screen fillers and crayons let oil-based inks pass through without dissolving. Tusche, litho crayons, and other materials that dissolve in solvents let water-based inks pass through without dissolving.

There is a water-soluble screen filler that works as a resist for both water- and oil-based inks. The Hunt Speedball water-soluble screen filler requires a heavy detergent such as Formula 409, Wisk, or Mr. Clean and warm water to remove it. Therefore inks or screen fillers that dissolve in cold water or with petroleum solvents can be successfully used with it.

You can make a negative screen using a three-step process. First paint Hunt Speedball drawing fluid or Ulano number 60 drawing fluid with a brush in the areas that you want to print. When this drawing is dry, squeegee on Speedball screen filler, which will cover the areas not painted. Once the filler is very dry, wash out the drawing fluid with cool water, which will leave the screen filler undisturbed and an exposed area of screen where your drawing used to be. The ink will pass through this area, creating a replica of your drawing.

A similar principle applies to other combinations of materials. What you are looking for is a drawing medium that resists a screen and washes out of the screen with something that doesn't disturb the filler. This allows you to draw or paint a positive image that will dissolve while the surrounding screen filler stays intact. For example, water-soluble crayons designed for small children wash out with cold water and soap. Since this will not disturb Hunt Speedball water-soluble screen filler (which, as explained above, requires warm water and heavy detergent), you can use these crayons as a resist. Draw directly on the fabric, and then squeegee the filler over your crayon drawing. When you remove the crayon with cold water and soap, it leaves "holes" in the screen filler through which the ink can pass.

If oil-based inks will be used, you can create the image by painting liquid tusche or drawing with lithographic crayons on the fabric. Then squeegee water-soluble filler made of LePages glue diluted 50 percent with water over the screen filling in the open fabric. Next apply a "sandwich" of turpentine to both sides of the screen until the tusche or crayon is removed. (See the end of this chapter for more information about cleaning these sandwiches.)

Dorothy Hoyal applies Speedball drawing fluid to the screen, using a color painting underneath as a guideline. This is a common practice for creating stencils with the reductive technique. The drawing fluid is water-soluble but will work as a block-out material with her oil-based Naz-Dar inks.

Once she has completed her design on the screen, Hoyal positions paper beneath it and prints with gold ink. This first printing shows how the drawing fluid blocked out the areas that are to remain the color of the paper. She will now block out the areas that are to remain this background gold.

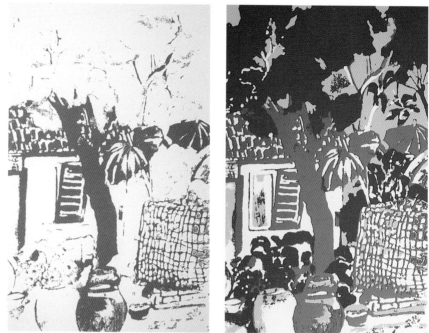

Next she uses solvent to clean the oil-based ink off the screen but does not disturb the drawing fluid. Instead she gradually builds up the design, painting more drawing fluid onto the screen to block out the areas where she wants gold but no green, and then prints the green ink over the gold printing.

After further blocking Hoyal prints red through the screen. *Left:* Here is the red by itself. *Right:* When she prints the red over the gold and green, the edition of prints looks like this.

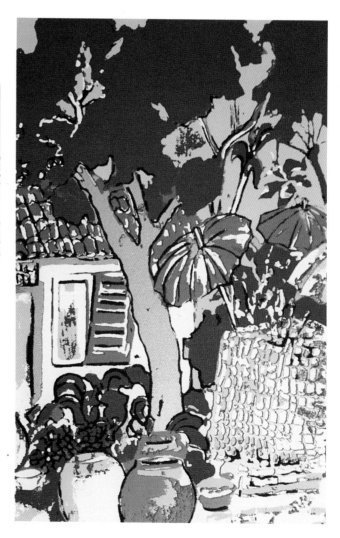

This screen gives the print a warm foreground gold.

The last screen adds black detail. Detail is usually printed last, so that other colors won't cover it.

Dorothy Hoyal, *Bali Bungalow.* Screen print, 7 × 11" (18 × 28 cm).

The finished print shows all the colors working together to form a harmonious whole. You can see the importance of precise registration for this type of work.

INDIRECT STENCILS

Stencils cut or developed away from the screen and then attached for printing are termed indirect stencils. You can make thin paper stencils and tape the outside edges of the paper to the screen bottom, the "print side" of the frame, in the blocked margins. The first stroke of ink will catch the cut work of the stencil and act as a glue during printing. The entire printing should be handled without stopping. I have made up to 30 prints from one paper stencil.

FILM STENCILS

Indirect stencils can be cut from films that are dissolved or adhered with water or lacquer thinner. Ulano Amba film adheres to the screen with water. If you use water-based inks, an Ulano Amba stencil can be cut in the positive form and attached to the screen.

The Ulano Amba is a water-soluble knife-cut film on a polyester base. It is backed by a transparent sheet that should remain on it until after the surface is adhered to

the print surface of the screen. As you cut out your design, it is important to cut just through the gelatin surface and not the backing, because the backing helps hold the fragile film together until it is safely attached to the screen. Put leftover pieces of the film in a jar and dissolve them with enough distilled water to make a syrupy fluid; this solution becomes a block-out material that you can use later to brush on the screen for other procedures.

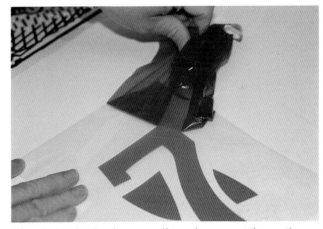

Lynwood Kreneck cuts through Ulano Amba film but not its clear polyester backing. (Photos of Lynwood Kreneck demonstrations on pages 121–123: Eleanor Kreneck and Julia Ayres.)

After the design has been cut, Kreneck removes the sections of film not to be used.

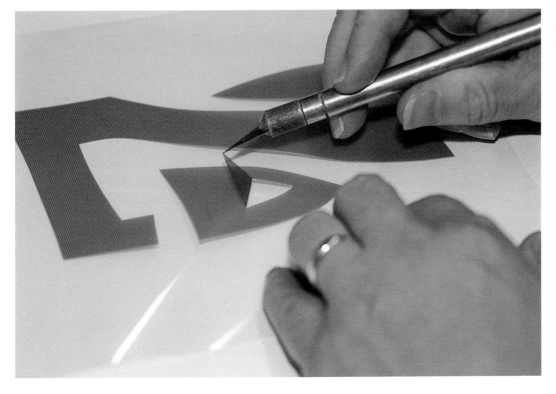

He lifts off detail cuts with the blade tip.

Before adhering a stencil, degrease and rinse the screen. Place the water-soluble film, gelatin side up, on a firm stack of cardboard or paper toweling that is as large as the screen opening but smaller than the frame. Then lay the moist screen on top of the stencil with the print (bottom) side of the frame down, against the stencil. The stack of cardboard or toweling serves to support the stencil and push it up evenly against the screen.

In one hand hold a moist sponge, in the other a dry towel. Working from the squeegee (top) side, press but do not rub the stencil with the sponge and quickly blot up excess water with the towel. The water seeps through the screen to attach the gelatin to the bottom. Repeat this process in an organized pattern across the whole screen until the film is firmly attached. The Ulano Amba stencil will appear bright red from the top of the screen when it is thoroughly attached to the bottom. Then, once the stencil is dry, peel off the clear plastic from the back.

You are now ready to squeegee Speedball filler across to fill in the unprotected fabric. When the filler is dry, wash out the stencil with cold water. If you are using oil-based inks, this type of stencil can be cut as a negative and the inks will pass through in the positive areas.

Kreneck's stencil is laid with the emulsion side toward the bottom of the screen. He moistens it with a sponge and blots it with a paper towel until it adheres firmly in the interstices of the fabric.

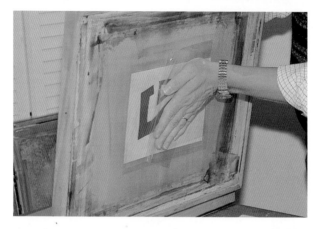

The clear backing is carefully rolled back, leaving the area around the design open.

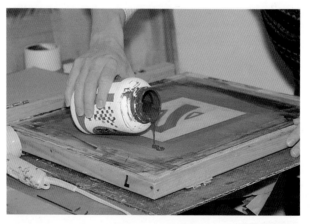

Kreneck pours Speedball screen filler as a bead across one end of the screen.

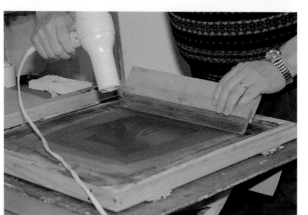

He uses a squeegee to draw the filler across the stencil, filling in the open fabric. A hair drier speeds up the filler's drying time.

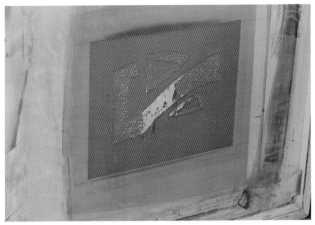

At the sink the stencil dissolves under a spray of cool water. The screen filler is also water-soluble but stays firm unless detergent and warm water are used to remove it.

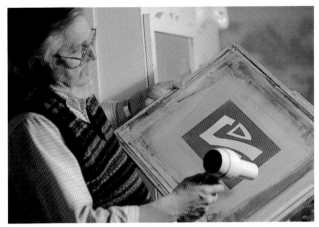

Kreneck dries the screen again to prepare it for printing.

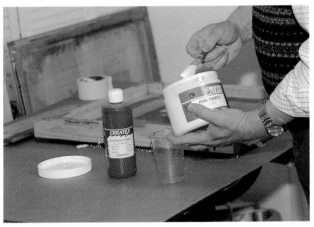

Next Kreneck mixes Lyntex base with Createx crimson poster/fabric ink.

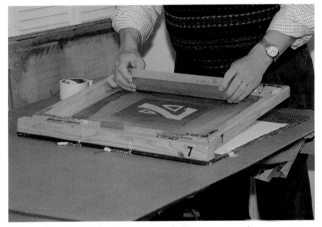

He applies the ink in the margin of the screen and squeegees it across the surface, filling the open fabric in a float stroke. Kreneck made his working margins with thick layers of exposed and developed photo emulsion.

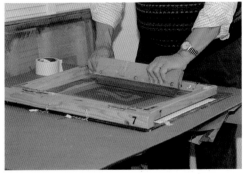

Now Kreneck lowers the screen onto the paper and brings the ink back across the surface for the print stroke.

The printed design, courtesy of the artist.

THE PRINTING PROCESS

Screen printing can be done on numerous types of surfaces: paper, fabric, board, metal, and even glass.

REGISTRATION METHODS

Place the paper on the baseboard for printing. Even for a simple one-stencil print on paper, you will need a registration system to align the work within the paper margins. You can use cardboard or plastic tabs that grasp two sides of one corner of the paper. As you print, make sure that these tabs align with other tabs taped into place on the baseboard.

If you are making a multicolor print, another alternative is to hinge a sheet of Mylar to the baseboard with tape and print it with the first color. Then pull back the Mylar to print the first color on enough sheets of paper for your edition. Once the first color has dried on paper and you are ready to add the second color, put the first sheet of paper back on the baseboard and then flip the Mylar on top of it. Make any minor adjustments if necessary so that the first color on the paper aligns with that on the Mylar. Since the Mylar is actually attached to the backboard, you can count on it as an accurate gauge of where the screen will fall.

FLOAT AND PRINT STROKES

After the paper is in place, elevate the screen on the leg stand, and add the ink in a line across the screen. Use the squeegee to push the ink across the image to the opposite side of the screen. This is called the float stroke, and it fills the mesh of the screen with ink. Now lower the frame. Firmly and deliberately, with both hands, pull the squeegee and ink across the screen. This is called the print stroke, and it forces the ink through the screen to the paper

below. This two-stroke method ensures more even printing than if you tried to use only one stroke. It also prevents ink from drying in the screen mesh and blocking the design.

Finally raise the leg stand and remove the paper. If the paper moves or sticks to the fabric, off-screen printing is needed. This is done by lifting the frame from the print surface. Prop up the front of the screen on tabs $1/4$ to $1/2$ inch high, and raise the hinge system in the back equally. (You can use small pieces of cardboard, tacks, or pushpins as tabs.) Thus the screen is still flat but slightly separated from the paper. The squeegee presses the fabric to the paper surface and the screen snaps back after the blade passes.

DRYING

Before you begin the printing process, plan where you will dry your prints. Clothespins or bulldog clips strung on wires are effective for clipping prints and hanging them to dry.

CLEANING THE SCREEN

Regardless of what screen-printing method you have been using, start the screen cleanup by detaching the frame from the backboard and using cardboard squares to scrape the unused ink back into its container. Wash the screen in the sink with water and detergent. Rinse it thoroughly and dry off excess water before proceeding to next step.

Cleanup of the screen fabric will vary according to the inks and stencil materials you used. A water-based ink used with Hunt Speedball screen filler will require simple cleanup with soap and water. First rinse the ink from the fabric, and remove the stencil material by placing the screen in a "sandwich" of

paper toweling and detergent, such as Mr. Clean, to soak. Oil-based inks are effectively removed with the sandwich soak. Each manufacturer recommends the proper solvent for its ink or stencil material.

The sandwich soaking technique is an effective way to clean screens with the least amount of detergent or solvent needed. This is partly because the plastic prevents the solvent from evaporating into the surrounding air and thus concentrates it on the screen. First lay a sheet of plastic on the counter. (I use garbage bags.) Then place a bed of about three layers of paper toweling. On top of this, place the screen, print side down. Pour the detergent or solvent over the screen, and layer more toweling on the inside of the frame, pressing until it is moist. Check the bottom towels and make sure enough solvent seeped through to make them evenly moist. On top lay another piece of plastic and let the sandwich stand for about 20 minutes. At the end of this time, most materials will have dissolved from the screen. Return the screen to the sink, wash it with detergent, rinse it, and then dry it.

Some photo emulsion stencils can be cleaned using household bleach as a solvent. Individual products carry cleaning instructions, sometimes involving special cleaning solutions formulated specifically for them. Soaking with the sandwich technique most often works well here also.

Some screen-printing solvents are highly toxic, and it is important to read warning labels carefully. Many manufacturers are trying to make them safer. Livos citrus solvent cleans many oil-based inks. Also see the List of Suppliers for sources of information about the safest solvents for oil-based inks.

PHOTOSENSITIVE STENCILS

The most serious screen-printing artists discover photostencil techniques to be the most convenient, most versatile, and often the least expensive way to make a stencil. You can directly coat the screen with photo emulsion or develop an indirect stencil and then attach it to the screen. In either case, put an opaque positive transparency between a light source and the emulsion. The light cures, or hardens, the emulsion except where it was blocked with the opaque drawing. The uncured area is immediately washed from the screen with water and becomes the open area for the ink to pass.

There is not enough space in this book to describe the most advanced cameras, darkroom facilities, and techniques, so I will describe the most basic, simple system for the home studio. If you need a larger, more sophisticated screen, you may be able to buy one from a local commercial screen printer.

MAKING THE POSITIVE TRANSPARENCY

An opaque positive transparency has black opaque areas and clear areas; any shaded areas are handled as halftones composed of tiny black dots spaced at different intervals. During exposure, light passes through the clear areas and hardens the emulsion. The blocked areas remain soft and will wash out.

The opaque areas can be made by drawing with black felt pens on transparent acetate sheets. You can also tear black paper and lay it on the transparency under the glass. Thin found objects such as leaves, lace, or paper clips can be used to block light. Rubylith and similar knife-cut masking films can be shaped to make the positive image.

You can also make a black and white drawing on opaque paper and have it transferred by a copy machine to a transparent sheet. Commercial photocopy services offer this service. Before using your own machine, check the manual and make sure you have compatible transparency paper that will not melt in the process.

Photosensitive indirect stencils are also available. These are also exposed to the light through the transparency, washed out at the sink, and attached to the bottom of the screen with water according to directions, similarly to the Ulano Amba film discussed earlier. Most require darkroom conditions when they are handled outside the protective covers. Once you have developed a photosensitive stencil and attached it properly to the screen, you print it just like any other kind of stencil.

Dorla Mayer, *The Visit.* Screen print, 22 × 30" (56 × 76 cm). Courtesy of the artist and Survival Graphics.

Mayer developed this print with multiple photodeveloped stencils and water-based inks. The intriguing image invites the viewer to guess the story behind it.

DIRECT PHOTO EMULSION SCREENS

Hunt Speedball manufactures a photo emulsion kit that will tolerate low-light situations when you are mixing or applying the solution; the film doesn't start to develop until the mixture has dried. (Just cover windows and turn off lights, but you don't need a darkroom.) This kit permits a simple introduction to the photo emulsion stencil. Mix two chemicals to get the photo emulsion, according to directions, and coat it thinly and evenly on the screen. A squeegee, a sharp piece of cardboard, or a emulsion applicator will work. Then put the screen in a dark closet or on a shelf away from light to dry.

When the emulsion has dried, put the screen, bottom (print) side up, on some cardboard. On top of this lay the opaque transparency. Next set on top of this a clean sheet of glass large enough to rest on the wooden part of the screen frame. Now turn on the light and expose the emulsion according to the directions on the emulsion package. To expose the emulsion you will need a photoflood bulb in a socket surrounded by a reflector. My small screen was exposed 12" (30 cm) from the light. (I found a way to attach the bulb to a TV tray table stand, and by building up cardboard on a box to get the right distance between the light and the glass, I had my first exposure table.)

Lynwood Kreneck has a specially constructed exposure box with a hinged glass lid. Dark spongelike material fits inside his screen and pushes the photosensitized screen against the positive transparency and the glass surface. The box is placed upright and is exposed to a photoflood lamp.

Protecting the glass from too much heat is important because the entire emulsion, even below the opaque lines, will harden at too high a temperature. A fan set up to blow on the glass surface helps.

After the film is exposed, quickly take it to the sink and spray it with cool water. The wetness stops the reaction to light. The areas blocked from the photoflood light will wash out, and a semitransparent negative stencil will remain in the screen.

Once you have mastered direct photo emulsion techniques, it is a simple matter to make a mat with this material by coating the screen with the emulsion, blocking out the image area, exposing the screen to light, and washing out the blocked area.

A photoflood lamp attached to a TV tray stand became my photo exposure setup. I squeegeed Speedball photo emulsion on the screen and was able to work in low-light studio conditions.

On top of the emulsion-coated screen I laid a thin sheet of Mylar. Then I arranged spring flowers and set clear glass on top to hold them in place. The light exposed the emulsion, which I developed simply with cold water at the sink. The screen printed like this when I ran a trial proof with black ink.

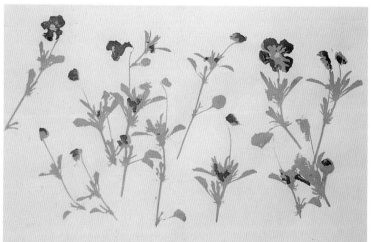

I used solvent to dissolve the emulsion in some places so that I could make some of the flowers larger. Next I printed the edition in green water-based inks. I then used a brush to paint Speedball screen filler on the areas that I wanted to remain green and printed next in dark purple. I continued with this reductive technique to print light purple, and finally yellow in water-based inks. I ended up with a small edition of *Johnny-Jump-Ups*.

Lynwood Kreneck pours Diazo T2 emulsion from Ulano into a scoop made for coating screens. (Photos on this page: Eleanor Kreneck and Julia Ayres.)

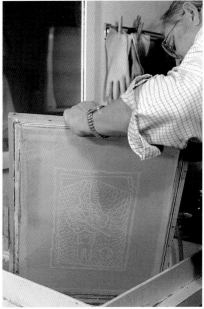

By holding the screen at a slight angle, he applies the solution of the screen through to the bottom. It is then dried in a no-light environment.

After the image is exposed, Kreneck develops it in a water bath at the sink. The lighter lines of the image are the open fabric in the stencil.

Here is the exposure box that will hold the screen. The foam center will hold the screen and transparency against the glass lid on the left.

Kreneck prints the screen with Speedball water-soluble black ink.

This transparency was made by a photocopy service from Kreneck's drawing. I slipped the brown paper at the top left under a corner of it to show you that the drawing is on truly transparent, not white, material.

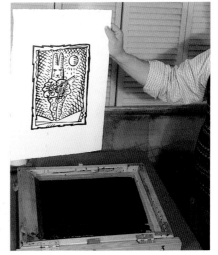

The transparency and screen are held upright in the box as they are exposed to the photoflood light on the left behind Kreneck's arm. Here Kreneck sponges the surface of the glass to prevent it from overheating.

Here is a print of *Clown Apprentice* on white card stock. Kreneck will develop this art further using his "no-print" procedure.

"NO-PRINT" AND OTHER WORK METHODS

Lynwood Kreneck has developed exciting artwork from what he terms his "no-print" technique. First he prints black water-soluble ink on black two-ply archival board. The dried printed ink becomes a resist lift for work on top. Using art crayons, Kreneck fills the page with patterns of color over the printed image. When this step is completed, Kreneck takes the board to the sink and washes the surface with water. The black printing underneath lifts off the work on top—operating almost like a sugar lift in intaglio—and the image develops. Because the printwork is washed away, Kreneck uses the term "no-print" to describe the process. If he chose, Kreneck could make other unique no-prints from the same screened image by varying the patterns of color applied on top.

Glues or varnishes can also be screened onto cardboard and washed off the screen afterward with water or appropriate solvents. You can immediately sprinkle materials such as flocking, sand, or ground glass onto the print, and the glue will bind the materials to the paper in the set design. When it has dried, brush off the excess material.

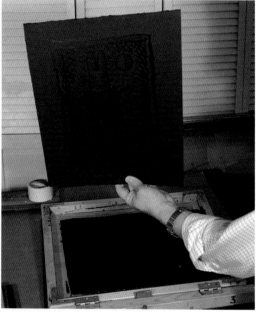

Kreneck prints his *Clown Apprentice* screen on two-ply black archival board with black Speedball water-soluble ink. (Photos on these two pages: Eleanor Kreneck and Julia Ayres.)

Kreneck takes the print to the sink and washes it with water. The water-soluble image dissolves and lifts the color that was on top of it, but the rest of the color remains undisturbed.

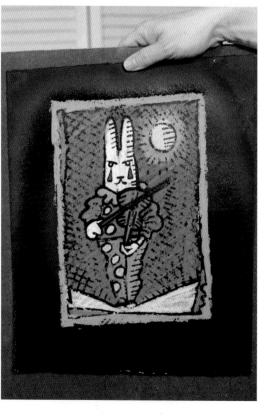

Here you see how the black ink has lifted away the color on top of it to reveal the black archival board below. *Clown Apprentice* is what Kreneck calls a "no-print" screen drawing because the water-soluble printing ink gets washed away.

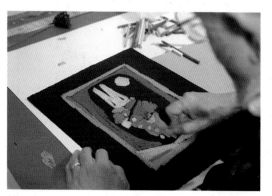

Now he covers the print entirely with Prismacolor crayons.

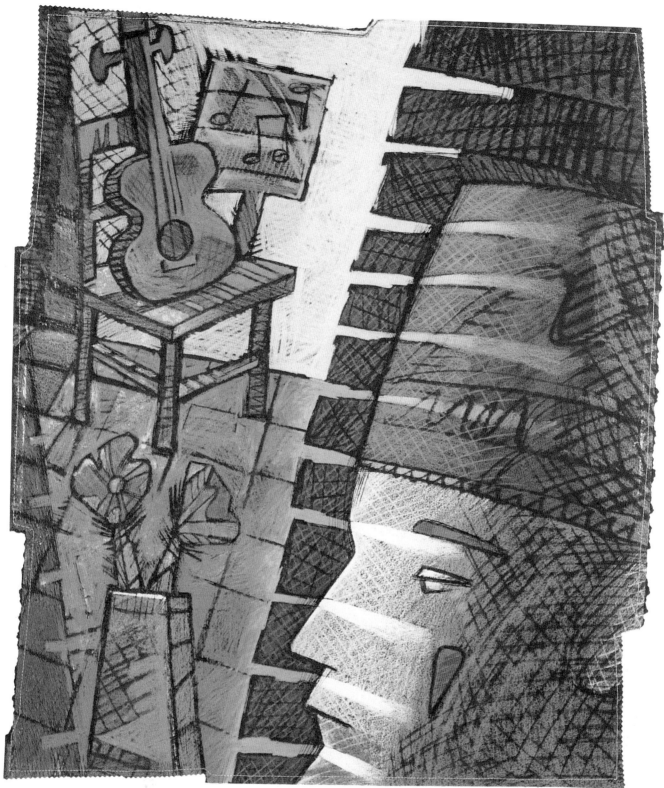

Lynwood Kreneck, *Clown at Home—The Music Lesson.* "No-print" screen drawing, 40 × 30" (102 × 76 cm). Courtesy of the artist.

Kreneck developed this drawing with the same techniques he used in *Clown Apprentice,* but on a larger scale. His bold use of color enhances his playful exploration of his favorite themes, which include clowns and music.

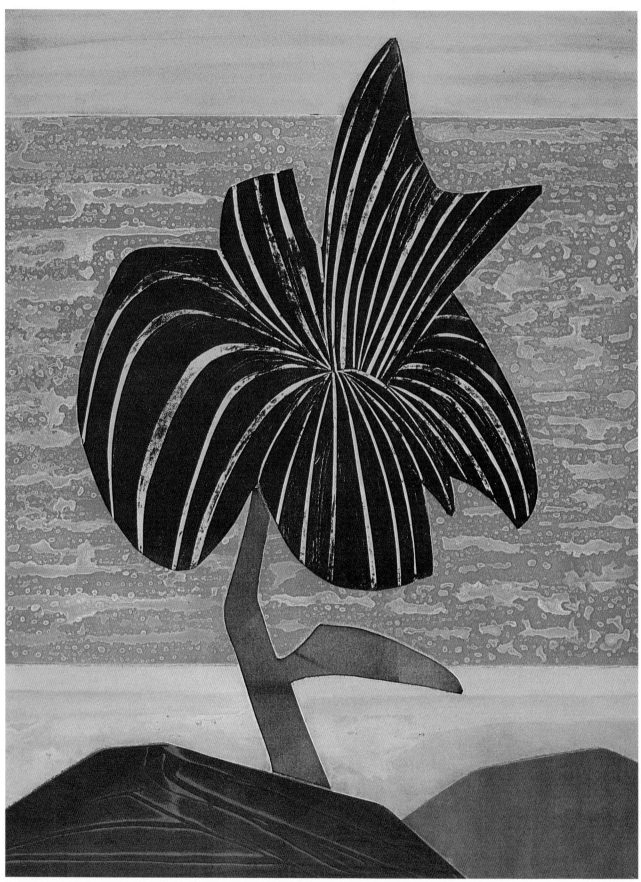

Barbara Young, *Tides.* Collagraph, 25 $^1/_2$ × 19 $^1/_2$" (65 × 50 cm). Photo: Richard Pucci.

6 MORE TECHNIQUES AND ESSENTIAL PRINTMAKING INFORMATION

This chapter gives an overview of several additional innovative techniques used by hand printmakers today. Collagraphs, briefly mentioned earlier, have aspects in common with both relief and intaglio printing, but they deserve to be considered as a separate category. Three-dimensional assemblages offer exciting possibilities. You may also enjoy working with cliché verre artworks, in which the artist paints on glass or some other clear substance to create a negative that is then developed photographically. Computer-generated prints are becoming more and more popular with today's sophisticated computer programs. Intaglio plates can be framed and exhibited as discrete artworks in their own right. Hand-printed books and cards are wonderful formats for a printmaker's experimentation.

Here you will also find more detail about the crucial issue of health and safety in the printmaking studio, and how to sign and present your finished prints.

COLLAGRAPH

A collagraph plate is a collage of various techniques and materials that are assembled to print as line and texture. Making a collagraph plate invites spontaneous creativity and personal response to natural materials and found objects. New ways of working seem to develop as you go along. Most artists who use this medium develop the plate by gluing or painting textured materials onto a thin, flat base material such as mat board or Masonite. The plate can then be inked and printed as an intaglio plate, so that the concave areas hold the ink; in other applications the convex relief surface is printed. Often both printing techniques are employed.

The exploration of collage techniques by artists such as Georges Braque, Juan Gris, and Pablo Picasso contributed to the growth of collagraph. The actual printing of this work was left to other artists, such as Rolf Nesch, a Norwegian who worked with metals, and Boris Margo, an American who worked with dissolved celluloid to develop printing texture. These first collagraph prints were made in the 1930s, so collagraph is a newer printmaking process than, say, etching or lithography.

There are several basic methods for making the plate. One is to glue thin found shapes on a base plate material. A second is to build lines and textures by painting the surface with a modeling material such as acrylic gel, papier-mâché, or gesso. Another method is to make an intaglio plate with fabric and acrylic medium.

TOOLS

Cutting tools and brushes are the basic tools you will need for making collagraph plates. The cutting tools are for cutting shapes, scoring lines, and carving into the material. You can also use brushes, pieces of mat board, and palette or painting knives to build up shapes with gesso and modeling paste. Synthetic paintbrushes work well to apply acrylic medium, white glue, and gesso. Wash them afterward in soap and warm water.

The base materials for collagraph plates are readily available. Mat board or relatively heavy cardboard are commonly used from the paper family. Thin hardboard (such as the Masonite trade name) or plywood are the popular wood choices. Plastic and metal printing plates also work well. Choose proper adhesives to attach the materials to the base plate. For instance, metals such as copper, brass, or steel can be soldered together, while aluminum cannot be soldered but can be bonded with epoxy glue.

IMAGING MATERIALS

Apply your imaging materials to the plate. Most often they will print as embossment in the paper. It is important that each level of material be kept within 1/8" (0.32 cm) height of those immediately next to it, or there will be too much stress on the paper to print well. However, you can build up deeper embossments gradually in increments, like stairs.

Layering of the materials often requires lingering drying times before the next procedure can start. You may find it helpful to have more than one plate in progress so that you can work on one plate while the other is drying. This approach often creates a synergy of creative ideas, so that the work remains spontaneous and exciting.

Mat board is a very versatile material for making imagery for collagraphs. You can score its surface with an X-Acto knife and tear the cut material from the board. By tearing strips of mat board away,

you can reveal various patterned layers. You can also cut shapes from mat board or thinner cardboard and apply them to the base surface with white glue. When everything is glued into place, seal the surface with thinned gesso or acrylic medium. This prevents porous surfaces from absorbing ink and protects fragile edges.

Acrylic gesso is another versatile material for working on collagraphs. You can apply it smoothly to seal a surface. Textures are easily developed by manipulating it with a brush, running a comb through the surface, or inscribing it with a single line using a pointed stick. By setting paper down on a wet gesso surface and quickly lifting it away, you can create various "pulled" textures. You can also stick masking tape to the plate, apply gesso on top of it, and then remove the tape before the gesso is dry to create a hard-edged shape.

Modeling paste is a good medium for achieving a higher or more exaggerated surface texture. I use the J-Ben brand. The surface can be scored with a veining gouge or X-Acto knife after the modeling paste has dried.

White glue squeezed from a bottle or a line of glue from a hot-glue gun will make relief lines that will emboss into the paper. The hot-glue gun material sets up almost immediately. The low-temperature type of glue gun is easier to handle. White glue is slower to dry and can be manipulated for some time.

Try sprinkling carborundum or sand into a wet gesso or acrylic medium surface. This surface will catch ink and can be used for techniques similar to intaglio aquatint procedures. You can also glue a piece of sandpaper onto the

base material and apply a thin coating of acrylic medium to seal the surface. (Many types of sandpaper are on a porous backing and will break down quickly in water.)

Fabric is also wonderful for adding shape and texture to collagraphs. Simply cut the fabric into shapes and glue it to the surface. Materials such as burlap or corduroy will yield interesting and distinct textures, while romantic materials such as lace or doilies are appropriate for other types of collagraph work. Some of the more open-weave materials may act as a template through which gesso can be applied; this is yet another method of texturing the surface.

The interstices (spaces between the threads) of a woven fabric such as silk or cotton organza glued onto the plate will catch ink that is wiped onto the surface and will print as tone.

Betty Sellars glued cotton organza onto thin pressed wood for this collagraph plate and painted the shapes with colored acrylic medium. The darker shapes indicate more layers of acrylic medium; these will be the lightest in the finished print.

Betty Sellars, *Bridge at Twilight.* Two-plate print, 12 × 18" (30 × 46 cm).

Sellars first printed the fabric collagraph plate above. With a second pass through the press, she printed an intaglio line etching plate on top of the collagraph print to develop fine details.

A synthetic sponge was stamped into wet gesso to create this relief texture when the plate was inked.

A paper doily printed like this with an intaglio plate wipe.

The same doily printed like this for a simple relief-style inking with a brayer.

A crocheted doily was pressed into wet gesso, and the surface of the plate was rolled for this relief print.

If the interstices are partially filled with a material like acrylic medium, less ink will catch and a lighter tone will print. To develop a plate this way, dip the woven fabric in a solution of 50 percent acrylic medium and 50 percent water, and stretch it over a support such as $1/8$" (0.32 cm) Masonite. You can add colored acrylic paint to the medium so that as each layer is added it will appear slightly darker on the plate than the layer before it; this helps you see what you are doing. However, the printed tones will be in reverse to those on the plate because the lighter printed tones will be the darkest, most layered coats of medium.

Organic materials such as pressed flowers, leaves, or grasses are often used in collagraph work. If the plant parts are fresh, run them through an etching press first. As mentioned in Chapter 3, whenever you run organic materials through a press, cover them with waxed paper—several layers of it for really fresh material—to protect the press blankets from the juices of the plants. I enjoy collecting plant parts throughout the year, which I prepare in a simple flower press. (See the illustration on page 135.) In a few days they are dry and ready to be glued to the base plate. If the plant parts stick up too high, they may print with halos surrounding the shapes. To avoid this, you can shave high areas or recess the shape into a cut surface. After you have arranged the elements of your collage as you want them, glue them to the board, and after they are dry, coat them with acrylic gesso or medium to seal and protect the surface.

All sorts of found flat objects will print as relief shapes. Gaskets, bamboo shade material, or shavings from tools can be assembled and printed. Old sewing box contents yield other possibilities. Your imagination is the limit. Again, if an object sticks up too high from the

base plate, recess it by outlining the shape and cutting away the necessary material from the base.

Modeling materials that will harden can be shaped to become collagraph elements. Fimo clay and similar materials found in craft stores can be modeled and hardened in the oven. Other materials such as Amaco Sculptamold, a product whose texture is similar to papier-mâché, modeled, carved, or used to cast shapes.

You can cut and develop metal plates with power machinery. Shapes can be soldered or bonded together using molten solder or the glues sold in hardware stores as "liquid solder." Also trying applying these substances to the surface to develop raised textures. Intaglio techniques can be used to incise imagery into the surface.

Here is another technique to try: Crumple aluminum foil or thin paper and glue it to the surface. If there is air space behind these materials that will collapse under the pressure of the press, fill the backside with gesso or modeling paste. Stick the crumpled foil to the board while the modeling paste is still wet, and manipulate the foil until its peaks and valleys are where you want them and feel well enough supported by the modeling paste below. Let it dry in place.

I used dried flowers and hot glue on mat board to form the base for this plate.

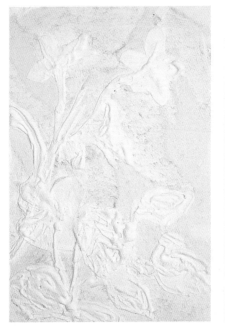

I covered the plate with acrylic gesso—including the back—to protect it from absorbing ink, water, or solvent.

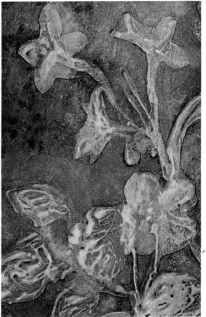

I painted and wiped the plate so that the most ink would remain in its deepest recesses. Here is the finished print.

A simple flower press: (a) top and bottom are two ¼" (0.6 cm) thick square wooden boards with four holes to fit bolt and wing nut fasteners; (b) put slightly smaller squares of corrugated cardboard between them; (c) put flowers inside a folded sheet of paper toweling and then place them between the corrugated cardboard squares; (d) insert bolts and wing nuts, with the wing nut at the top, in all holes connecting the top and bottom boards. Then tighten the wing nuts to give firm and even pressure on all four corners.

INKING AND PRINTING THE COLLAGRAPH PLATE

It often takes a number of proofs to discover how to ink and print individual collagraph plates. In many instances, you can create quite a wide variety of effects from the same plate simply by inking and printing the plate differently, so it all depends on what effect you are looking for. For example, if the plate has cut shapes with flat surfaces, you can roll it with ink and print it as a relief print. If incised lines and recessed textures are to be printed, you can ink and wipe the plate as an intaglio plate. You will almost always want moistened heavier printing papers, relief or intaglio inks, and an etching press.

When multilevel sculpturing and textures are on the plate, it is often necessary to ink the plate with a paintbrush in order to make sure all areas will have color. You can wipe the surface heavily with lintless cloths or tarlatan. You can experiment with wiping the surface as if it were an etching or engraving (so that incised imagery holds that color of ink), and then rolling a different color across the surface as if it were also a woodblock or linocut. This technique is most effective with collagraphs that have a strong definition of raised versus lowered areas.

I applied ink to the plate with a paintbrush to make this print.

For this plate, thin cut shapes were glued to mat board. Then they were sealed and textured by painting with acrylic gesso.

The plate was rolled with a soft brayer for this print. The light "halos" outline the changes in the plate's level.

Wiping the plate with tarlatan produces a different effect. This time the most ink is held in the changes of level, as in the incisions of an intaglio plate.

Here the plate was inked and wiped with darker ink for the recessed areas. Then it was rolled with a lighter color on a hard rubber brayer so that the higher shapes printed in relief.

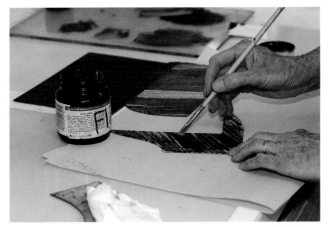

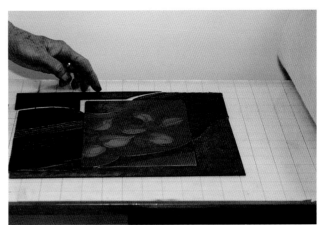

Betty Sellars uses a brush to ink texture detail where a brayer will not reach.

Sellars has inked her seven-part metal intaglio and collagraph plate and is assembling it on the press bed.

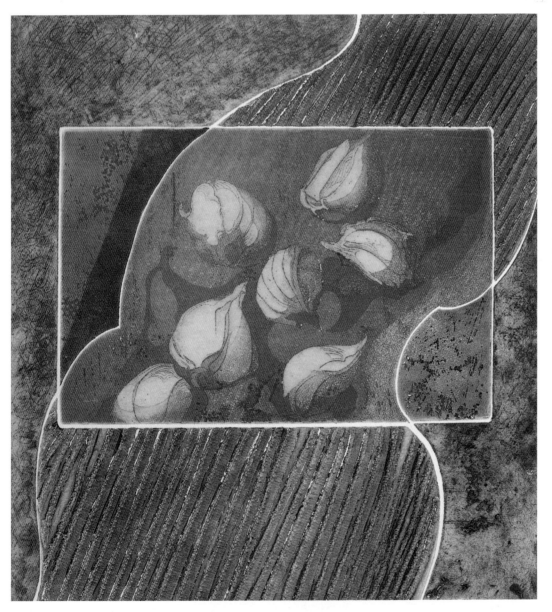

Betty Sellars, *Garlics.* Print made with etching and collagraph techniques, 11 × 12" (28 × 30 cm).

The garlics were etched in metal, but the textures in the borders were accomplished with collagraph platemaking. Glued and sealed corduroy material on two sections and textured modeling paste on the others complete the image.

Collagraph plates can be developed to make embossed prints without ink. Such prints are made on very moist paper with added blankets to cushion and form the wet paper. These prints should be left to dry freely, without weights or blotters. The natural form of the dried paper will emphasize the three-dimensional quality of the collagraph print.

If a collagraph plate has multiple levels to print, it is often necessary to use extra blankets or sponge rubber to print it successfully on an etching press. The extra blankets should be the soft forming type. This is particularly true in cases where there are multiple variances in plate levels. For a different effect, you could use a firm blanket and print only the top level of the collagraph, as if you were printing a relief plate.

Gloria Jacobson built her plate to emboss shapes. She cut mat board shapes of different thicknesses and glued them onto a base mat board. The plate was sealed with acrylic gesso on the front and back.

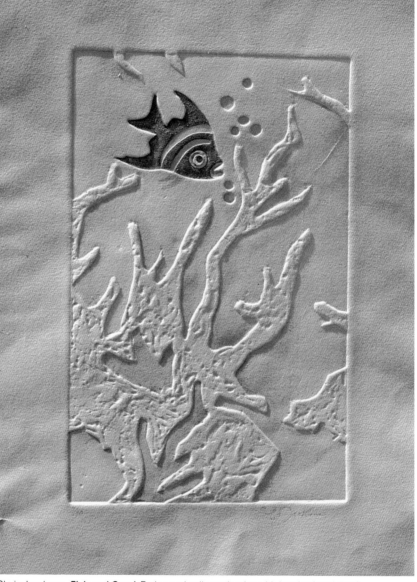

Gloria Jacobson, *Fish and Coral.* Embossed collagraph print with hand-painted detail, 15 ³/₄ × 9 ³/₄" (40 × 25 cm).

Jacobson left the print to dry without weights, which would flatten the paper and destroy the three-dimensional effect.

COMPUTER-GENERATED PRINTS

A graphic artist today is almost required to work on a computer to be competitive in the marketplace. Fine artists have been increasing their experimentation in this field. Most graphic design programs are two-dimensional, and there are three-dimensional programs.

Roger Guillemin developed his computer paintings on a screen and saved them in permanent memory. He then sent a disk copy of the image to Image Set in San Francisco, where color separations were made from the digital information stored on the disk. Separating a color image means breaking it down into separate plates—usually, as in this case, yellow, magenta, cyan, and black. Actually hundreds of tints and hues can be made by recombining these four colors in different proportions, so that when they are printed on top of one another, they re-create a good facsimile of the original image. The separations of Guillemin's work were exposed on four photolithography plates and then hand-printed in the color order just mentioned. Photodeveloped prints can also be made using computer disk information.

Changes in the computer field are taking place so rapidly that the information I write could be obsolete before this book is out of print. However, for the time being, computer imagery is drawn in dots, or pixels. Computers and programs with many fine pixels close together are said to have high resolution. The higher the resolution, the more refined the image—especially for purposes of smooth curves and diagonal lines. Guillemin updated his computer and program so that the dot

resolution is finer in *Truchas* than it was in *Paradise Lost,* which appears in the Introduction. The program on my computer is considered to be a dinosaur by my computer-wise friends, but I still find that it excites my creative juices.

Both Guillemin and I currently work on computer programs where the user draws two-dimensionally but can also draw lines that represent three-dimensional imagery. Recently I became intrigued with the possibilities of working with the DesignCAD 3-D program because it can draw imagery in three dimensions. At the push of a button, the artist can flop a drawn object on the screen and change it instantly to the top or side views. This is quite useful for some kinds of work.

Roger Guillemin, *Japanesa.* Computer painting/Fujichrome print, 4 × 5" (10 × 13 cm) on black background.

Guillemin developed this computer painting on a Macintosh IIcx with PixelPaint and PixelPaint Professional software. He had several options for printing it. In this case a scanner converted the digital document to a 35mm transparency, from which four prints were then made on a Fuji printer.

Roger Guillemin, *Truchas.* Computer painting/Fujichrome print, 8 × 10" (20 × 25 cm).

This computer painting has more refined imagery than either *Japanesa* above or *Paradise Lost,* which was printed by hand lithographic methods and appears on page 14. In *Truchas* Guillemin's upgraded equipment generated higher dot resolution for smoother curves. For this painting, he used a Macintosh IIfx computer in the 24-bit RGB mode, with Adobe Photoshop 1.0.7. software.

THE PLATE AS A WORK OF ART

Kathleen Morris painted oil on canvas before she was introduced to etching on copper plates. She was moved by the beauty of the metal plate itself and decided it should be displayed. For her 1992 gallery exhibitions she etched 22 copper intaglio plates, each 32 × 48" (81 × 122 cm), with intuitive depictions of the tarot cards. For instance, her image of "the magician" is a pregnant woman with many hands. Before exhibiting the plates themselves, she used them to print a series of monoprints.

Morris experimented with rubbing on small amounts of a number of chemicals to give her plates patinas. She also painted a little on the plates with her brushes and oils. The plates were framed with simple metal strips.

Kathleen Morris, *The Fool.* Intaglio monoprint from the Tarot series, 47 × 32 ¹/₂" (119 × 83 cm).

Morris printed an etched intaglio plate and then developed it into a monoprint by painting oil-based inks onto a second plate and printing it on top of the first. She then developed the image even further by brushing oil-based ink directly onto the print.

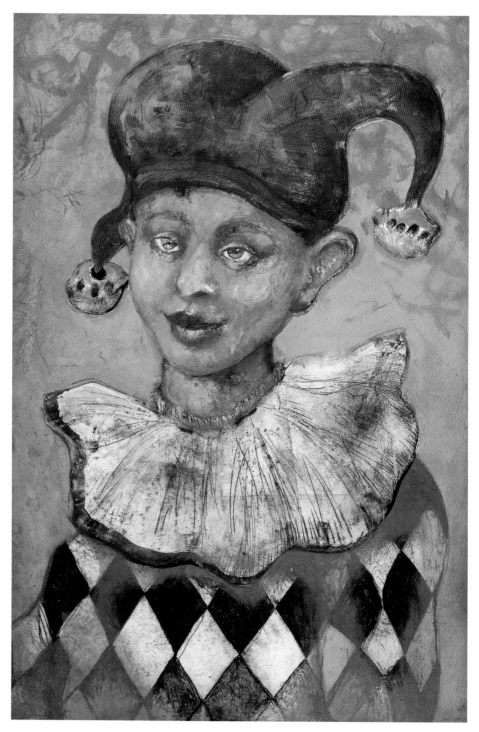

Kathleen Morris, *The Fool.* Intaglio copper plate from the Tarot series, 48 × 32" (122 × 81 cm).

Morris gave the plate patinas by applying various chemicals that reacted with the copper, as well as using oil inks. The plate—like the others in her Tarot series—was framed and exhibited.

CLICHÉ VERRE

Earlier in this book we discussed how to use photodeveloping techniques on traditional printmaking surfaces, such as etching and lithography plates. In cliché verre, the artist makes a negative on glass or some other transparent surface, which is then exposed and printed using a process similar to developing a negative created by a camera. It is a way of producing an edition photographically. Cliché verre has the advantage that you can mix as many transparent colors as you like on one negative, compared with needing several plates in lithography.

Whether you are working in black and white or color, cliché verre takes imagination and practice because you will get the opposite color from what you paint. For example, when I wanted white orchid blossoms in a dark field, I painted a black blossom on clear acetate. This painted

I painted this black-and-white negative on acetate with ink.

Jack Hardy exposed and developed the black-and-white photographic print.

Martin Green, *Deep Blooming.* Cliché verre diptych, 18 × 38" (46 × 97 cm). Courtesy of Louise and George Gilbert.

Green created a transparent photographic negative by painting transparent dyes. When the negative was developed photographically, the colors printed the color-wheel opposite of what he had painted.

I then painted the print with Winsor & Newton transparent inks.

negative was then exposed and developed in a photo lab much as I would have a large photo negative printed. You can color black-and-white photo prints by hand using Winsor & Newton transparent inks.

To create a color cliché verre print, you use transparent photo retouching dyes on glass or clear acetate to make the negative. The colors must be transparent because an opaque pigment would block light during the exposure. In this process you paint the color-wheel opposite hue of the one you eventually want on the print. Red, blue, and green are the three primary colors of a photographic negative. For example, a green area on the negative prints red. A great deal of experimentation is needed to find a desired palette! After painting a color negative on glass, Martin Green developed and printed his work on fine photo papers.

If you are interested in doing serious work in cliché verre, you will need to explore darkroom procedures for printing in black and white—or in color. Books and literature on the subject are readily available. The Eastman Kodak Company publishes a number of books and other publications about photographic subjects and also has an information hotline; see the List of Suppliers in the back of this book.

THREE-DIMENSIONAL PRINTED ASSEMBLAGES

Some printmaking processes can be done on a heavy support such as card stock, plastic, or metal. Robert Schwieger has been very innovative in turning his screen prints on archivally sound cardboard into three-dimensional assemblages. He prints out pieces of his constructions on archival-quality cardboard, printing a number of pieces on the same flat sheet. The pieces are then cut, scored, folded, and glued to become three-dimensional parts in the construction. Openings may be cut to reveal imagery below. Schwieger used to assemble the pieces identically to make editions. Now he enjoys taking printed elements from his past work and assembling them with new found objects to create monoprints.

This is the photo positive Schwieger made on acetate that was used to make the photo screen stencil.

And here is the print as it appeared on the card stock.

The blue shape was cut out, scored and folded, and assembled on a work in progress.

Robert Schwieger, *Chix and Cats.* Screen-printed assemblage that includes found elements, 18 1/8 × 25 5/8 × 1 1/2" (46 × 65 × 4 cm).

Here is a finished piece made with techniques similar to those just demonstrated. This type of art has its own unique appeal.

HAND-PRINTED CARDS AND BOOKS

Not all prints are to be framed and hung. Many artists enjoy assembling prints in some form where people can study the artwork closely, unhampered by glass or distance. Prints can also be made into cards, books, or three-dimensional assemblages.

GREETING CARDS

Betty Sellars has made unlimited editions of hand-printed cards that are special to send. She prints her small intaglio plates on fine paper and then glues the prints to writing paper that is folded over once (a folio fold). The writing paper has matching envelopes that accommodate the greeting cards.

I made some cards (see next page) while exploring photocopier printmaking. After gathering wildflowers and other grasses from our field, I assembled them with dried garden flowers, photocopies of copyright-free wood engravings from the late 1800s, and a dead Monarch butterfly found on a pathway during one of my morning walks. All these elements expressed my Oklahoma summer. I collaged them onto three 8 ½ × 11" (22 × 28 cm) sheets of paper and used a photocopier to reproduce them onto card stock. The printed sheets were cut, folded, and assembled.

Betty Sellars, *Dogwood Blossoms.* Two-color, single-plate etching, 3 × 4" (8 × 10 cm), glued to folded writing paper.
Special greeting cards like this one can be made by attaching prints to writing paper. They have a uniquely elegant look.

Here is the front of a greeting card I made by photocopying three cut layers of drawn and collaged imagery onto card stock. I cut around different shapes and then reassembled them.

The back of the card has photocopied reproductions of a found Monarch butterfly, black-eyed Susans from our field, and an assortment of other plant material.

The centerfold was printed from this master of collaged copyright-free wood engravings and dried plant material. I folded and cut it so that some of the creatures would pop outward when the card was opened. Messages could be put in the center of the card by lifting a cut-out.

Small parts were cut from additional sheets and glued to the centerfold to create three-dimensional pop-outs. I used white glue to bind the pages.

Each card stands on its own, but it might become the dummy for printing in other techniques. Such a card could inspire the first pages of a children's book, for example.

BOOKS

The dummy (working model or mockup) for a book is necessary in order to plan the number of pages needed and how they will be laid out. A miniature page layout sheet, similar to one given to me for this book by my editor, is helpful for roughing in the first layout. The next stage is a full-size dummy made on inexpensive paper, so that you can visualize the full product before starting to print and cut expensive papers.

The layout can be a scroll, an accordion fold-out, bound single sheets, or gathered folded sheets known as signatures. This book was made with multiple signatures. By looking at the edge of the spine, you will see groups of papers that were folded once and gathered one inside the other. Open any signature in the center and you will see how it was sewn together on the fold. Multiple signatures are gathered and attached with tapes, glue, and/or sewing.

If folds are made along the grain of a paper, it is easier to make the pages stay flat. To determine the grain of the paper, fold a sheet both lengthwise and crosswise. The fold will be crisper when done with the grain. Sometimes it is necessary to fold against the grain to make the best use of paper for some layouts. In that case, folds against the grain can be made harder by burnishing the edge.

David C. Jansheski, *Am'auan,* (Book of Understanding), detail. One of six 9 × 12" (23 × 30 cm) relief-cut panels from Jansheski's book.

Jansheski worked in collaboration with the Duntog Foundation in Baguio, Philippines. He used several relief-cut blocks to print each of the color images.

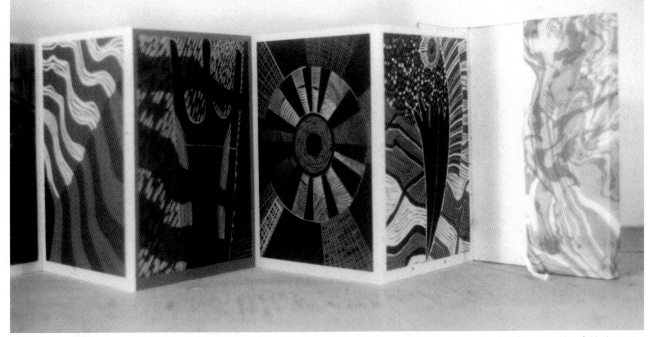

David C. Jansheski, *Ag-agat Diary,* (detail). Seven 12 × 9" (30 × 23 cm) woodcut panels assembled in an accordion-fold format inside a folded cover. Here again, Jansheski worked at the Duntog Foundation, where special papers were designed and made specifically for his two bookmaking projects.

To assemble single or signature pages, you may prefer the traditional hand-sewing methods of the bookbinder's art. Staples, spiral rings, and plastic or metal fasteners can also be used to bind single papers, and staples can be used to bind signatures.

Book covers can be front and back boards covered with fabric, either separately with a bare spine as in some scrapbooks, or in such a way that the fabric covers the spine. Remove the dust cover of this book and study how the material covers the front and back boards with space between to cover the spine of the folded and gathered signatures. The endpaper that is glued to the inside front board and the first fly sheet are a folio fold of a heavier paper than appears inside the book. In hand bookmaking the endpapers and fly sheets may be the outside papers of the signatures.

Betty C. Bowen and Mary Dryburgh used a sewing machine to assemble their single-signature book. Not only were the pages bound with the machine sewing, but the hand-printed woodcuts were sewn onto the support papers. Their book contains lesser-known poems by William Butler Yeats, printed with hand-set type on a Vandercook press by Bowen. Dryburgh made the strong image woodcuts to illustrate the works. (They secured rights from the Yeats estate to make the limited edition of this publication.)

When you are hand-printing a book, you have freedom to be experimental and creative in the presentation. Pages can be lifted up, be folded inward, or have elements collaged onto the surface. You can use several kinds of paper in the same signature—even transparent Mylar works as a print support. There is complete freedom of expression.

A three-hole sewn binding. Top left: (1) The needle enters the center hole, (2) passes below to come up through an outside hole, (3) crosses the top and enters the other outside hole, and (4) comes back up through the center hole. With the two loose ends on opposite sides of the (3) stitch, loop and tie them together. Bottom left: In actuality the stitching will lie flat. You can use this stitching pattern to sew a signature of folded papers. Right: Hinged covered boards can be tied in the three-hole pattern. These boards hold single sheets.

A five-hole sewn binding:
(a) nine stitches are used to sew this signature of papers;
(b) the tied signature as it appears from the back fold;
(c) a pattern to link several signatures as you sew them.

a

b

c

Mary Dryburgh, *Unnoticed Like a Bird.* Woodcut, 12 1/2 × 20" (32 × 51 cm).

This is the title page for this hand-printed book of some of William Butler Yeats's lesser-known poetry. Mary Dryburgh (whose name was then Mary Sprague) printed this recurring image here as a woodcut with light ink. Betty Bowen hand-set the type on a Vandercook press.

The centerfold page opens to the right to reveal printed poetry.

Elsewhere in the book, a page lifts upward to include additional poetry still facing the same image on the right.

Two additional spreads in more traditional format.

CURATING THE PRINT

Once the printmaking process has been completed, the work is curated and labeled. Curating involves examining each print to make sure that it meets the standards of the artist and printer. Labeling involves numbering the edition, identifying the image, and signing the print.

Examine each print to make sure all the work transferred as expected. If some of the border contains smudge marks, they can often be cleaned with a Pink Pearl or gum eraser. If the paper is too wavy, mist the back of the print and put it between blotters, under weight, to dry flat.

Terms are given to prints to keep chronological records of the edition. As the printmaking surface is developed, *proofs* are pulled to study the state they are in. These proofs are labeled *state 1, state 2,* and so on. (You have seen examples of such proofs several times in this book.) The first proofs pulled from the completed surface are labeled AP for *artist's proofs* and can be given to a gallery or sold. Up to 10 percent of the edition can be made ethically as artist's proofs. The smaller the edition, the more valuable each print. This is why too many artist's prints would mislead the serious collector who wanted to know how many prints were in the total edition.

Francisco Goya (1746–1828), *Modo de Volar* (Way of Flying) from his collection *Los Proverbios.* Line etching and aquatint, 9 1/2 × 13 1/4" (24 × 34 cm). Courtesy of Sarah Campbell Blaffer Foundation, Houston, Texas.

The artist chooses and approves a *bon à tirer* (French for "good to pull"), or printer's proof, to serve as the standard for the edition if the artist is working in collaboration with another printer. Before the printing of the actual edition begins, the total number in the edition, not including proofs, is determined by the artist, or by the artist and printer together. Some types of plates will last for larger editions than others; for example, drypoint plates are relatively fragile. Any plate will eventually start to break down and lose print quality.

As subsequent prints are made they are numbered in sequence, and this number is placed over the total in the edition in the margin of the print surface. The notation looks like a fraction; for example, 12/20 designates a print as twelfth out of an edition of 20. Collectors consider the first prints pulled to be the best because of the gradual plate breakdown just mentioned. If the entire edition is not printed at one time, especially careful records must be kept. It would be unethical not to be accurate in edition information.

After the edition is completed, some printmakers scar their plates to show collectors that no more prints will be made from it, and a *cancellation proof* may be printed. However, if monoprints are to be printed, this cancellation step is not made. Monoprint plates can be used different ways to produce an indefinite number of prints.

Labeling on the face of the print is traditionally done in pencil, in the margin directly under the image. The numbering is usually done on the left or at the center. The title is written at the left or toward the center, and the artist signs to the right. If a print shop made the edition, a chop mark—the stamp of that particular print shop—is embossed in the margin.

Labeling a monotype or monoprint can be done in several ways. The most common method is to label it with a 1/1 and then state whether it is a monotype or monoprint. In a varied edition, where the image itself remains unaltered but the printmaker deliberately changes the color or paper during the edition, the place of the print is stated over the number in the edition followed by the words "varied edition."

CERTIFICATES OF AUTHENTICITY

During the writing of this book I saw a number of certificates of authenticity. These accompany the print when it is sold and give accurate information to the collector. The most clear and complete statement was designed by Cutler Associates in Vista, California. A small black-and-white reproduction of the color print appears on the certificate. The page is headed by the title, date, and type of print. This is followed by the image size, paper size, and the paper used.

The next information on the authenticity sheet is under edition information: total number printed; regular edition size; number of trial proofs made during the development of the work (similar to state proofs), artist's proofs, printer's proofs, and any other special prints made. This was followed by the name and address of the workshop where the work was made. There is also space for detailed information concerning the number of plates and colors used.

Finally, the following statement is signed and dated by the artist:

All other proofs and impressions have been destroyed and the plates have been effaced.

I hereby attest that the foregoing facts in this document of authenticity are true and accurate statements describing this work of art.

The above [small black-and-white] image is for identification purposes only.

_____ _____

Artist's signature *Date*

ARTISTS' BIOGRAPHICAL NOTES

Ayres, Julia The author of *Monotype: Mediums and Methods of Painterly Printmaking* (New York: Watson-Guptill, 1991), Ayres has contributed a number of articles to *American Artist* magazine's *Watercolor* issues. Her artwork has been included in exhibitions by the National Watercolor Society, National Art Club, American Artists Professional League, Los Angeles Audubon Society, and Oklahoma Watercolor Society. Her work is also found in numerous private, public, and corporate collections.

Bowen, Betty C. An artist and printmaker working in Guthrie, Oklahoma, Bowen received an MFA in printmaking from the University of Wisconsin. Her hand-printed books are in rare book collections, and her prints have been exhibited at several universities and museums here and abroad.

Brady, Carolyn Numerous prestigious collections include Brady's work: The Metropolitan Museum of Art, New York City; AT&T, New Jersey; and Chase Manhattan Bank, New York City, among others. She is represented by Nancy Hoffman Gallery in New York City.

Dryburgh, Mary As assistant professor of art at Tulsa University, Dryburgh teaches printmaking and drawing. She received the 1992 Individual Artist/Scholar Award from the Arts and Humanities Council of Tulsa. Her work was exhibited in numerous shows, including the one-person exhibit "Envisioning Worlds: New Works on Paper," Alexandre Hogue Gallery, University of Tulsa.

Ferrer, Rafael The list of Ferrer's impressive exhibitions includes numerous museum and gallery shows nationwide and abroad. His work is in many permanent museum collections. He is represented by Nancy Hoffman Gallery in New York.

Fitzgerald, Scott After receiving his master's degree in art at California University at Fullerton in 1974, Fitzgerald went on to teach there for several years. Since that time he has devoted himself to printmaking. One group of his etchings was used to illustrate Robert Louis Stevenson's *A Child's Garden of Verses* with the English printer John Randle at Whittington Press. He has also collaborated on a project with writer Ray Bradbury.

Friese, Nancy Currently head of the printmaking department at Rhode Island School of Design, Friese received a MFA in printmaking from Yale University School of Art. She has received several prestigious grants and awards. She is represented by the Toni Birckhead Gallery in Cincinnati.

Gilot, Françoise Gilot was the first woman artist privileged to work with the legendary Murlot Workshop in Paris in the early 1950s. Her work is included in numerous museum collections, and the Bibliothèque Nationale in Paris owns a complete collection of her lithographs. Gilot is also the author of a number of books, including the recently published *Matisse and Picasso: A Friendship in Art* (New York: Doubleday, 1990). She was awarded the Legion d'Honneur by the French Government for her work as an artist, writer, and feminist. Her prints are represented by Richard Reed Armstrong in Chicago.

Green, Martin A highly respected artist, Green, who died in 1991, was known for his versatility as a printmaker and for his innovations in the fields of monotype and cliché verre. The author remains indebted to him for his considerable contributions to *Monotype*. Green's work is represented in numerous corporate and public collections.

Guillemin, Roger In 1977 Guillemin won the Nobel Prize in medicine. His computer paintings are currently being shown and represented by the Williams Collection in Princeton, New Jersey; and Hand Graphics Gallery in Santa Fe, New Mexico. His work was also exhibited in a one-person show at L'Agrifoglio Gallery, Milan, Italy, in 1991.

Haralson, Dianne Haralson currently acts as director of the Five Civilized Tribes Art Museum in Muskogee, Oklahoma. She is also an instructor of humanities and fine arts at Connors State College, Muskogee, and she holds artist-in-residence status with the State Arts Council of Oklahoma.

Hill, Joan Hill's artwork concerns her Native American heritage of Creek and Cherokee ancestry. She has won over 254 awards and commendations. Over 85 of her artworks are included in permanent museum and college collections. She was commissioned by the Bicentennial Commission to do a work for the USA Center of Military History at the Smithsonian.

Hodes, Suzanne Hodes worked in Paris on a Fulbright Grant and also studied with Oscar Kokoschka in Austria and George Grosz at the

Skowhegan School in Maine. She has exhibited in over 75 group and solo shows in Boston, New York, and San Francisco. Her work is in many public and private collections.

Hoyal, Dorothy Hoyal's work is included in the permanent collections of the State of California Interpretive Center in Lancaster, and NASA at Edwards Air Force Base, as well as several corporate collections. Her work was included in the exhibit "Printmaking from Currier & Ives to Andy Warhol" at the Lancaster Museum, California. She is represented by Kathleen Warner Fine Arts in Los Angeles.

Jacobson, Gloria Jacobson has works included in corporate collections such as Fairbanks Country Club, Flour Corp., Bank of America, Hitachi, and North American Rockwell. Her work has appeared in *American Artist* magazine and has been a subject of exhibitions nationwide. She is represented by Art Angles Gallery in Orange, California.

Jansheski, David C. Jansheski has exhibited widely. In 1990 he was invited to work at the Experimental Graphics Workshop in Salzburg, Austria. His many commissions include one for the Cleveland Print Club and one for the Otaru Grand Hotel in Sapporo, Japan.

Kapp, David Kapp has exhibited extensively in group and one-person exhibitions, as well as at the Museum of Art at the Rhode Island School of Design, and the Gallerie Christian Cheneau, Paris, France. His extensive bibliography includes articles in *The New York Times*, *Arts* magazine, and *Art News*. He is represented by Solo Gallery in New York.

Kendis, Maggie Best known for her large batik paintings, Kendis

has work in many corporate and private collections, including the Disney Hilton Hotel, Orlando; the Rye Hilton, New York; and the Tobu Hotel, Japan. She is represented by Kathleen Warner Fine Arts in Los Angeles.

Kreneck, Lynwood A professor of art at Texas Tech University in Lubbock, Kreneck is also director of "Colorprint, U.S.A.," a prestigious print exhibition. His work has been included in over 100 national and international juried exhibitions, where he has received over 30 awards and honors. His work is represented in over 38 museum and university collections. Kreneck has published many articles. His book *Water-Based Screenprinting: Shop Note Manual* is available from Hogarth Mesa Press, P.O. Box 98343, Lubbock, TX 79499.

Lee, Willis F. A Santa Fe photographer, Lee started in 1973 to specialize in the highly developed technique of making photogravure plates. Lee has work in exhibitions and collections, including Hallmark Fine Art Collection, Kansas City; Dallas Museum of Natural History; and The Lajitas Museum, Lajitas, Texas. He is represented by Hand Graphics in Santa Fe.

Lindgren, Eric Lindgren works as a master printer of lithographs, etchings, and monotypes at Hand Graphics in Santa Fe. His art has overlapped into theater, where he has worked as a stage designer and artistic director—and has also executed sculptural and wearable art—for the Santa Fe Opera. He is represented by Hand Graphics in Santa Fe.

Lindquist, Evan A professor of art at Arkansas University, Lindquist has an extensive list of prestigious art and printmaking exhibitions that dates back to 1964. Many well-

known national and international museums and institutions include his work, such as The Museum of Fine Arts, Boston, and The Whitney Museum of Art, New York.

Macrorie, Joyce T. Macrorie's work has been exhibited nationally, notably in New York, Illinois, and Michigan. Permanent collections that include her work are the Detroit Institute of the Arts, IBM, and Kalamazoo College. She is represented by Munson Gallery in Santa Fe.

Mayer, Dorla After earning her MA in printmaking from the University of Wisconsin, Mayer co-founded Survival Graphics in Madison, Wisconsin, in 1979 and is still active there today. She pioneered the use of water-based screen-printing systems at her location. Her work has been shown locally in group and solo exhibitions in Madison.

Morris, Kathleen Morris studied at the Ascademia in Bergamo, Italy, in 1983. From there she was selected to show at the Salon d'Automne in Paris. Her most recent solo exhibitions have been at the Lowe Galleries in Atlanta and Los Angeles and the Peyton Wright Gallery in Santa Fe.

Nilson, Kurt Nilson has work in the permanent collection of Oklahoma State University, where he won awards in stone sculpture in 1990, 1991, and 1992. Nilson apprenticed a few weeks with the author between graduating from OSU in 1992 and moving to Europe.

Pass, Dewayne An art and printmaking instructor at Tulsa Junior College, Pass has had work exhibited successfully in regional shows. He also has work in the permanent collection of Arizona State University, where he received his MFA in 1985.

Pokrasso, Ron Founder and director of Graphics Workshop in Santa Fe, Pokrasso has had work included in a number of prestigious national exhibitions and collections. In 1989 he was the subject of a solo show in Riverside Art Museum, California; and the Reynolds Gallery, Westmont College, Santa Barbara, California.

Raffael, Joseph Raffael is an internationally recognized artist who lives and works in southern France. Public collections include The Art Institute of Chicago; Cleveland Museum of Art; National Collection of Fine Arts, Smithsonian Institution; and the Whitney Museum of Fine Art, New York. He is represented by the Nancy Hoffman Gallery in New York.

Resnick, Minna Resnick has received several grants. Her work is in the collections of The Brooklyn Museum, New York; The Sheldon Art Museum, Lincoln, Nebraska; and the Victoria and Albert Museum, London. Her work was a solo subject at the Monterey Museum of Art in California in 1987.

Royce, Richard Now the owner of Atelier Royce in Salem, Massachusetts, Royce was first a student and then served as Massier to Atelier 17 with Stanley W. Hayter in Paris. Royce's own work is in such collections as the Bibliothèque Nationale, Paris; The Fine Arts Museum of Long Island, New York; and Uyasuda Life Insurance Co., Japan. His work has also appeared in numerous publications.

Samaniego, AnaMaria A printer and teacher at Graphics Workshop in Santa Fe, Samaniego studied under Ron Pokrasso and Deli Sacilotto, among other printmakers. Her work has been exhibited in numerous New Mexico and Southwest exhibitions, including the 1992 invitational

"Contemporary Hispanic Art" in the Governor's Gallery, Santa Fe.

Schoen, Pat Schoen studied art at the University of New Orleans and the Academy of Fine Arts in New Orleans, where her work is included in many private collections. She now lives in Oklahoma and participates in the Experimental Studio Sessions at the Whitbread Press in Tulsa with Betty Sellars, and the Philbrook Museum Art School with Maxine Richard.

Schwieger, Robert Schwieger is currently a professor of art at Missouri Southern State College. His work has been the subject of numerous solo shows, including a 1992 exhibition at the Alexander Hogue Gallery at the University of Tulsa, Oklahoma. His work was included in "Colorprint U.S.A." and *The Complete Printmaker: Techniques—Traditions—Innovations* by Ross, Romano, and Ross (New York: Free Press, 1989).

Sellars, Betty As the owner and founder of Whitbread Press in Tulsa, Oklahoma, Sellars has taught intaglio printmaking to many artists. Her work is included in numerous private collections locally in Tulsa as well as in New York and abroad. She is represented by Color Connections Gallery, Tulsa.

Siamis, Janet N. Siamis was an award winner in the 1991 exhibition of the Florida Watercolor Society, of which she is a member. Her work is included in many corporate collections, including several prestigious Marriott hotels. She is represented by Riggs Galleries in La Jolla, California, and Nice Picture Company in Havana, Florida.

Spencer, Editha Joshua's Tract Conservation and Historic Trust, the Windham Regional Arts Council, The University of Connecticut

Foundation, and the University of Connecticut Library have all commissioned prints from Spencer. Her block-print book plates appeared in *Ex-Libris* VI, the 1982 publication of the International Ex-Libris Congress. Her work has appeared in several group exhibitions, as well as a solo 1983 exhibition in the University of Connecticut Library.

Walters, Sylvia Solochek Currently a professor of art at San Francisco State University, Walters is also asked to lecture and teach at other institutions, including Kala Institute, Berkeley, California. Her work is in such collections as the St. Louis Art Museum, United States Information Agency, *Reader's Digest* permanent collection, 3-M Corporation, and 15 university and college collections.

Wax, Carol Wax is the author of *The Mezzotint: History and Technique* (New York: Harry N. Abrams, 1990), and an essay entitled *Yozo Hamagushi: Master of the Mezzotint,* (Tokyo: Tokyo Metropolitan Teien Art Museum, 1990). She received the Artists Fellowship Grant from the New York Foundation for the Arts in 1987. She has also had two solo exhibits: *Contemporary Mezzotints,* 32 mezzotints 1986 at the Witchita Art Museum, Kansas, and the 1990 *Mezzotints* at Sylvan Cole Gallery, New York. Her work is in numerous collections. She designed the weight attachment system for mezzotint rockers made by Edward C. Lyons.

Young, Barbara Young lives and works in Ohio, and her work has been exhibited in numerous invitational and juried exhibitions nationwide. Among the numerous public and corporate collections that include her works are the Museum of Fine Arts, Boston; the Cincinnati Art Museum; The Miami University Art Museum; and the University of Michigan Art Museum.

LIST OF SUPPLIERS

You may live near a good art supply store. Good-quality papers and screen-printing supplies are readily available in most cities. If you can't find what you need, here are some tips on locating some of the products and workshops mentioned in this book.

Mail-order supplies:

American Clay Company
AMACO
4717 West Sixteenth Street
Indianapolis, IN 46222
(Litho-Sketch materials)

American Small Business
Computers
One American Way
Pryor, OK 74361
(DesignCAD 3-D, a three-dimensional computer design program)

Colorcraft Ltd.
14 Airport Park Road
East Granby, CT 06026
(Createx water-based inks)

Daniel Smith Inc.
4130 First Avenue South
Seattle, WA 98134-2302
(Inks, papers, tools)

Dick Blick
P.O. Box 1267
Galesburg, IL 61401
(Printmaking and art supplies)

ECO Design Company
1365 Ruffina Circle
Santa Fe, NM 87501
(Livos citros thinner)

Edward C. Lyons
3646 White Plains Road
Bronx, NY 10467
(Printmaking cutting tools)

Fuji Photo Films USA
Graphic Systems Division
1285 Hamilton Parkway
Itasca, IL 60143
(Fuji photolithographic plates and related information)

Graphic Chemical & Ink Co.
P.O. Box 27
728 North Yale Avenue
Villa Park, IL 60181
(Printmaking supplies and chemicals)

Intercontinental Chemical Corp.
(ICC Chemical)
4660 Spring Grove Avenue
Cincinnati, OH 45232
(Nontoxic screen-printing solvent)

J-Ben Company
4573 West L13
Quartz Hill, CA 93536
(J-Ben Sculpture-eze modeling compound for collagraph)

New York Central Art Supply
62 Third Avenue
New York, NY 10003
(Papers and art materials)

Savoir Faire
P.O. Box 2021
Sausalito, CA 94966
(Lana handmade papers)

Sinclair and Valentine, L.P.
P.O. Box 3525
Santa Fe Springs, CA 90670
(Inks for stone lithography)

Twinrocker Handmade Paper
100 East 3rd Street
Brookston, IN 47923
(Handmade printing papers)

Watermark Editions
Mahri Brennan and
Larry Taylor, owners
S.E. 3591 Old Olympic Highway
Shelton, WA 98584
(Steel facing of copper plates and photo-etched plates from drawings)

Woodworkers Source
5402 S. 40th
Phoenix, AZ 85040
(Woods, including hardwoods)

Etching and lithography presses:

Charles Brand Machinery Inc.
45 York Street
Brooklyn, NY 11201-1420

Sturges and Printmakers Presses
Printmakers Machine Company
724 N. Yale Avenue
P.O. Box 71
Villa Park, IL 60181

Takach Press Corporation (formerly Takach-Garfield Press Co. Inc.)
3207 Morningside N.E.
Albuquerque, NM 87110

Printmaking facilities mentioned in this book where artists can work with an experienced printer:

Atelier Royce
Richard Royce, owner
57 Grove
Salem, MA 01970

Experimental Workshop
Ann McLaughlin, owner
P.O. Box 77504
San Francisco, CA 94107

Graphics Workshop
Ron Pokrasso, owner
632 Aqua Fria
Santa Fe, NM 87501

Hand Graphics
Michael Costello, owner
419 Montezuma
Santa Fe, NM 87501

Iris Editions (specializing in
photogravure)
Deli Sacilotto, owner
399 Washington Street
New York, NY 10013

Solo Press and Solo Gallery
Judith Solodkin, owner
520 Broadway, 8th floor
New York, NY 10012

Tiger Lily Press
Cincinnati Art Academy Annex
1125 St. Gregory Street
Cincinnati, OH 45202

**Up-to-date information on safety
of art materials:**

Art and Craft Materials Institute Inc.
100 Boylston Street, Suite 1050
Boston, MA 02116
617-426-6400
Fax 617-426-6639
(Product information)

Eastman Kodak Company
Printing and Publishing Imaging
Division
343 State Street
Rochester, NY 14650
800-242-2424, ext. 724
(Information on safety of
photographic printmaking
materials)

Intercontinental Chemical Corp.
(ICC Chemical)
4660 Spring Grove Avenue
Cincinnati, OH 45232
800-543-2075
(Information about the safest
solvents for oil-based inks)

National Art Materials Trade
Association (NAMTA)
178 Lakeview Avenue
Clifton, NJ 07011
201-546-6400
Fax 201-546-0393
(Video entitled *The Safe and
Successful Use of Art Materials,*
which includes a section on
printmaking; literature)

INDEX